Home Sweet Home

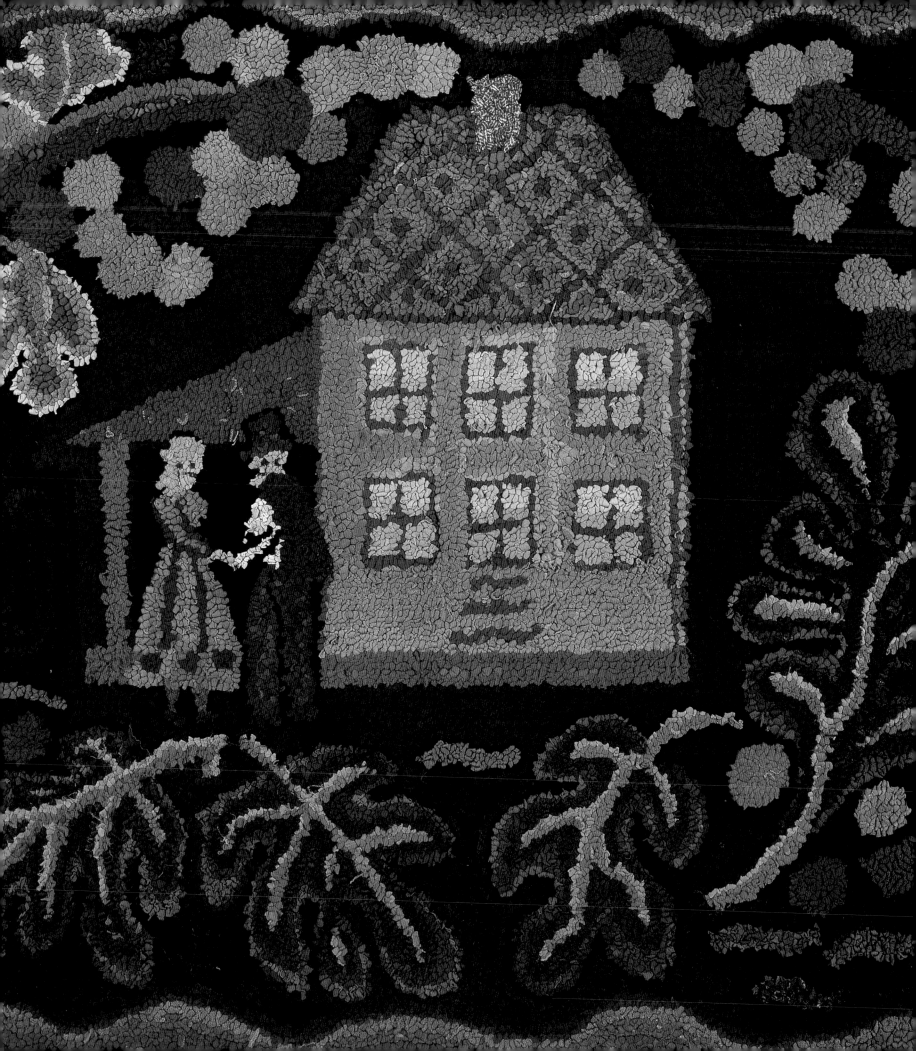

HOME SWEET HOME

The House in American Folk Art

DEBORAH HARDING AND LAURA FISHER

RIZZOLI
NEW YORK

First published in the United States of America in 2001 by
RIZZOLI INTERNATIONAL PUBLICATIONS, INC.
300 Park Avenue South
New York, NY 10010

ISBN: 0-8478-2409-8
LC: 2001088404

Endpapers photo credit:
Classic HOUSE QUILT in red and white, c. 1880.
Based on either "Old Kentucky Home" pattern published
in *Needlecraft Magazine*, April 1929, or "Old Homestead"
pattern published in the *Romance of the Patchwork Quilt in America*.
Collection of Laura Fisher

Distributed by St. Martin's Press

Printed and bound in Hong Kong

ACKNOWLEDGMENTS

We wish to express our appreciation to the following individuals and organizations who have generously shared their expertise, their collections, and their photographic resources in the development of this publication. ❋ First and foremost, thanks to the Museum of American Folk Art, New York, with special recognition for their inspiring 1996 exhibition *A Place for Us,* and specifically to Gerard C. Wertkin, director; Lee Kogan, director, Folk Art Institute and curator of special projects for the Contemporary Center; Stacy C. Hollander, senior curator and director of exhibitions; Janey Fire, director of photographic services; Katya Ullmann, library assistant; and Cyril I. Nelson, trustee, a valued friend to the museum and to us. ❋ We are also grateful to the following: Rebecca Aaronson, Society for the Preservation of New England Antiquities; Elma Ackley, Skinner, Boston; Kimberly Alexander, Peabody Essex Museum; Ned Allen, Berkshire County Historical Society; Aarne Anton, American Primitive Gallery; Dr. Andrew Aronson; Robert Barone; Patrick Bell and Ed Hild, Olde Hope Antiques; Cuesta Benberry; Ron Bourgeault, Luigi Pellitieri, and Merrilee J. Possner, Northeast Auctions; Jane Bowers, Kendall Whaling Museum; Doris M. Bowman, National Museum of American History, Smithsonian Institution; Mary Brooks, Westtown School; Norman Brosterman; Patrick Browne, Duxbury Rural and Historical Society.; Nancy Bryk and Melissa Haddock, Henry Ford Museum and Greenfield Village; Jean M. Burks, Celia Oliver, and Shawn Digney-Peer, Shelburne Museum; Virginia Cave; Stiles Tuthill Colwill; Don Cresswell, Philadelphia Print Shop; Paul S. D'Ambrosio and Kathleen Stocking, New York State Historical Association; Patricia M. Davis; Vincent DiCicco; Nancy Druckman, Sotheby's, New York; Larry Dupuis; Ali Elai, Cameraarts; Melody Ennis, Rhode Island School of Design; Helaine Fendelman; Amy Finkel, M. Finkel & Daughter; Jennifer F. Goldsborough; Olive Graffam, DAR Museum; Christine Granat, Memorial Hall Museum; Blanche Greenstein and Thomas Woodard, Woodard & Greenstein; Catherine H. Grosfils, Abby Aldrich Rockefeller Folk Art Museum; Bonnie Grossman; Connie Hayes; Dr. and Mrs. Donald Herr; Jonathan Holstein; Alexander Hoyt; Carol and Stephen Huber; Barbara Israel; Flora Gill Jacobs; Ruth Janson, Brooklyn Museum of Art; Beverly Jn-Charles; Susan D. Kleckner, Christie's, New York; Kristina Johnson; Dr. J. Kenneth Kohn; Sharon Duane Koomler, Sally Morse Majewski, and Lawrence Yerdon, Hancock Shaker Village; Kate and Joel Kopp, America Hurrah Archive, New York; Paula Laverty; Penny Marshall; Robert Meltzer; Judith and James Milne; Hossein Montazaran; Gillian Moss, Cooper-Hewitt National Design Museum, New York; Paul Neuman; Susan Newton and Linda Eaton, Winterthur; Pamela Parmal, Museum of Fine Arts, Boston; Susan Parrish; Mildred Peladeau; Candace K. Perry, Schwenkfelder Library and Heritage Center; Betty Ring; Charles Ritchie, National Gallery of Art; Stella Rubin; Dr. Susan Schoelwer and Richard C. Malley, Connecticut Historical Society; David A. Schorsch, David Schorsch American Antiques, Inc.; Jonathan Schmalzbach, Independence Hall Association; John and Linda Sholl; Annie Spring; Catherine Thomas and Nancy Boyle Press, Baltimore Museum of Art; Nancy B. Tiffin, Hingham Historical Society; Frank Tosto; Jessie A. Turbayne; Bonnie Wetherly, Daughters of Charity, Saint Joseph's Provincial House; Merikay Waldvogel; Carolyn J. Weekley, Colonial Williamsburg; Leon and Steven Weiss; Jeffrey R. Wells, Rocky Mountain Conservation Center; David Wheatcroft; Dr. Leslie Williamson; Mack Woodward, Rhode Island Historical Preservation and Heritage Commission; Shelly Zegart. ❋ Our thanks to everyone at Rizzoli, especially to our gifted and diligent editors Ellen Hogan Elsen and Tricia Levi.

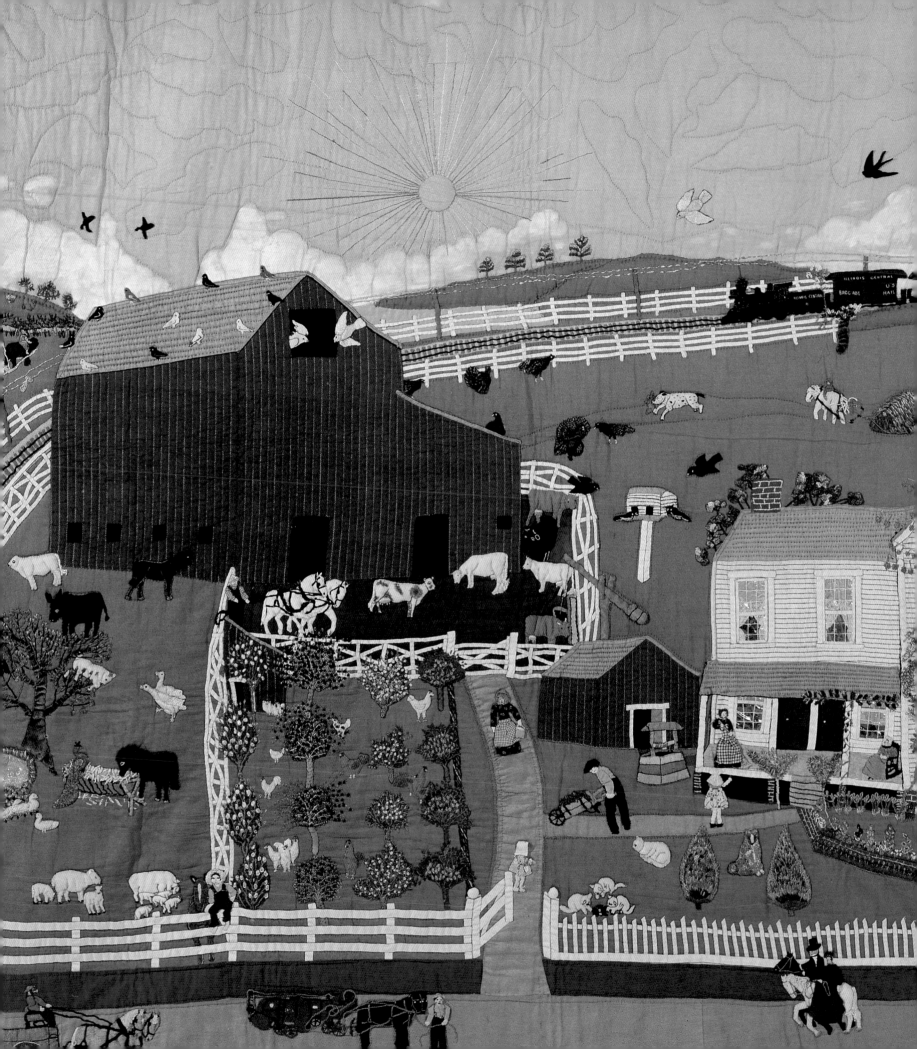

Contents

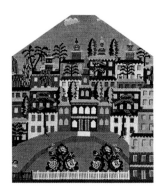

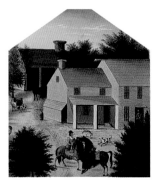

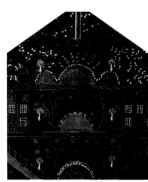

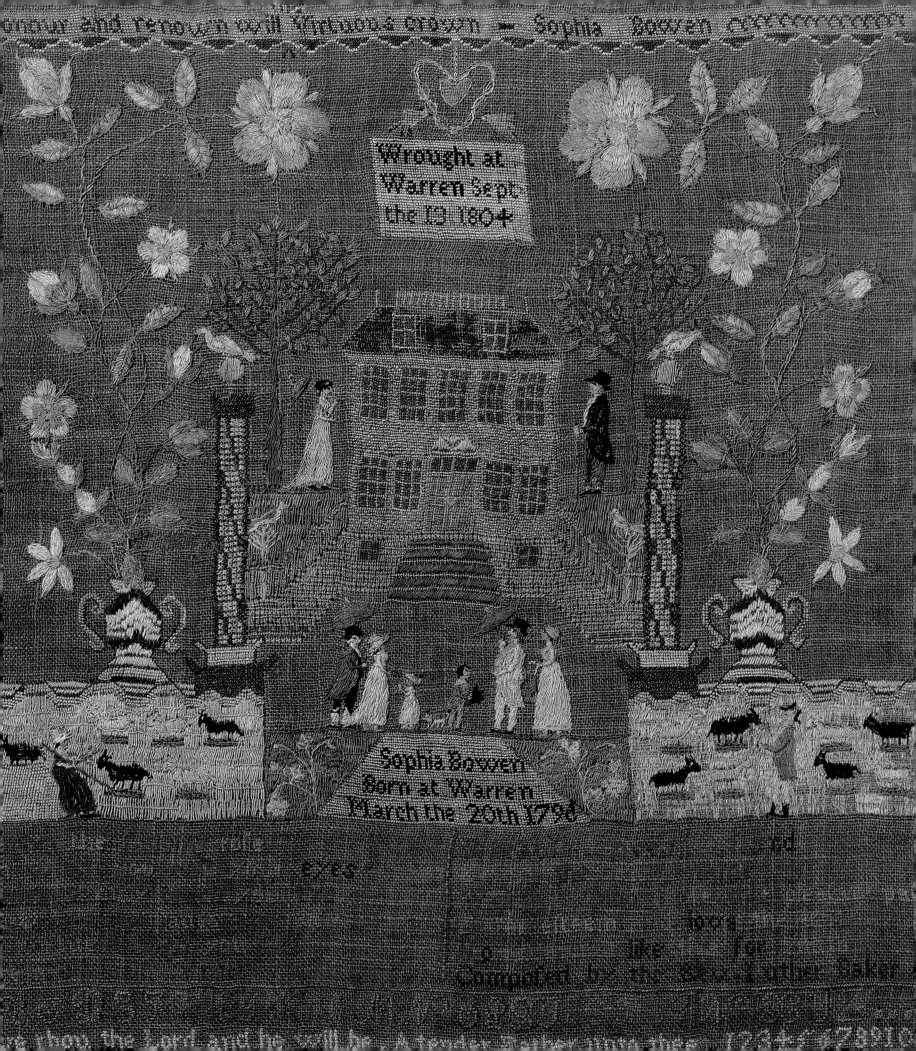

Wrought at Warren Sept the 10 1804

Sophia Bowen Born at Warren March the 20th 1790

American folk art is inextricably bound up with the ideas of "home" and "community." As this delightful and instructive volume demonstrates, folk artists have been inspired to depict, interpret, or enliven the built environment from early in our history—and in almost every format and medium. This should not surprise us: although this field of artistic expression is remarkably diverse, many of its traditions are rooted in domestic life. To speak about "home" or "home town" often prompts sentimental or even trite reflections, but it is clear from the illustrations that animate the pages of *Home Sweet Home* that folk artists have found a potent symbol in these images. ❋ As recorders of daily life, folk artists have left a rich visual chronicle of the way Americans have lived; in their paintings, needlework samplers, quilts, and other works, we can view depictions of dwelling places, houses of worship, schools, work structures, and other buildings that otherwise might be lost to us. To be sure, the record they provide is incomplete, if not idealized. Not every American lived in a cozy, picture-perfect home. Nevertheless, the aspirations inherent in these works of folk art relate to the very ideas that underpinned the new democracy. They are as telling in their own way as the reality itself. We are drawn to these images not only for insights into how some of our ancestors lived and worked and worshipped, but for evidence of the unparalleled yet unfulfilled promise of America itself. ❋ Lydia Howard Sigourney, a popular nineteenth-century American writer and poet, expressed the sentiments of her compatriots when she observed, "The strength of a nation, especially a republican nation, is in the intelligent and well-ordered homes of the people." That sense of a rational built environment, which was often commented upon by early visitors to the United States, is at the heart of the American experience. The wonderful works of art highlighted in *Home Sweet Home* point to the centrality of this idea in American culture and thought.

As director of the Museum of American Folk Art, I have long been aware of the hold that images of home—of the built, vernacular landscape—have on visitors to our galleries. Now through the welcome contributions of Deborah Harding and Laura Fisher, this heritage will reach an even larger audience. I invite you to read and enjoy *Home Sweet Home*. I am certain that you will be as beguiled as I am by its splendid images.

FOREWORD

By Gerard C. Wertkin, director
Museum of American Folk Art
New York

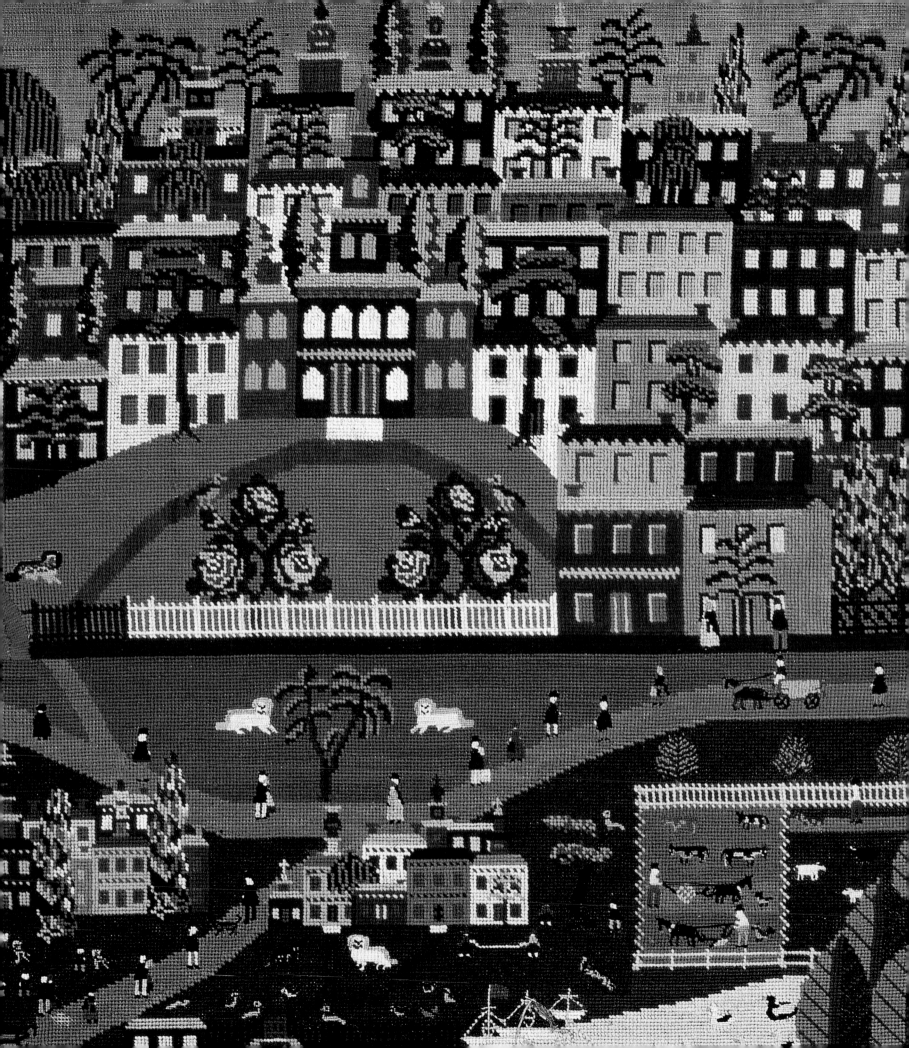

When buildings appear in seventeenth-, eigh-teenth-, and nineteenth-century American embroidery, the architecture depicted is often a clue to the date and the locale.

It may be a local landmark: a church, government building, schoolhouse, the home of a notable person. Or it could be a private dwelling, a fantasized house or castle, or even an entire townscape. ❋ "Home" did not necessarily refer to the house that the needleworker lived in as much as it did to her home community. ❋ Of significant importance in understanding this body of art is the knowledge that the majority of this needlework was stitched by children. Gillian Moss, textile curator at the Smithsonian Institution, Cooper-Hewitt National Design Museum in New York, explains, "The intimate world of childhood, domesticity, and the school room was the world of the embroidered sampler. Almost without exception, samplers were stitched by young girls who were attempting to master the techniques of such future tasks as mending, darning, marking household linens, and creating decorative accessories. Overall, the needlework of these young children was of high quality, although the pedagogic mistakes of childhood—backwards letters, reversed numerals, and mis-spelled words—occasionally asserted themselves." ❋ By the last quarter of the eighteenth century in America, needlework was considered such an important social accomplishment for any well-bred young lady that privileged girls, especially on the East Coast, were enrolled in private finishing schools to master this skill. Mothers might be able to teach daughters the basics of plain sewing at home, but fancywork needed to be learned in a classroom, from an experienced teacher. ❋ America's foremost authority on schoolgirl embroidery, Betty Ring, has researched and reconstructed the biographies of many of the girls who stitched these early samplers and of their teachers. "Most people think that samplers were made at home," explains Ring. "And they also think that children devised their own designs, though this was rarely the case. I try to direct credit for this most appealing form of naive art to those who deserve it—the forgotten schoolmistresses of early America." ❋ The years 1800 to 1835 were prolific in the production of samplers, many of which can be traced to New England and mid-Atlantic states. Port cities such as Boston, New York, Philadelphia, and Newport welcomed new settlers, and schools opened to meet their needs.

chapter one

SAMPLERS & SILK EMBROIDERY

Samplers

One of the earliest references to a sampler is a verse by the English poet Skelton (1469–1529): "the sampler to sowe on, the laces to embroide"[1] and a sampler was listed in the inventory of Edward VI (1552) "Item: Sampler or set of patterns worked on normandy canvas, with green and black silks."[2] The first American sampler, circa 1640, is attributed to Loara Standish, daughter of Plymouth Colony's Myles Standish.

The word *sampler* comes from the Latin *examplar*, which means "an example to learn from." Indeed, girls and boys learned their ABCs from simple samplers either at home or at a neighborhood school known as a dame school.

Although cross-stitch letters are a significant component in a number of pieces, there is more to samplers than alphabets. As girls mastered fancier stitches, pictures and verses were added to their work. The more skillful the maker, the more elaborate the results. The term *sampler* also connotes a sampling of a variety of work and indeed early sixteenth- and seventeenth-century samplers were just that—a means of recording new stitches and designs as learned, a pattern-keeper for reference. Not intended for display, these work pieces were rolled up and stored away until needed.

"By the eighteenth century, samplers were always made to be framed—as a picture—rather than rolled up and stored away," relates Philadelphia needlework specialist and dealer Amy Finkel. "Girls would return from school and if their parents could afford it, they would take the sampler to a good picture framer in town. The finished and framed needlework was displayed as a status symbol (reflecting not only the girl's proficiency with a needle but the parents' financial ability to send her to a school) and passed down in families. When a picture has its original frame, there may be a label on the backboard that can be checked against a list of known picture framers and their labels. This provides great documentation," she adds.

Basic samplers were usually mounted in simple frames of walnut or mahogany.

Finkel describes basic American sampler types, as follows:

Band Samplers

These samplers, popular in America from the late seventeenth through the beginning of the eighteenth century, are the earliest style known. Each horizontal band or row recorded a different technique, size, or style of lettering and/or motif. Long and narrow in shape, band samplers might be just 8 or 9 inches wide and 20 or 30 inches long.

Bordered Samplers

The use of borders on pictorial (and some band) samplers emerged in the early to mid-eighteenth century, ranging from a simple little running vine to more elaborate motifs. Sampler shapes became shorter and wider. Intended for framing, these needlework pictures frequently included a well-developed scene with a lawn or ground expanse, foliage, flowers, figures, and animals and—most significantly—houses.

Genealogical Samplers

Eighteenth- and early-nineteenth-century homesteaders took great pride in family life. Genealogical embroideries, the most indigenous American sampler form, transcended the family Bible by providing a more visual way to keep a family register. Names along with dates of birth, death, and marriage were stitched in cartouches, charts, blocks, or lists. These samplers are increasingly collectible today; genealogical research is one of the fastest-growing hobbies in the United States.

Borders as a design element to frame pictorials developed naturally from rows of motifs on band samplers to rows of decorative motifs that extended around the sides, top, and bottom. Family records and moral and religious verses were a predictable transition from alphabets and numbers.

Subjects chosen for pictorials reflected familiar sights such as flowers, trees, birds, people, family pets, and buildings, often rather grand ones. The architecture of these structures might be highly detailed, including paned and shuttered windows; columns and chimneys; gates, fences, railings; widow's walks and balustrades; porticos and pediments; brickwork and clapboard; cupolas and pergolas; steps, steeples, and spires—all sketched with needle and thread. The popularity of architectural images as a design element in needlework is apparent from the number of diverse examples that survive today.

Samplers were inscribed with the name and age of the maker, her date of birth and/or the date she finished the work, sometimes the town, and perhaps even the name of her teacher and the school in which she learned these valuable lessons. Similar and sometimes almost identical samplers from the same region, school, and period exist with the only major difference being the name of the student and the date that the piece was completed.

The samplers we are likely to see today date from the late eighteenth and early nineteenth centuries. Sampler making was diminishing in appeal by the mid-1800s, when girls were encouraged to apply themselves to more academic subjects.

Silk Embroideries and Mourning Pictures

Samplers, usually worked with silk on linen, are not the only form of schoolgirl embroidery. At the turn of the nineteenth century, it was fashionable for advanced students to create elegant, ornamental silk-on-silk pictorials that incorporated metallic threads, chenille, beading, sequins, and even human hair. Watercolor painting was used to define

the larger areas like sky and clouds or small features such as faces, arms, and hands. These sophisticated works with neoclassical subjects inspired by printwork were so intricately stitched that it might have taken several semesters to complete one piece.

Mourning pictures usually documented the death of a relative and were characterized by a tombstone, plinth, and/or urn, marked with the name of the deceased, around which were gathered well-dressed, grieving relatives—sometimes with hankies in hand—standing beneath weeping willow trees or evergreens. This style of silk embroidery became popular after the 1799 death of George Washington (many were made to honor him). The names for the epitaphs were sometimes printed on paper or a separate piece of fabric and applied to the monument or stone. This type of picture was so fashionable that a girl might be inclined to stitch one even if no recent family death had occurred, in which case a sentiment such as "Sacred to Friendship" might appear on the monument (see page 32) or a space was left blank to be filled in at a later date.

For some silk embroideries, teachers are credited with sketching the designs onto fabric, presenting them to the class to embroider, and then directing or actually completing any painting. Occasionally, portrait miniaturists were engaged to paint facial features or other complex finishing touches. Or, in some instances, framers might provide the painted detail when they framed the piece. Opulent silk pictorials merited opulent frames, often a glittering gold-leaf with a mirrorlike black or white églomisé mat that included gilt lettering of the needleworker's name and the date.

One school renowned for the silk pictorials produced by its students was led by Abby Wright in South Hadley, Massachusetts. Schools in Portland, Maine, were known for their exceptional genealogical silk embroideries. Townscapes were stitched and/or painted at the bottom of many Portland genealogical pictorials and in the background of some mourning pictures.

CANVAS WORK AND BERLIN WORK

Canvas work is embroidery with crewel wool on either canvas mesh or loosely woven linen. One of the most important known examples of American canvas work is the circa 1750 Hannah Otis chimneypiece (for display over a fireplace) at the Museum of Fine Arts, Boston (pages 18–19). Hannah's artistic imagination led her to combine wool with silk and metallic threads, and beads on linen. Her original composition depicts real people and real places: The setting is Beacon Hill, complete with identifiable buildings including the Hancock House, built by Thomas Hancock in 1737 and later passed on to his nephew, Declaration of Independence signer John Hancock.

Berlin work (also known as Berlin woolwork), a type of embroidery that originated in Berlin, Germany, gained widespread acceptance in America, after 1840. Paper patterns printed and colored in Berlin were imported to the States in great quantities. Also worked on a grid, the results were not as sophisticated as traditional canvas work. Thanks to new discoveries in dying wools, softer yarns (known as Merino) became available in brilliant hues of magenta, blue, violet, green, and—in 1856—mauve, accidentally discovered by an English chemist named William Henry Perkins.[3] These bold colors are intrinsic to Berlin work. Usually applied to larger items such as footstools, bell pulls, and firescreens, Berlin work also appears on late nineteenth-century samplers featuring grouped motifs of large floral bouquets, domestic pets, and brightly colored buildings.

Whatever technique or style was being taught, it was usually the schoolmistress's responsibility to choose, assemble, and often design the embroidery motifs. She might select a favorite print for students to duplicate, and suggest how to incorporate it into a picture with other motifs, border treatments, and/or verses. Students in the same class, inspired by the same print, could personalize their work through the selection of colors or their choice of small motifs, favorite flowers, and perhaps even figures to represent family and pets.

Talented schoolmistresses developed individual, recognizable styles that not only gained them prominence at the time but that are still distinguishable today. This explains why recurring motifs found in schoolgirl needlework can often be identified and why many people believe that it is the teachers, rather than their students, who should be considered to be the true folk artists.

Considering that these teachers usually gave classes in their homes, that they stopped teaching if they married, and that records were seldom kept after their deaths, it is remarkable that scholars such as Betty Ring have unearthed enough documentation to enable trained eyes today to see the rendering of a flower, a leaf shape, a building, a border element, a background color, a stitchery technique, or even a particular color silk thread and be able to document the work not only as to region and approximate date but to credit it to a specific school and/or teacher.

Certainly there were instances when a girl learned needlework at home from a skillful female relative or even a private tutor, but chances are that that person had originally studied at one of the local schools and thus perpetuated regional design characteristics. These vernacular styles were influenced to some extent by the homelands of the settlers; for example, Boston embroideries resembled English needlework and German motifs can be found in Pennsylvania stitcheries.

It cannot be assumed, however, that all embroidery was stitched by very young students. The majority of the girls ranged in age from nine to sixteen but unmarried girls with a special aptitude, particularly in the northeastern states, might continue on to academies to advance their education and perfect their skills. Some of them would become apprentice teachers and perhaps even schoolmistresses themselves. (Not until the twentieth century did adults began to cross-stitch samplers on a regular basis.)

ARCHITECTURE IN EMBROIDERY

Buildings that appear in needlework pictures were often inspired by prints or derived from architecture in published sources. Different schools specialized in, and are represented by, specific images. For example, the samplers from Mary (Polly) Balch's school in Providence comprise one of the largest groups of schoolgirl needlework attributable to a specific early American school and the most celebrated examples picture important Providence buildings. Buildings portrayed include the First Congregational Church (pages 28–29); the Providence State House, also known as the Court House (see page 29); the College Edifice representing the first building of Rhode Island College and the college president's house; and the First Baptist Meeting House.

Another recognizable building found on needlework is the Friends' Westtown Boarding School (also spelled West-Town, West Town, and even Weston) in Chester County, Pennsylvania. Westtown, a Quaker school, is shown as a four-story red building with (and without) lots of blue-shuttered windows. Curiously, research verifies that the names on signed samplers depicting the Westtown School seldom match up with the school's records of registered students. Therefore, it is believed that students from

Westtown who went on to become teachers themselves used this distinctive building as a prototype design for their own classes.

St. Joseph's Academy, a Catholic girls school near Emmitsburg, Maryland, was a favorite subject for its student artwork. The main building, St. Joseph's House (also known as the White House) is usually presented from a three-quarter view. It is shown as a two-and-a-half story, two-chimneyed, dormer-windowed building with an addition on the left. On pictorials, this building is stitched as the focal point of the picture, whereas in mourning pictures, it is painted as a distant image in the background. Other embroidered school buildings include a small spring house to the left of St. Joseph's House and the later circa 1821 Dubois Building to the right. This school, founded by Mother Seton, initiated the parochial school system in America.

Examples of American architecture can also be found on a large group of Baltimore samplers from the first quarter of the nineteenth century. These images include colorful houses (some brick), churches, and renditions of the Baltimore Hospital. And from 1840s Kutztown, Pennsylvania, there are local churches such as Old Saint John's Union Church and the Franklin Academy.

Based on Betty Ring's research,[4] additional regional needlework categories featuring building motifs include:

Neoclassical silk embroideries, copied from prints, from the Derby School in Hingham, Massachusetts

Newport's 1780s to 1835 "elegant house" group of samplers; many of which portray a centered house with an elaborate gated fence, birds perched on shrubbery lining the fence, and a cartouche for the name and date

Federal-period vertical samplers, from the Boston area featuring deeply arcaded borders at the top and sides and with a sawtooth border enclosing a center section

with an alphabet and a verse above a variety of pictorial elements, of which a house is most common

Plymouth, Massachusetts, samplers with small-scale houses stitched and/or painted in landscapes, under three alphabets and a verse—all enclosed in a floral bordered octagonal field—with rounded or squared-off corners

The 1804–21 townscapes of Wethersfield, Connecticut, samplers, occasionally embellished with paint and applied paper, which often feature the First Church of Christ meetinghouse

Solidly worked Connecticut embroideries with buildings (some red and blue), people, flowers, and birds stitched in wool on linen from New London and Norwich

Portsmouth, New Hampshire, "House and Barn" samplers from the Walden and Smith schools, made in the first quarter of the nineteenth century

The 1801–20 mourning pictures of Albany, New York—specifically printwork embroideries, from designs drawn by engravers Henry W. Snyder (a trained architect) and Ezra Ames that depicted actual buildings including a Gothic church, Whitehall, the Dutch Reformed Church, and meetinghouses that were most likely local churches

Federal-period pictorial samplers from Philadelphia that showcase a variety of architectural images, including the stepped-terrace embroideries with Georgian mansions; castlelike dwellings such as the three-towered black-and-orange structures from Mary Zeller's school; house-and-garden samplers with strolling couples in plumed hats; red mansions; and brick houses with giant eagles hovering overhead

Samplers from Mrs. Buchanan's school in Susquehanna Valley, Pennsylvania, featuring a red-roofed house complete with front steps, garden furniture, and a fenced-in yard above a verse and/or name

- The "Towering Ladies of Lebanon" embroideries portraying a very large woman standing next to a house that is at least half her size

- From Lehigh Valley, Pennsylvania, 1813–34, designs credited to the teacher, Mary Ralston, notable for impressive buildings surrounded by heavy floral borders, worked in wool

- Building samplers from the Quaker schools of Burlington County, New Jersey, which fall into three groups: one showing a building enclosed in an oval with an arched sky and curving fence; a second group including versions of the Westtown School; and a third with a three- or five-bay house on a fenced mound with an inscription beneath a grapevine garland

COLLECTING SAMPLERS

As early as 1921, Candace Wheeler, an artist, an advocate for women, and a founder of the Decorative Arts Society and Woman's Exchange, stated that collecting samplers "has become rather of a fad in these days. . . . It gives an opportunity of acquaintance with the little Puritan girl which is not without its charm. As most of their samplers were signed with their names, the acquaintance becomes quite intimate, and one feels that these little Puritans were good as well as diligent. . . . What child whose name was Harmony could quarrel with other children, or how could this other, whose long-suffering name was Patience, be resentful. . . . Thanks and Unity

must have sat together like little doves and made crooked A's and B's and C's and picked out the frayed sewing-silk threads under the reproofs of the teacher."[5]

However, it was not until the last two decades of the twentieth century that the unique merits of schoolgirl embroidery began to receive serious recognition in the art field. Although some impressive private collections of samplers had been amassed, including the corporate collection of Whitman's Chocolate Company (a sampler is used as the name and design on their familiar yellow boxes), it was at Sotheby's 1981 auction of the Theodore H. Kapnek collection that American samplers and silk embroidered pictures came into their own in the antiques market. Prices paid tripled the pre-auction estimates.

"Collectors began to realize that this was one antiques field that had long been underestimated and that there were (and still are) good buys to invest in," says Old Saybrook, Connecticut, needlework dealer Carol Huber. "Samplers, passed down in families, including treasures from the 1700s are still being unearthed in attic trunks."

Although fewer samplers were made than quilts, they did not change hands frequently, have not suffered as much wear and tear, and can still be found in good condition. Stephen Huber, Carol's husband and business partner, explains this: "In the decorative arts field, samplers and silk embroideries were the only things made for the home that were not for commercial sale."

"Few fields offer as much signed, dated, and regionally specific pieces with provable provenance," says dealer Amy Finkel. "There are a number of needlework pictures that resemble folk paintings; some, in fact, are earlier than documented folk paintings, and can be purchased at a fraction of the cost," she adds.

Record prices in recent years include $198,000, paid at Skinner, Boston, in 1987 for the circa 1789 "Ruthy Rogers" silk on linen needlework picture, which shows a woman under a tree with birds and flowers in a solidly worked center surrounded by a strawberry border. A 1727 Philadelphia band sampler worked by Ann Marsh sold for $299,500 at Sotheby's, New York, in January 2000 to the Hubers. The Ann Marsh piece had great historical value because Ann (and her mother, Elizabeth) were legendary Quaker schoolmistresses and the quality of their work was greatly renowned. The "Hannah Otis" pre-Revolutionary chimneypiece, described under canvas work, was purchased by the Museum of Fine Arts, Boston, in 1996 for $1,557,000.

Collectors and scholars may concentrate on work from a certain geographical area, examples from a single school or each of the major schools; may collect mourning pictures, family records or floral borders; may look for particular verses, or may focus on samplers and pictorials representing different styles of architecture, as shown on the following pages.

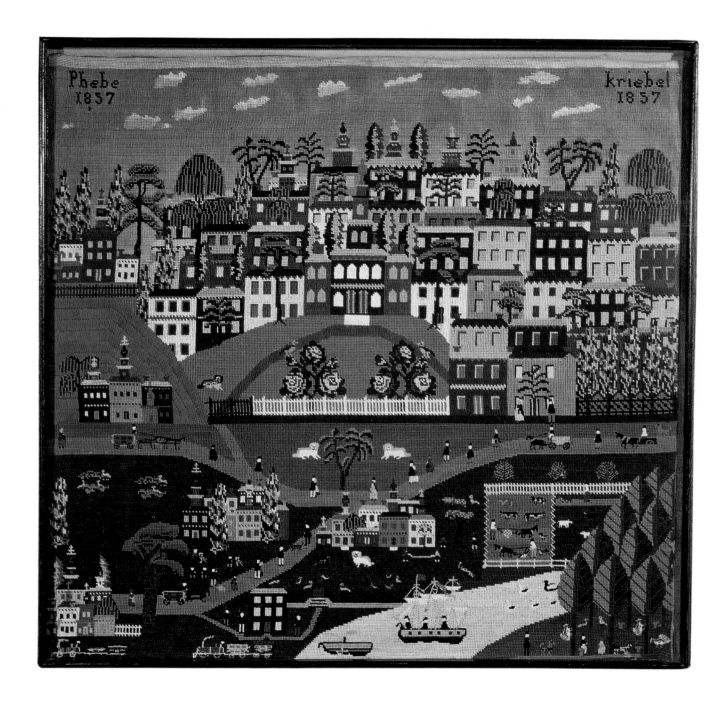

TOWNSCAPE,

Dated 1857

Worked by Phebe Kriebel; Pennsylvania

Wool on canvas, 27 x 25 in.

Collection of the Schwenkfelder

Library and Heritage Center,

Pennsburg, Pennsylvania

(Detail shown on page 10)

The Townscape composition of Phebe Kriebel (1837–1894) is not unusual in terms of technique or design choices for its time. Motifs such as the outsized spaniels (a nod to Staffordshire-type spaniels so popular in the Victorian era), full-blown roses, and stylized trees are common images in Berlin work, a type of needlework popular in the United States in the 1850s. This townscape is believed to represent the city of Philadelphia because of the multistoried townhouses, vehicles transporting goods, and promenading pedestrians.

The piece may also be a conglomeration of Berlin work motifs and traditional sampler devices combined to create a vividly colored, imaginary town. In Phebe's distorted perspective—a charming hallmark of folk art—the background buildings appear larger and closer than the neighborhood in the foreground. She captured an era of transition by including a variety of modes of transportation contrasting mid-nineteenth-century progress with centuries-old traditions, from the wagon to the railroad and the tall ship to the steamboat.

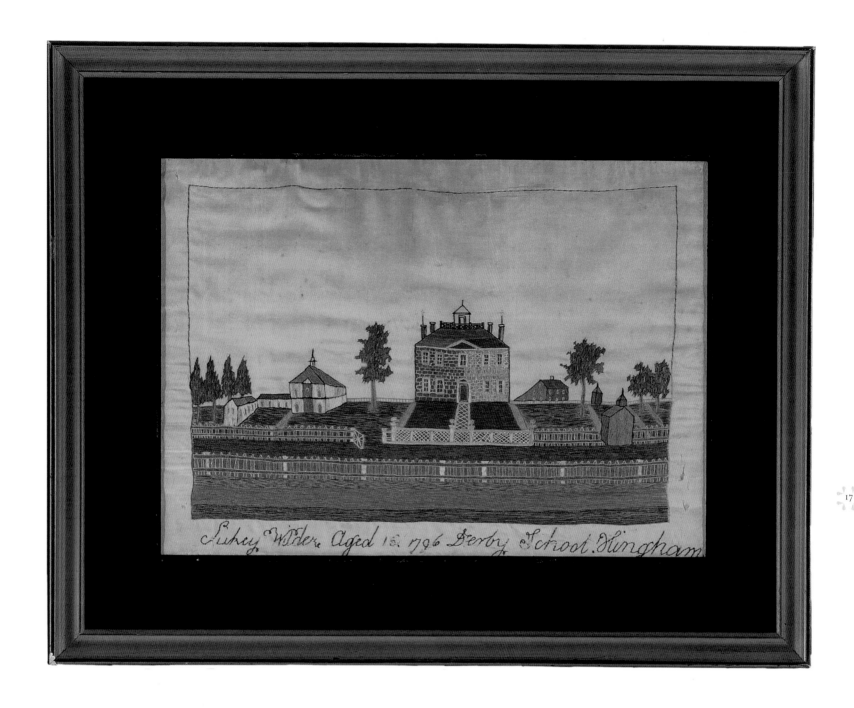

Sukey Wilder Aged 15. 1796 Derby School Hingham

STREETSCAPE OF
BUILDINGS AND FENCE
LINES, Dated 1796

Worked by Sukey Wilder;
 Massachusetts

Silk on silk, 16 3/4 x 11 3/4 in.

Collection of the Hingham Historical
 Society, Hingham, Massachusetts

This beautiful silk pictorial was stitched by fifteen-year-old Sukey (Susa) Wilder, a student at the Derby School in Hingham, Massachusetts, which was known for its neoclassical silk embroideries based on prints. In *Girlhood Embroidery*, Betty Ring credits Jane Nylander with discovering the print that inspired this particular piece: "View of the Seat of The Hon. MOSES GILL Esq. at Princeton in the County of Worcester, Mass, engraved by Samuel Hill, State Street, Boston, and used as the frontispiece for the Massachusetts Magazine, November 1792."[6] Details worth noting are the intricately stitched brickwork facade of Mr. Gill's hip-roofed, four-chimney manor house and the patience-testing picket fences—even an inviting open gate—bordering the street in the foreground. With all of the fences, no animals appear to be constrained by them. Embroidered in black at the bottom of the picture are the words "Sukey Wilder, Aged 15. 1796 Derby School. Hingham."

CANVAS WORK CHIMNEYPIECE,
c. 1750

Worked by Hannah Otis; Massachusetts
Wool, silk, metallic threads, and beads on linen,
 24½ x 52¼ in.
Collection of the Museum of Fine Arts, Boston;
 Photo courtesy Sotheby's, New York

Hannah Otis (1732–1801) is credited with the original design of this extraordinary colonial masterpiece. It includes a view of Beacon Hill, the 1737 Hancock House, and Boston Common. This scene depicts the Hancock mansion complete with livestock and pets as well as the Copley homes in the distance. The church spire in the background is believed to be the Old North Church but it has also been identified as the West Church. Scholars question whether the fortlike structure flying the colorful King's Flag was a real building known as the Block House or an imaginary device used to suggest the presence of British soldiers. People in action are included: the couple represents Thomas Hancock and his wife, Lydia; the horseman is presumed to be his nephew John Hancock; a black groom approaches the horse and an archer readies his bow.

Pamela Parmal, curator of the Department of Textiles and Costumes at the Museum of Fine Arts, Boston, points out that although this piece is Hannah's own composition, she may have been influenced by conventional design elements of the period, which would explain the stylized trees and animals, the oversized birds in the sky, and the giant strawberries in the foreground. This exceptional chimneypiece, in the original frame, remained in the Otis family until the 1950s, when it went on longterm loan to the museum. The museum purchased it at Sotheby's in 1996 for $1,557,000, a record price for needlework at auction.

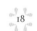

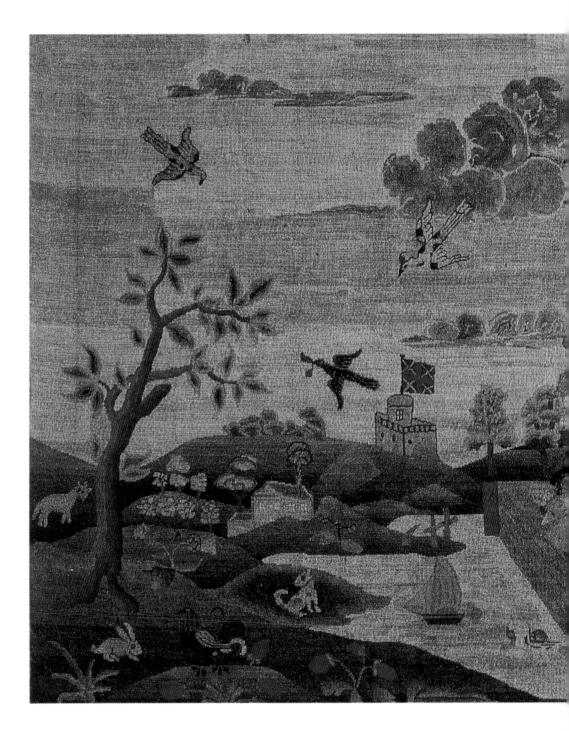

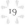

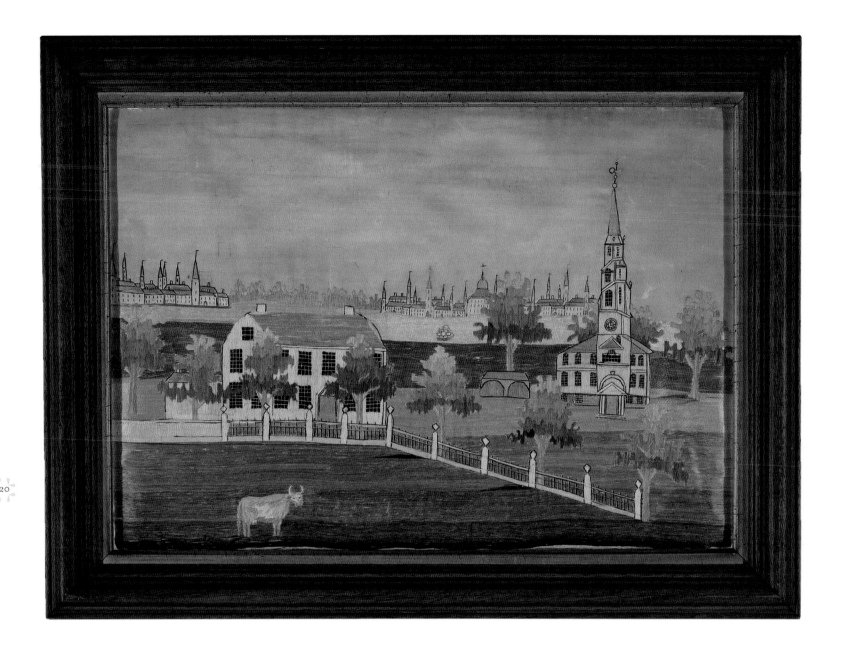

VIEW OF BOSTON AND
CAMBRIDGE, c. 1800
Worked by Lydia Cushing;
Massachusetts
Silk and paint on silk, 18¹/8 x 12¹/2 in.
Collection of the Hingham Historical
Society, Hingham, Massachusetts

It is interesting to compare this silkwork landscape from the Derby School in Hingham, Massachusetts, to Hannah Otis's view (pages 18–19) of the same house and scene approximately fifty years earlier. The large house with multipaned windows situated behind the trees is said to be that of John Hancock, and once again there is a cow grazing on Boston Common. Historical records match with Hannah's dormer-windowed rendering of the house while Lydia's stitchery depicts a somewhat simpler version. The tall weathervaned building at right is identified

as Park Street Church because of its distinctive steeple. The many flag- or vane-topped spires in the distance resemble a medieval townscape rather than urban expansion. Provenance that came with the piece identified them as Cambridge buildings, including Harvard College, with the Charles River separating Boston and Cambridge. However, this needleworker took some artistic license with her composition, since the buildings at Harvard, which are west of the common, would not have been visible in this scene.

VIEW OF MOUNT VERNON,
Dated 1838
Worked by Harriett Dector; New Jersey
Silk on linen, 16 1/2 x 20 1/2 in.
Collection of Joyce and Bill Subjack; Photo courtesy
M. Finkel & Daughter, Philadelphia

This particular image of Mount Vernon's east front was taken from an aquatint engraving by Frances Jukes (1747–1812) after a drawing by Alexander Robertson; it was titled *Mount Vernon in Virginia: The Seat of the late Lieu.t George Washington* and was issued in London on March 31, 1800, during the great national mourning period following Washington's death. This sampler maker stitched, with great accuracy, the three doorways, dormer windows, octagonal cupola, Palladian side window, and colonnade arches and inscribed it "Harriett Dector Elizabeth Town New Jersey Taught by Miss Barton AD 1838." The needlework is formalized within double borders, a vine and blossom motif on the inner one and a stylish elongated Greek key on the outer one.

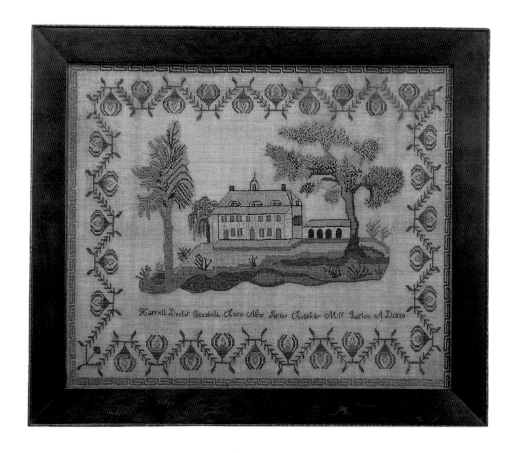

BAND SAMPLER, c. 1791
Worked by Hannah Staples; probably Maine
Silk on linen, 10 3/4 x 10 3/8 in.
Collection of the Museum of American Folk Art, New
York; Gift of Louise Nevelson and Mike Nevelson

Early "band" or "row" samplers were long and narrow and recorded a variety of stitches, motifs, and techniques. This almost-square example does not fit that description but it is considered a band sampler because it is worked in horizontal rows. The bottom half includes no less than nine different building shapes. Fifteen-year-old Hannah's name nearly gets lost among the geometric motifs and the several sets of alphabet letters and numbers, but her inscription "Hannah Staples . Born . September The 14, 1776" can be discerned about a third of the way from the top.

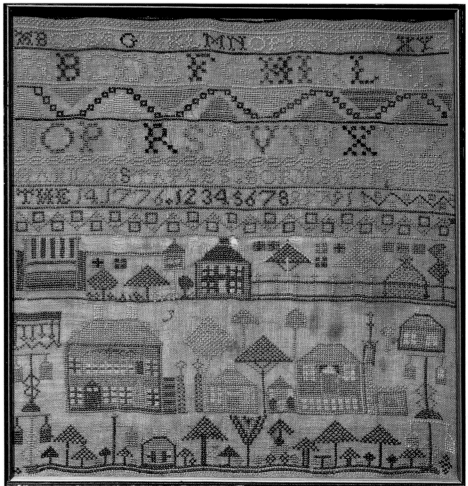

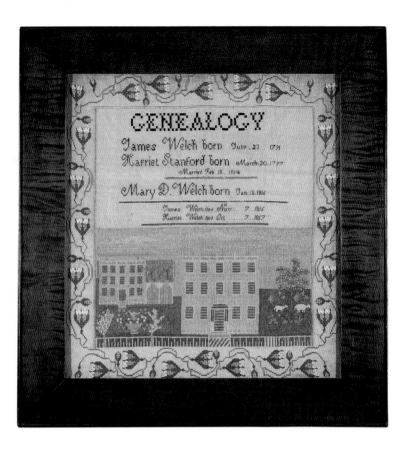

GENEALOGY, c. 1828

Worked by Mary D. Welch; Maine

Silk on linen, 17 x 16 in.

Private collection; Photo courtesy M. Finkel & Daughter, Philadelphia

Portland, Maine, is known for several needlework schools that produced important embroidered genealogies with verses and alphabets worked above a townscape. Akin to accounts inscribed in the family Bible, these records of family births and deaths done on samplers are indigenous to America. We can read that Mary D. Welch was born January 18, 1816 to James Welch and Mary Stanford and that both parents died before her second birthday. Mary's sampler, stitched when she was about 12 years old, shows a townscape with three-story yellow houses, fencing, manicured lawns, and grazing sheep—all characteristic of these pieces. An unusual aspect is the fine and complicated queen stitch rose and vine border, carried over from the 1803–15 era of Portland genealogical design and rarely found on those samplers beyond those dates.

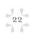

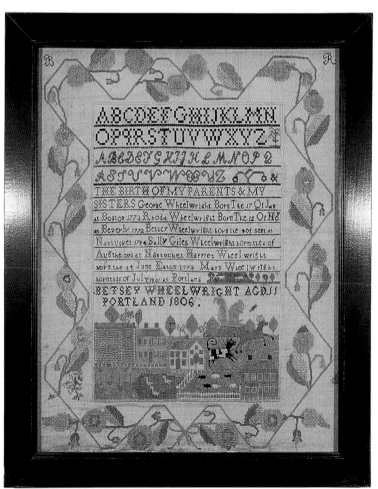

PORTLAND SAMPLER, Dated 1806

Worked by Betsey Wheelwright; Maine

Silk on linen, 24 1/8 x 18 5/8 in.

Photo courtesy Stephen and Carol Huber, Old Saybrook, Connecticut

Several different building styles appear on this Maine genealogical sampler. There is an imposing two story, four-bay Federal-style brick house with stone end chimneys; to its right, a yellow Georgian two story (and a red one in the foreground), appealing for the differing window treatments—shuttered on one side and open on the other; a neighboring white colonial house; and additional houses or barns in the background. While most Portland samplers of this type have straight-line fencing (see Mary Welch's Genealogy, above), Betsey places hers at angles, and while the ducks in the pond, grazing livestock, trees, and rosy flowers might imply pastoral calm, the explosive scale of the appliquéd squirrel and the dynamism of the leaping cow and stag suggest that Betsey's imagination wandered far beyond the confines of Portland.

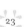

WARREN SAMPLER,
Dated 1804
Worked by Sophia Bowen;
Rhode Island
Silk on linen, 17¼ x 16¼ in.
Collection of Joyce and Bill Subjack;
Photo courtesy M. Finkel &
Daughter, Philadelphia
(Detail shown on page 8)

A group of Warren, Rhode Island, samplers worked under the instruction of Mrs. Martha Pease Davis (1743–1806) share virtually all of the characteristics shown on this sampler: an impressive five-bay brick house flanked by diagonally striped pillars surmounted by a pair of birds perched on finial balls; the overall format including steep front stairs, lawns, and trees; and the use of many different stitches to depict varied pictorial images. All these samplers are peopled with fashionably dressed couples and children. In Sophia's exercise, a shepherdess tends her flock at lower left and a shepherd at lower right. The reserves above the house and

below the large group of figures are similarly worked on all of these Warren samplers, and their makers typically include the date of their birth as well as the date of completion of the sampler. Many of the pieces display the same bannerlike inscription across the top, which reads, "Honor and renown will the virtuous crown," but ten-year-old Sophia seems not to have planned ahead; she worked the word "the" above the line with an insertion mark. The sampler is inscribed "Wrought at Warren Sept. the 13, 1804." However, the last digit of Sophia's birth date was reworked, most likely by the needleworker herself later in life.

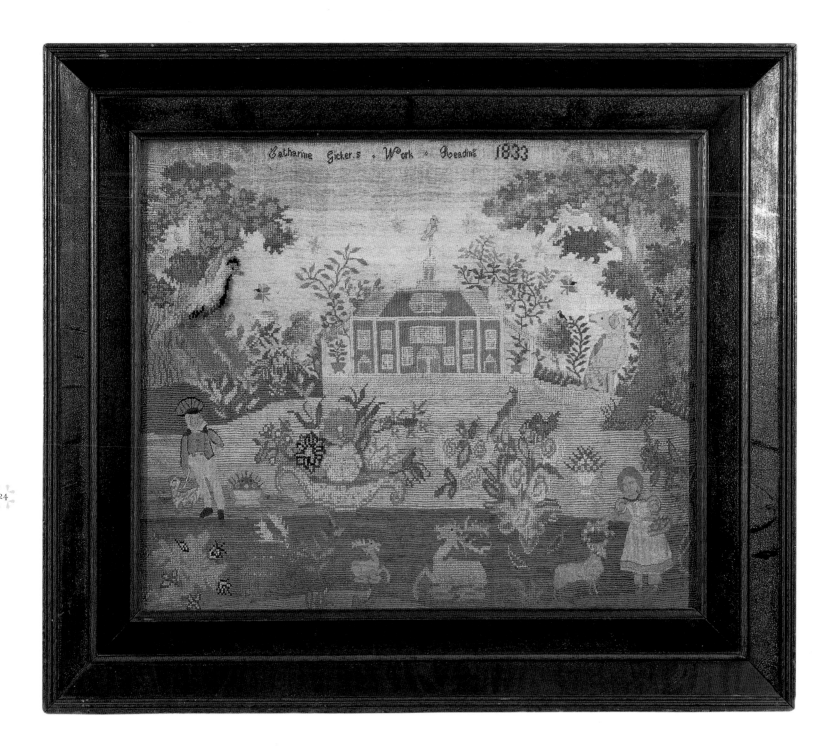

READING NEEDLEWORK
PICTURE, Dated 1833

Worked by Catherine Gicker;

Pennsylvania

Silk on linen with beads, 17 3/4 x 21 1/2 in.

Collection of Terri A. Brady and David

W. Johnson; Photo courtesy M.

Finkel & Daughter, Philadelphia

This painterly work is one of an extremely appealing group of whimsical needlework pictures that have emerged from Reading, Pennsylvania. Their shared motifs include an imposing house with its greenhouselike appendages; a Herculean dog, bird, and urn of flowers; a foppish young boy; and a basket-toting girl. Another characteristic is a necklace strung of tiny beads and sewn around

the girl's neck. The broadly proportioned columned Greek Revival house is interesting for the multishaped windows and doorways as well as the weathervane top (or is that meant to be a real bird resting on the spire?). This is believed to be the only solidly worked piece of this type and region. It is inscribed "Catherine Gicker.s Work Reading 1833."

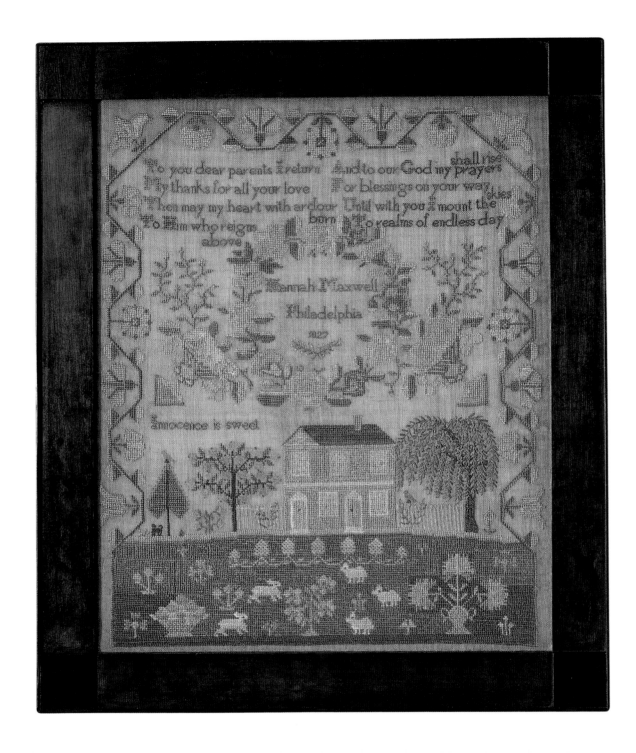

PHILADELPHIA SAMPLER,
Dated 1827
Worked by Hannah Maxwell;
Pennsylvania
Silk on linen, 20½ x 17¼ in.
Collection of Dr. Louis and Anita
Schwartz; Photo courtesy M. Finkel
& Daughter, Philadelphia

In 1827, Philadelphia was the second largest city in the United States and known for its decorative arts. Many outstanding pictorial schoolgirl samplers were produced there. Hannah Maxwell's superb example contains designs frequently associated with eastern Pennsylvania and the mid-Atlantic states, including the ribbed fence and deeply terraced lawn. A recognizable Quaker motif is the wreath of flowers surrounding Hannah's name. Sarah Elwell,

Hannah's classmate, executed a strikingly similar sampler; both works feature the same three-quarter house view with side and front entrances on the same plane. A solidly stitched lawn is cluttered with strawberries, sheep, rabbits, and baskets of flowers in no proportional relation to each other—and each sampler features a pair of flower baskets set on the diagonal. The aphorism "Innocence is sweet" appears in the same location on both pieces.

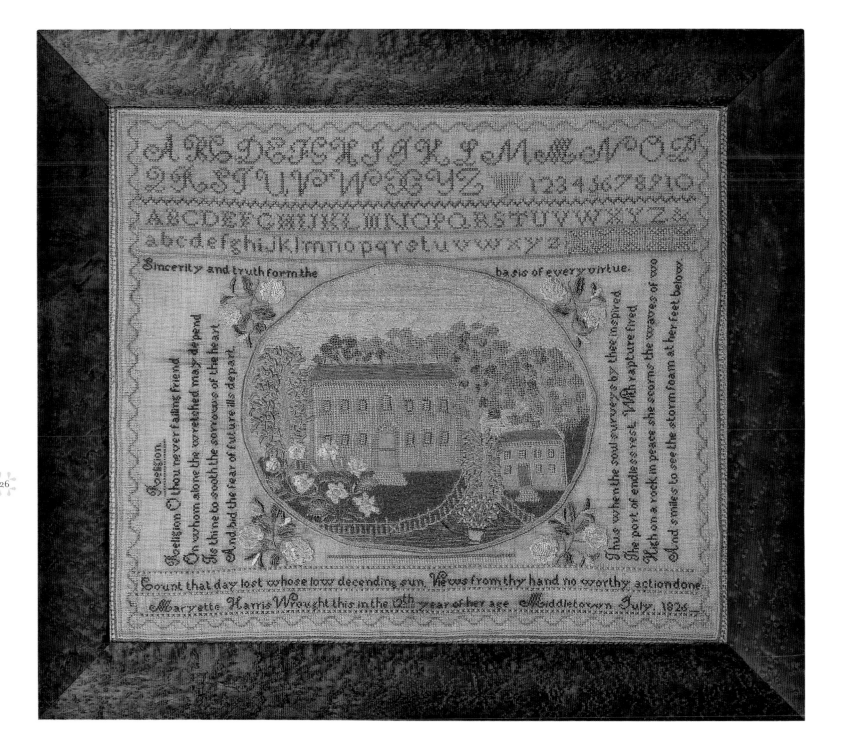

CONNECTICUT SAMPLER,
Dated 1826
Worked by Maryette Harris;
 Connecticut
Silk on linen, 15 x 18 in.
Private collection; Photo courtesy
 M. Finkel & Daughter, Philadelphia

This pictorial sampler is remarkable for the detail of its homes and gardens. The oval scene itself gives the illusion that it is framed. The precise lettering, contained within a serpentine-stitched border on all four sides, includes not only three styles of alphabets but religious and moralistic verses. Similar in shape and design but not in scale, the exquisitely worked pair of two-storied yellow houses features the same fencing style and stepped entrances. The landscape includes an apple tree, flowering bushes, and a forest beyond. While the name of the school or the teacher has not yet been discovered, several other oval samplers are now known and also attributed to Middletown, Connecticut. This one is inscribed "Maryette Harris Wrought this in the 12th year of her age Middletown July. 1826."

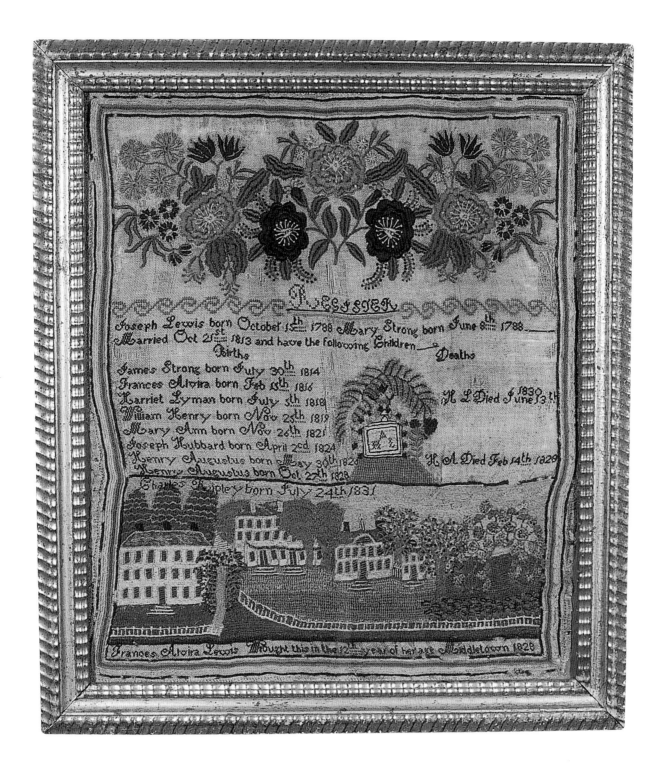

FAMILY REGISTER,
Dated 1828
Worked by Frances Alvira Lewis;
Connecticut
Silk and wool on linen, 17 3/8 x 15 in.
Photo courtesy Stephen and Carol
Huber, Old Saybrook, Connecticut

On her family register, Francis Alvira Lewis depicted Middletown, Connecticut, as the picture image of a New England town—white clapboard houses of two and three stories, inviting front steps, picket fences, and flowering trees on the village green that the buildings surround. The mansionlike dwellings have different facades but the windows are a common denominator on each. Frances must have relished stitching windows—there are several dozen. What might be interpreted as a tombstone divides the lists of births and deaths. Note that the last name, "Charles Ripley born July 24th, 1831," was added, in the same hand as the others, three years after Frances dated her work.

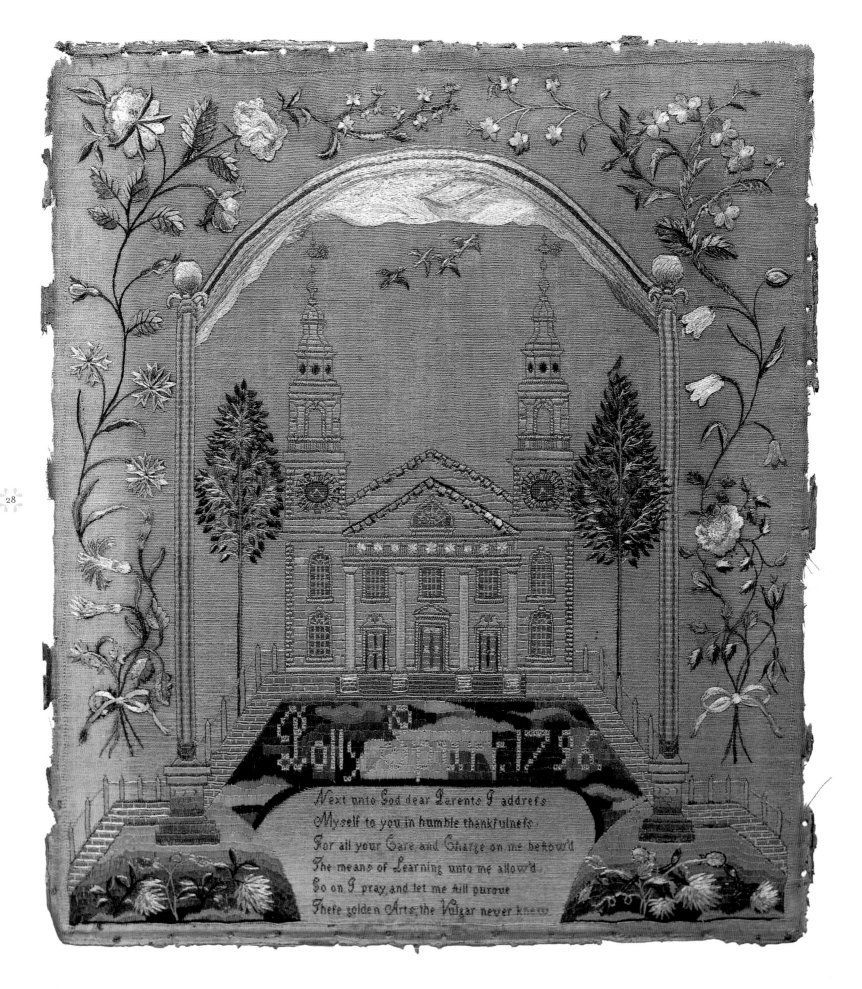

Next unto God dear Parents I address
Myself to you in humble thankfulness
For all your Care and Charge on me bestow'd
The means of Learning unto me allow'd
So on I pray, and let me still pursue
These golden Arts, the Vulgar never knew

Opposite:

FIRST CONGREGATIONAL
CHURCH, Dated 1796
Worked by Polly Spurr; Rhode Island
Silk on linen, 16¾ x 7³⁄₁₆ in.
Collection of the Museum of Art,
Rhode Island School of Design;
Gift of Miss Ellen D. Sharp

The building depicted on Polly's work from Miss Balch's Providence, Rhode Island school is the First Congregational Church, which stood at Benefit and Benevolent Streets. This large wooden Federal structure was one of Providence's most ambitious building projects of the early republican era. Erected in 1795, it was consumed by flames in 1814. Mack Woodward, of the Rhode Island Historical Preservation and Heritage Commission, says that it is likely that this church—constructed by builder-architect Caleb

Ormsbee—with a pedimented facade and Doric portico, flanked by twin towers (complete with clocks and matching weathervanes), was inspired by Christopher Wren's St. Paul's in London and by Charles Bulfinch's Hollis Street Church in Boston. Of particular interest is the original way in which Polly Spurr worked her name and date within the front lawn area of the multicolored foreground and how she used a rainbowlike arch to surround the church, her name, and the verse.

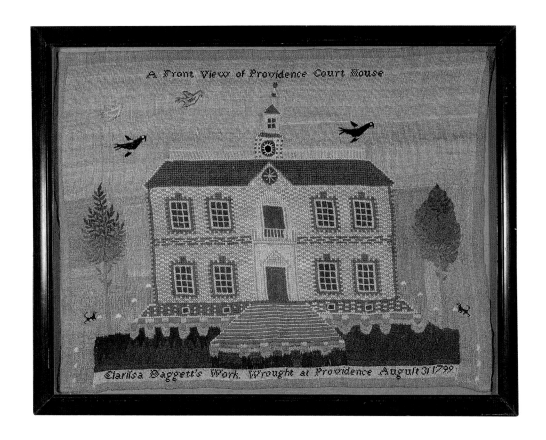

A FRONT VIEW OF
PROVIDENCE COURT
HOUSE, Dated 1799
Worked by Clarissa Daggett;
Rhode Island
Silk on canvas, 12⅛ x 16 in.
Collection of the Museum of Art,
Rhode Island School of Design;
Gift of Henry D. Sharpe

A favorite subject for Miss Balch's students was the Providence Court House, known as the State House after the Revolution. Some scholars see a strong resemblance to the old Colony House on Washington Square in Newport and think that it is possible that Mary Balch combined similar features from Newport and Providence for a design to present to her classes. However, Providence architectural historian Mack Woodward, whose office is situated in the original Providence State House building, is confident that the brick Georgian Colonial center-entrance, five-bay facade building that appears in the Balch school samplers is in fact the old State House, but points out that the Newport Colony House was the prototype for this one. Similarities to Providence include the cupola and belfry as well as a second-story balcony and rooftop fencing. Clarissa Daggett worked this meticulous pictorial when she was fourteen years old.

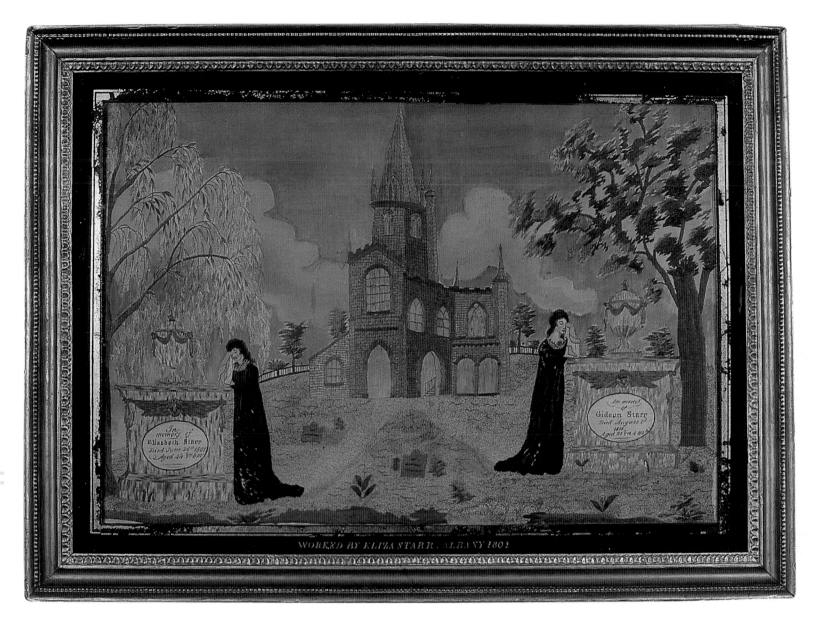

WORKED BY ELIZA STARR. ALBANY 1802

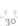

ALBANY MOURNING
PICTURE, c. 1802
Worked by Eliza Starr; New York
Silk and watercolor on silk with ink
inscription, 14½ x 22¼ in.
Photo courtesy Stephen and Carol
Huber, Old Saybrook, Connecticut

Many Albany mourning pictures were executed in black, white, and shades of gray, "en grisaille," resembling the printwork from which they were derived. In some of them, human hair was stitched into the needleworker's homage to the departed. Eliza's more colorful interpretation bears some of the usual elements such as the prominent Gothic church, freshly mounded graves with tilting tombstones, and the relative size of the mourners as compared to the monuments. Like many silk embroideries, it is mounted with a black églomisé glass mat with reverse-painted gilt lettering of Eliza's name, date, and town. The monuments are dedicated to her mother, Elizabeth, who died June 28, 1801, at age 44, and to her brother, Gideon, who died August 2, 1801, at age 21. The mourners are believed to represent Eliza and her sister, Hannah.

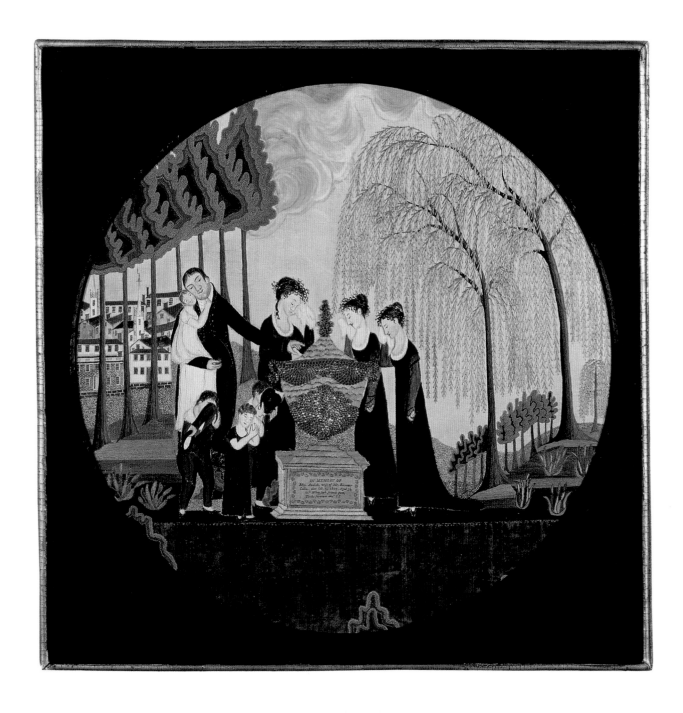

MOURNING PICTURE FOR
MRS. EBENEZER COLLINS,
Dated 1807
Probably worked by Lovice Collins;
South Hadley, Massachusetts
Watercolor, silver metallic thread, chenille,
and velvet appliqué on silk, applied
printed paper label, 17 in. diameter.
Collection of the Museum of American
Folk Art, New York; Eva and Morris
Feld Folk Art Acquisition Fund

This family group of mourners consists of the father and children. A paper label, printed in black ink and glued to the tombstone, identifies the mother's grave: "In Memory of Mrs. Azubah, wife of Mr. Ebenezer Collins, died Oct. 1, 1805, aged 38. When such friends part, Tis the survivor dies." Like most memorials, this one combines watercolor painting and embroidery but adds olive green velvet appliqué in the foreground, chenille for the weeping willows at right and several smaller trees, and the metallic thread to highlight the urn.

The clearly defined townscape is typical of the excellent work produced at Abby Wright's school in South Hadley, Massachusetts. Ebenezer Collins moved to South Hadley after his wife's death and went into business with Peter Allen, who married Abby Wright. More than likely some of the daughters became students of Abby Wright's and one of them completed this picture two years after her mother's death. An inscription on the silk beneath the glass mat (not visible in this photo) reads "So. Hadley July 15th, 1807."

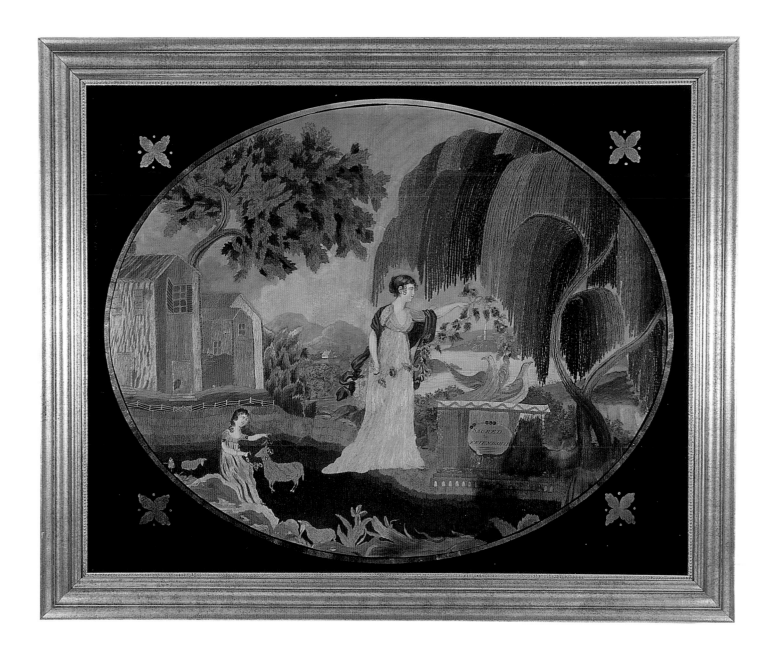

MEMORIAL PICTURE,
c. 1806–10

Artist unknown; Pennsylvania

Silk, chenille, paint, paper,
* and ink on silk, 21 x 27 in.*

Photo courtesy Stephen and Carol
* Huber, Old Saybrook, Connecticut*

This lustrous silk pictorial is from the Folwell School in Philadelphia. Samuel Folwell, a drawing teacher and a painter of miniatures, produced silk pictures for the embroidery school of his wife, Elizabeth, especially memorial pictures honoring George Washington. On these silkwork pictures, which are sometimes signed, the inscription on the plinth might read "Sacred To The Memory Of The Illustrious Washington/Thy Loss We E'r [or Er] Shall Mourn." There might be an image of Washington on the monument, the initials G. W., or an angel holding a banner with the words "The Deeds of Washington."

So much admired were these mourning pictures that some students created them without any mention of Washington or even to honor deceased family members. This one simply reads "Sacred To Friendship." On a very similar embroidery the words are "Innocence & Friendship."

Common traits include the lettering, an oval shape, crossed tree trunks, cascading flowers, and a mounded landscape. The cottages at left appear in a number of Folwell's designs, sometimes using real straw for the thatched roofs. What is significant about this particular piece is the well-developed painted scene in the distance, including a townscape.

SAINT JOSEPH'S
ACADEMY, c. 1840

Artist unknown; Maryland

Silk, chenille, and watercolor on silk,

16 x 18 in.

Photo courtesy Christie's Images

© 2000 and Marguerite Riordan

A small group of embroideries survive from this Catholic girls school in Maryland, which was founded by Elizabeth Ann Seton, the first American-born saint in 1809 and run by her order, the Sisters of Charity in America.

This example is exceptional for the creative ways in which a variety of stitches and materials have been used to achieve a richly textured and detailed likeness of the school buildings and grounds. St. Joseph's House, also known as the White House, is the two-and-a-half-story dormer-windowed structure. Completed in 1810, it was the school's first building. In the foreground appears the less

frequently depicted circa 1821 Dubois Building. Not only are the school buildings presented with accuracy, but the village of Emmitsburg can be seen in the valley beyond. Portrayed in golden-tone autumn colors, French knots and chenille are used for foliage. In contrast, silk threads are precisely employed to render window panes, stair rails, and detailed fencing that extends into the hills beyond.

A chiaroscuro effect is evidenced on a number of the trees, bushes, and patches of grass. Look carefully in the right front corner to discover a little shelter with three girls inside, perhaps waiting for a carriage bringing visitors.

GENEALOGY.

JOHN HAY,	born in Reading, Mass.,	Dec.	15, 1737,
SARAH RING,	" Salisbury, "	March	30, 1740.

Married in April, 1761.

Children of John and Sarah Hay.

SARAH,	born in Woburn, Mass.	March	26, 1762.
JONATHAN PIERPONT,	" " "	March	29, 1765.
CHARLOTTE,	" " "	Oct.	31, 1766.
CHARLES,	" " "	June	19, 1768.
ABIGAIL,	" " "	Oct.	", 1773.
ELIZABETH,	" " "	Jan.	13, 1773.
PAMELA,	" " "	Feb.	11, 1774.
ANNA,	" " "	April	5, 1776.
JOHN,	" " "	Aug.	12, 1777.
GEORGE,	" " "	Sept.	30, 1779.
MARY,	" Reading, "	Feb.	26, 1781.
FRANCIS,	" " "	Feb.	1, 1782.

JASIEL SMITH,	born in Taunton, Mass.	March	25, 1734.
ANNA CROSMAN,	" Raynham, "	Oct.	19, 1734.

Married, April 14, 1757.

Children of Jasiel and Anna Smith.

HANNAH,	born in Taunton, Mass.	Feb.	15, 1758.
LABAN,	" " "	July	1, 1760.
JASIEL,	" " "	Feb.	7, 1763.
ANA,	" " "	Aug.	22, 1765.
SENA,	" " "	June	13, 1767.
NANCY,	" " "	May	15, 1769.
KEZIA,	" " "	Sept.	22, 1771.
CHLOE,	" " "	March	16, 1774.
RACHEL,	" " "	March	30, 1780.

CHARLES HAY,	born in Woburn, Mass.,	June	19, 1768.
CHLOE SMITH,	" Taunton, "	March	16, 1774.

Married in Turner, Maine, Jan. 1, 1797.

Children of Charles and Chloe Hay.

CHARLES, Jr.	born in Turner, Maine,	Nov.	2, 1797.
VESTA LORING,	" Waterford, "	Aug.	7, 1800.
NANCY LIVERMORE,	" "	May	22, 1802.
JOHN RING,	" "	Aug.	13, 1804.
CHARLOTTE THOMPSON,	" "	May	11, 1806.
ELIZA BROWN,	" "	June	14, 1808.
JOSEPH EMERSON,	" "	Feb.	16, 1816.
GEORGE SMITH,	" Baldwin, "	July	14, 1811.
JOSEPH EMERSON,	" "	Feb.	15, 1813.
SOPHIA ANDREWS,	" Cape Elizabeth,	Feb.	24, 1815.
ZILPHA ANN,	" Waterford, Me.,	March	31, 1817.
HENRY HOMER,	" "	Oct.	26, 18".

OBITUARY.

JOSEPH EMERSON, 1st.	died in Cape Elizabeth Me.	Sept.	25, 1812.
JOHN RING,	" Waterford, "	Dec.	3, 1832.
JOSEPH EMERSON, 2d.	" Wareham, Mass.	Feb.	3, 1831.
CHARLES,	" Portland, Me.	March	19, 1831.
CHARLES, Jr.	" Wareham, Mass	Nov.	29, 1837.

Opposite:
FAMILY RECORD, c. 1837
Worked by a Hay family member,
name unknown; Maine
Silk, pencil, ink, printing, oil paint,
and watercolor on silk and linen,
22¹⁵/₁₆ x 27¹³/₁₆ in.
Collection of The Daughters of the
American Revolution Museum,
Washington, D.C.; Friends of the
Museum purchase

This Hay family needlework is attributed to Mary Rea's School in Portland, Maine. It features oil painting as well as watercolor; linen and silk combine for the background; the names are printed (typeset), rather than hand-lettered, on silk; the genealogy lists not only the maker's immediate family but also the complete families of the grandparents; and they are all shown on a monument although this is not a mourning picture.

This is a very important example architecturally, since it includes identifiable structures from several different cities: the Observatory, the Merchant's Exchange, a townhouse on Free Street, and the bridge over Back Bay from Portland, Maine; the Boston State House and Massachusetts General Hospital from Boston, Massachusetts; and St. John's Episcopal Church from Providence, Rhode Island. The detail work with which the buildings are portrayed suggests that the architectural drawings may have been prepared by a professional artist, some of them copied from prints, and then presented to the students to add the painting and embroidery.

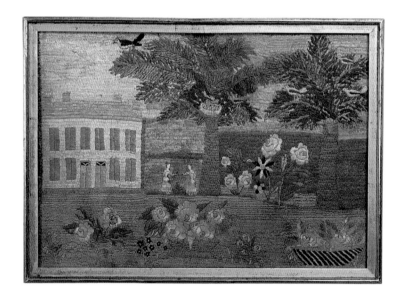

OHIO NEEDLEWORK
PICTURE, c. 1835
Worked by Hellen Crawford; Ohio
Silk on linen, 11 x 16 in.
Private collection; Photo courtesy
M. Finkel & Daughter, Philadelphia

"This spectacular, solidly stitched needlework picture is unusual in its sophistication, execution, and that it is from Ohio rather than the usual Northeast corridor," explains dealer Amy Finkel. The double-doored Federal house, its shutters closed, sits on a glowing green lawn, which provides the setting for two young ladies sharing a small bouquet. Two trees resembling tropical palms provide shelter for six birds and a nest for four peach-colored fledglings. The cross-stitch inscription on the reverse side reads "Wrought by Hellen Crawford aged 9 years January 2 1835 Elizabeth Shorter Instructress."

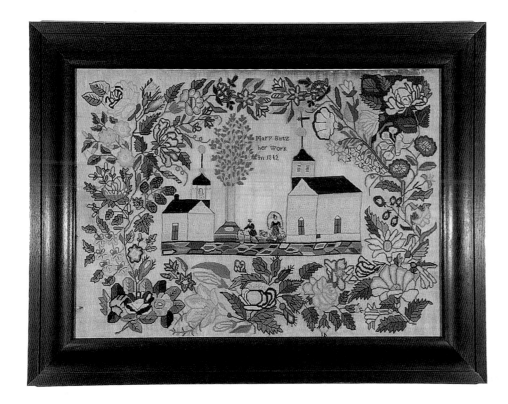

KUTZTOWN SAMPLER, Dated 1842

Worked by Mary Butz; Pennsylvania
Silk and wool on linen, 17¼ x 24⅛ in.
Photo courtesy Stephen and Carol Huber,
* Old Saybrook, Connecticut*

A boy rolling a hoop and a girl skipping rope are at play between the town's most significant public buildings—a school with its belfry and a church with its steeple. The church is Old Saint John's Union Church in Kutztown, Pennsylvania, and across White Oak Street is the Franklin Academy for boys, which survives today as a private residence. This folky vignette of village life, was probably worked at Elizabeth Mason's school. Distinctive of this area's samplers is the bold, colorful, naturalistic floral wreath surrounding the entire center scene.

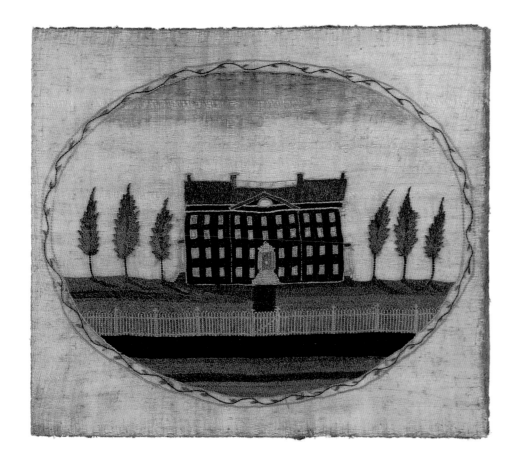

WESTTOWN SCHOOL, Labeled 1802

Artist unknown; Pennsylvania
Silk and watercolor on linen, 10¼ x 12 in.
Collection of the Westtown School, Westtown,
* Pennsylvania*

This impressive brick building is that of the Westtown School found on a small number of Chester County and Burlington County samplers. It is almost always depicted from this straight-on view with two or three poplar trees on each side and a picket fence in front, but minor differences do occur. Some renditions show blue shutters at the windows; the size of the windows in the top and/or bottom rows may be smaller then the rest; and the fanlight window in the pediment is sometimes left out.

This embroidery purchased by Charles Evans in Mt. Holly, New Jersey, in 1924 was a graduation gift to his daughter, a student at the school. A note on the back of it read "sewn Weston 1802" and "from the house of Rachel Hilliards" although no one by that maiden name ever attended Westtown.

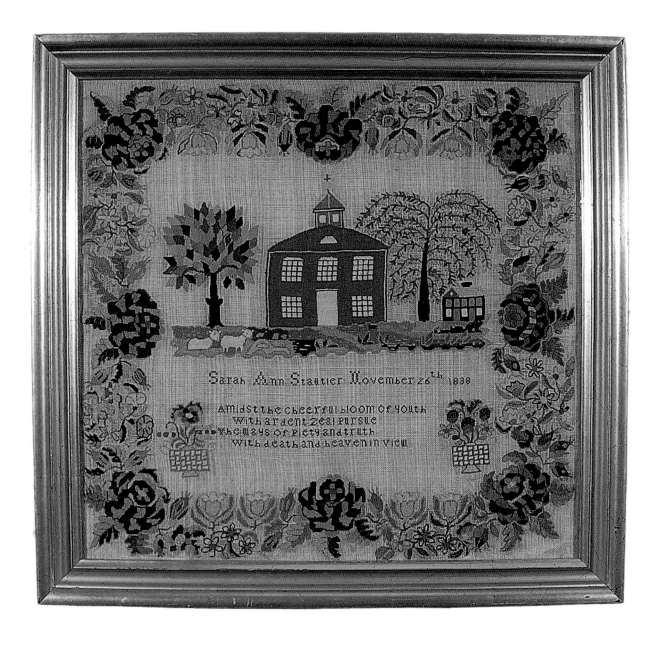

Sarah Ann Stautler November 26th 1838

Amidst the cheerful bloom of youth
With ardent zeal pursue
The ways of piety and truth
With death and heaven in view

BLUE BUILDING SAMPLER,
Dated 1838
Worked by Sarah Ann Stautler;
Pennsylvania
Wool on linen, 17 1/2 x 21 in.
Photo courtesy Stephen and Carol
Huber, Old Saybrook, Connecticut

Although this particular blue building has turned up on at least four Lehigh Valley, Pennsylvania, samplers, it has yet to be identified. The cross on the rooftop certainly indicates a church and/or meeting-house. It has mistakenly been thought to be St. Paul's Lutheran Church in Coopersburg, Pennsylvania, known as "the Blue Church," although St. Paul's is not blue and it does not resemble this one. The name of the school to which these samplers can be attributed also remains a mystery, but known samplers (1829–40) were all made by girls who lived in the Howertown area, north of Bethlehem.

Besides the blue building, there are other features shared by these samplers. The trees have a distinctive style; one with multicolored diamond-shaped leaves appears in all and the weeping willow appears in three. One, two, or three of the two-storied red houses are shown beside the blue build-ing. Sheep graze peacefully (the number of them varies) next to what has been interpreted to be a stylized hedge, although some scholars feel that it might be a stream. An 1829 example features the blue building but without the cross.

As is the custom with many Lehigh Valley embroideries, a brightly colored garland of realistic country flowers frames the work. All the "blue build-ing" samplers discovered to date have eight large red flowers in the border along with blue daisies.

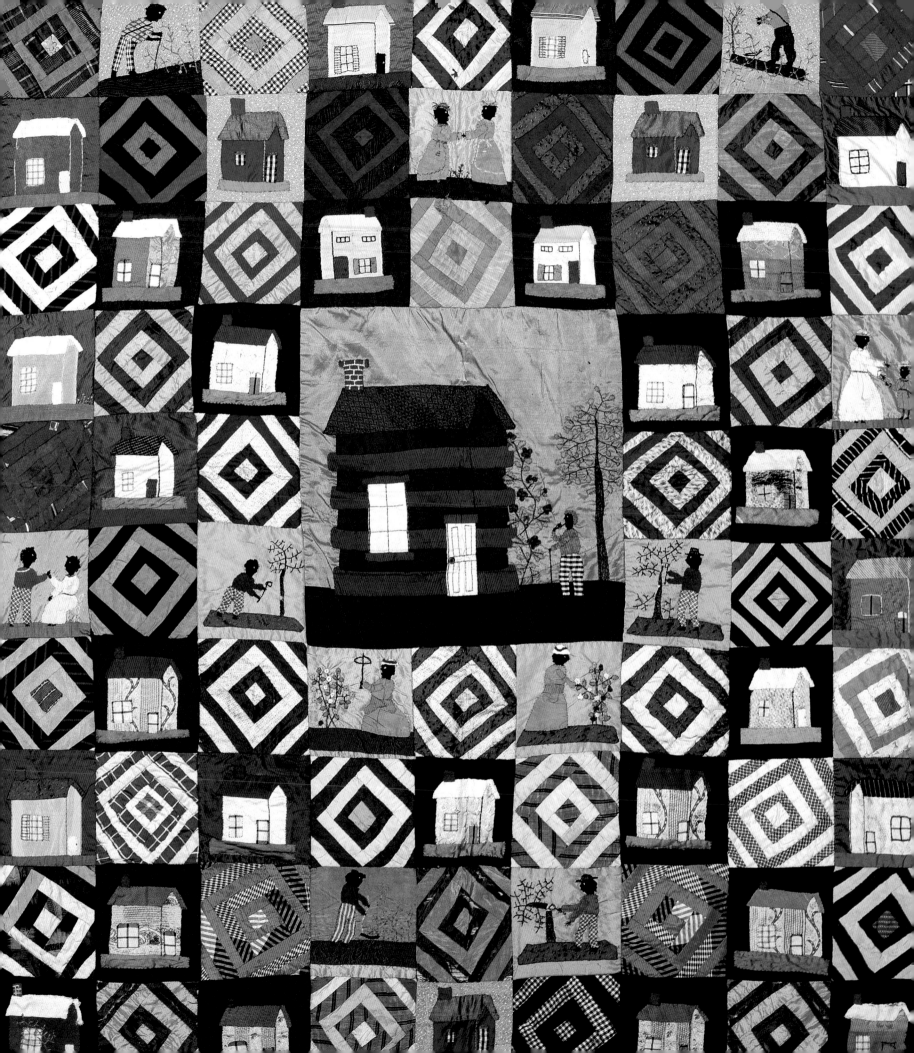

Quilts are recognized worldwide as an icon of American folk art, the one category of Americana collected, exhibited, written about, and copied by handcrafters in nearly every nation of the globe. ❋ A particularly meaningful category of quilts is the one that illustrates the practical and spiritual significance Americans placed on the sanctuary of home. Quilts depicting these vernacular structural images are invitations to step back in time to earlier centuries. Whether through an illustrious building on an 1840s Baltimore album appliqué, an 1890s "Little Red House" block, or a "Honeymoon Cottage" from the 1930s, patterns and fabrics serve as social commentary to the regional, ethnic, or religious context of a quilt. ❋ Tangible fragments of history, originally constructed for utilitarian purposes, are now appreciated as works of art. Over the past twenty-five years, the status of quilts in the art market has risen dramatically. Record high prices paid at auction include $176,000 at Sotheby's in 1987 for the Sarah and Mary J. Pool Baltimore Album quilt and $264,000 for the New York State Civil War "Reconciliation" presentation quilt in 1991. The Reconciliation quilt displays seven architectural

chapter two

QUILTS
&
COVERLETS

motifs (including a lighthouse and a dog house) and the Pool quilt features five structures. What role does the presence of these architectural images play in bringing prices for these quilts to record levels? According to Sotheby's director of American folk art, Nancy Druckman, "A piece of folk art with architectural elements has a measure of importance that seems, at least from my vantage point, to put it at the top of the list assuming that other criteria for a desirable piece have been met. Townscapes, portrayals of villages, or an actual building in the context of a piece of folk art makes the heart flutter. People respond to it because in addition to its charm and color, there's a significant element of American history there. This is primary source material without any self-consciousness. Nothing says it better than a building, particularly if it is no longer standing." ❋ House and building images appear on quilts in the form of repetitive pieced or appliquéd blocks; as single images; as central images or as elements of landscape on pictorial quilts; as outline embroidery, usually in red on white cotton quilts, or on crazy quilts; and printed on commemorative yardage and on souvenir handkerchiefs.

PIECED PATTERNS

❋

One of the most recognizable house patterns is that of a one- or two-chimneyed house with a gable roof. Both the narrow front entrance, complete with doorway, and a windowed side facade are visible on the same plane. Pattern details and names vary but the basic structure remains the same. Almost all variations resemble a child's basic line drawing of a house.

Yet quilt historian Carter Houck regards this house motif to be "probably the most sophisticated of the folk patterns, the kind of wonderful building that can be converted to look like a church or a home or whatever the quilter needs to tell her story."[1]

Jonathan Holstein, whose 1971 Whitney Museum exhibition focused attention on American quilts as art, considers the house block a "schematic abstraction of an architectural form. Because it was too difficult for most quiltmakers to undertake a major depiction of a complicated building, the house pattern emerged."

This familiar house motif is a "pieced design," meaning simply that small geometrically cut pieces of fabric are stitched together like a jigsaw puzzle to create a larger piece—a quilt block. These blocks can be used singly, joined in symmetrical rows with or without sashing, centered amid a larger design, or grouped in original ways.

By the late 1800s, house patterns were printed in, or could be ordered from, ladies' magazines, newspaper columns, farm journals, almanacs, and needlework catalogs.

The number of pieces varied slightly from one pattern to another, resulting in subtle differences such as the size, shape, and number of windows; the height of the structure and its chimneys; or the shape of the doors. Some familiar published names include "House," "Schoolhouse," "Old Kentucky Home," and "Log Home."

Many companies produced essentially the same designs but changed the names to attract customers.

Ladies Art Company, a popular mail-order source for quilt patterns and needlework supplies, offered several variations of the house design in their catalogs, including #108, "The Old Homestead"; #373, "Little Red House"; #396, "Jack's House"; and #307, "Log Cabin Quilt."[2] Also available from them was a front view of a steepled building identified as #123, "Village Church."

At a cost of 10 cents each, three for 25 cents, seven for 50 cents, and 15 for $1.00, a customer received a large colored diagram on heavy cardboard and pattern pieces packaged in an envelope with the pattern number.

Little known is the fact that Ladies Art Company, for a price, would make finished fabric blocks of any pattern, or even entire quilts to order.

Some publications directed a quilter to enhance her house design through fabric selection: a grid or a scalloped print could simulate brickwork and shingles; a front yard could emerge through flowered calico. This was the case with Ruby McKim's "House on the Hill," which suggested a plain or flowered green print for the hill. Syndicated throughout the midwest in the first three decades of the twentieth century, McKim attracted a large and loyal following. In describing her house pattern, McKim wrote, "Most naturalistic of all the old-time quilt blocks are the House or Cabin patterns which piece roof with chimney, windows, door, etc. You may have difficulty in distinguishing between a patchwork 'Pineapple' and 'Washington's Pavement' but 'House on the Hill' really looks like that. This is a cunning, dumpy little cottage with a variety of units, but very easy to piece once the materials are cut."[3]

The "Pineapple" and "Washington's Pavement" patterns to which she refers were made with a technique then called Log Patchwork now known as Log Cabin. The name was derived from stitching narrow log-like strips of fabric or ribbon around a center square that represented the hearth of the log home. Log cabin variations have architectural names—"Barn Raising," "Windmill Blades," "Courthouse Steps," "White House Steps," "Church Windows"—but no building shape.

Writing in 1929, quilt-study pioneer Ruth Finley described the 1870s as "an era of decadence—in architecture, furniture, silver, glass, china, decoration, dress, manners and morals," yet she acknowledged, "for

LADIES ART COMPANY PATTERNS

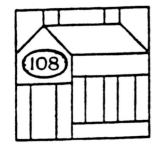

#108, "The Old Homestead"

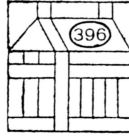

#373, "Little Red House"

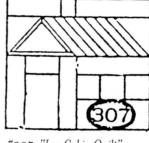

#396, "Jack's House"

#307, "Log Cabin Quilt"

#123, "Village Church"

what might be called realistic quilts there was a veritable craze, beginning about 1870. . . . Appealing yet absurd were the pieced 'Little Red Schoolhouse' quilts that seem to have originated in New Jersey," yet they had "the saving grace of being quaint."[4]

Some quilt scholars attribute the source of the generic house motif to William Henry Harrison's 1840 presidential campaign for which a log cabin was the symbol (see page 92). The building and its hard cider barrel at the door (and sometimes with a raccoon on the roof) appeared on a vast number and variety of souvenirs including at least twenty varieties of silk kerchiefs, bandannas, printed chintzes, and political ribbons.[5]

However, since log cabin homes existed in America as far back as the mid-seventeenth century, it is entirely possible that this realistic design was used, if not published, at an earlier date. Whatever the origin, some variation of the house design remains popular even today.

Appliqué Designs

House designs with curvilinear features were suitable for appliqué, a method of cutting and layering fabric shapes to create a design.

Documented, commercial appliqué house patterns can be found mid-nineteenth century—before their pieced cousins. By the twentieth century, appliqué house patterns featured sloping roofs, garden paths, arched windows and doors, bushes, trees, birds, sunsets, and more. Frequently sewn were the "Honeymoon Cottage," "Little Village," "House and Hill," "Peeny Pen's Cottage," "Cottage Behind the Hill," "Sunnyside, Enchanted Cottage," and "Homestead" (the last two set on the diagonal within the block).

Whether inspired by magazine and newspaper articles or their next-door neighbors, some women personalized the patterns by adding lace curtains, French-knot door knobs, embroidered window panes, flower boxes, and other domestic details.

The most spectacular depictions of houses and buildings on quilts are found on the exquisitely crafted Baltimore album quilts. Made for a relatively short period of time, about 1845–55, these distinctive collage-style quilts are revered for the intricate and innovative method of layering plain and printed fabrics (mostly cotton), sometimes with padding, to create dimension, texture, and shading. Composed of different designs, often stitched by different people, many of these quilt tops included inked signatures, dates, sentimental sayings, and/or Bible or hymn verses. "Album" refers to the resemblance to popular autograph albums of the time. "Album quilts were like a collection of different cloth pages laid side by side instead of bound between covers."[6]

Block designs could be purchased as cut pieces ready to be stitched, or even basted in place. The best-known designer of Baltimore album quilt blocks is Mary Simon; blocks attributed to her may be mixed with squares by other designers or with individualistic blocks. Because cost was involved, the number of expert squares used on a given top may indicate the affluence of the quilt group or quiltmaker.

Baltimore appliqué motifs include latticed baskets of flowers, flower-filled cornucopias, floral wreaths, looped bows, eagles, ships, animals, people, fraternal symbols, and/or snowflake-like patterns cut from folded fabric. In addition to the appliqué, stuffed work, and writing, detail work might include embroidery and even painting.

Houses and landmarks on some of the most prized Baltimore album quilts include:

- The 1840s U.S. Capitol building (before the addition of its cast-iron dome), embellished with eagles and flags
- The domed Baltimore Merchants Exchange
- The impressive center-domed, brickwork Baltimore City Hall of the mid-1800s
- Baltimore Battle Monument, with X-banded shaft; often shown with eagles at the sides or crossed flags
- Baltimore's Washington Monument, probably the most frequently seen structure on surviving quilts; a smooth column with a small dome capped with a sculpture of Washington
- Ringgold Monument, honoring Mexican war hero Major Samuel Ringgold
- Churches of small, generic house shapes representing Methodist and other sects of the period; difficult to recognize unless there is an inscription, cross, or steeple
- Castlelike building believed to be the Odd-Fellows Lodge, or a militia armory
- Rebekah Lodge I, the four-chimneyed home of the female Odd Fellows
- Farm with geese
- Pagoda with two flying birds
- The Brickmaker's Home, a generic house within a floral wreath
- City Springs Square, a columned, open, domed-top structure
- Log Cabin, from William Henry Harrison's 1840 presidential campaign

Jennifer Goldsborough, Baltimore album quilts expert and former chief curator of the Maryland Historical Society, discusses the design sources for these motifs: "Middle-class Baltimore women had little visual stimulation from the sources we take for granted today. . . . Instead they cleverly turned to other textiles, home furnishings of numerous sorts, the printed designs in gift books, wood-block prints in guidebooks, and the simple vocabulary of illustrations produced by major local printing and printers' supply houses, as well as paper currency, billheads, and membership certificates, and to the familiar sampler, needlework, and watercolor designs of their girlhoods. My research revealed that perhaps the most frequently used design source for the Baltimore album quilt picture squares was English transfer printed dishes made for the American market and imported through Baltimore. The buildings were, of course, stylized and it may take a few minutes to

recognize even the U.S. Capitol when it has been shortened to fit the block and then stitched in bright calicoes."

Figurative appliqué with architectural details was not the sole province of Baltimore quiltmakers. Appliquéd pictorial quilts, where a large-scale house or other structure commands center stage, are those rare and stunning examples frequently referred to as textile paintings. Buildings and surrounding landscape occupy most of the quilt surface. Farms, public buildings, and urban landscapes were all likely subjects. Many chronicle daily life: people going about their chores; children playing; and domestic and barnyard animals. Original compositions, not patterns, they give new meaning to the term *house proud*.

COMMEMORATIVES

Specialty fabrics and stamped muslin squares were manufactured to commemorate significant American events such as patriotic celebrations, fairs, and political campaigns. These keepsake textiles were often preserved on quilt tops.

European mills exported cotton yardage with pictorials depicting American current events. But with Eli Whitney's 1793 invention of the cotton gin and the progress of the Industrial Revolution, textile mills opened at home, in the New England states, including the Cranston Print Works Company in Rhode Island in 1824.

Printed handkerchiefs, also called kerchiefs or bandannas, proliferated to advertise political campaigns, expositions, and other significant occasions. The principle buildings of the 1876 United States Centennial Exhibition held in Fairmount Park, Philadelphia, were captured on several detailed kerchiefs, including the Memorial Hall Art Gallery, Main Exhibition Building, Machinery Hall, Horticultural Hall, and Agricultural Hall, all accented with patriotic symbols.

For World's Fair celebrations, entire complexes were commissioned from well-known architects to house industrial and scientific advances, the arts, agriculture, and state and foreign country exhibits. Souvenir images were produced in quantity, often illustrated with the buildings.

The 1893 Chicago World's Fair (the Columbian Exposition) commemorated the four hundredth anniversary of Columbus's discovery of America. Known as the "Great White City," its classical architectural styles were constructed predominately in light-color materials illuminated at night with recently invented incandescent lights. Pennsylvania reproduced Independence Hall's clocktower; California had a Spanish-American building with a red-tiled roof; Germany had a medieval town hall; England, a manor house; Spain reproduced a convent; and Japan, a temple.

At the 1901 Pan American Exposition in Buffalo, New York, fairgoers could purchase an envelope of fifty 9-by-9-inch muslin "penny squares" stamped with the "Buildings of the Pan American" for 50 cents.[7] A title describing the image was printed beneath the picture on each muslin block. Individual squares for embroidery were available for 5 cents each. Penny-square designs were outline drawings meant to be embroidered in one basic stitch, using colorfast Turkey red floss—a type of needlework known as redwork.

Among the Pan Am's most popular subjects were the House Upside Down and the Temple of Music, where President William McKinley was assassinated while attending the exposition. Blocks of President McKinley, Mrs. McKinley, successor President Theodore Roosevelt, and Mrs. Roosevelt are often seen in combination with the building blocks.

At the 1904 Louisiana Purchase Exposition in St. Louis (Missouri was part of the Louisiana Purchase), souvenir penny squares were also plentiful and building choices included the Festival Hall and Cascades, the Hall of Congress, the U.S. Government's "Bird Cage" display, the Main Entrance Administration Building, and the pagoda-shaped Washington Building, among others.

Local, less grand buildings were also commemorated in redwork embroidery on quilt tops. Civic-minded women made fund-raiser quilts to benefit a local school, church, or hospital, usually centering the building and surrounding it with the names of church or community members who contributed to the cause by paying a small fee to be represented. The completed quilt was often raffled off to raise additional funds.

The 1933 Chicago World's Fair, known as the "Century of Progress Exposition," generated many creative quilts featuring buildings. Fair scholar and author Merikay Waldvogel explains, "This was an international exposition in celebration of Chicago's hundredth anniversary. The purpose was to educate the public about the effects of scientific research on industry and society. Known as the 'Rainbow City' (in contrast to the 1893 'White City'), the buildings had soaring towers and angular designs of flat surfaces painted in bright colors outlined at night by neon tube lighting. Sears Roebuck & Co. sponsored a National Quilt Contest challenging entrants to make a quilt in the Fair's theme for a $1000 grand prize. Innovative entries featured the fair buildings and pavilions."

Popular choices included a barrel-shaped building with metal towers (the Travel and Transport Building), a fort with a log stockade (Fort Dearborn), and a white building with a central tower and low wings and ramps extending to either side (the Sears Pavilion).

Although quilts were made in several countries, the expansive design vocabulary and rampant creativity that emerged from the American melting pot during the eighteenth, nineteenth, and twentieth centuries have no equal elsewhere.

COVERLETS

❄

Whereas quilts are pieces and layers of cloth stitched together, true coverlets are woven on a loom, from wool and/or cotton threads (rarely linen), usually in color combinations of off-white (natural) combined with shades of blue, red, and sometimes green or even purple.

The earliest coverlets were hand woven on home looms and ranged from simple unpatterned blankets to geometric designs produced through the weaves known as overshot and summer-winter. More complex geometric weaves such as the "double cloth" ("block") woven coverlet, and the most complex weave—the figured "jacquard" coverlet—were "undoubtedly the work of professional craftsmen outside the home as few homes would have contained the elaborate loom required for their manufacture."[8]

Only jacquard coverlets have architectural images. The jacquard attachment, invented in France by Joseph Marie Jacquard at the beginning of the nineteenth century, revolutionized the textile industry by enabling a weaver to create, vary, and combine curvilinear naturalistic motifs. At first coverlets were hand woven in two parts on narrow draw looms, fitted with the jacquard mechanism, and then seamed. By 1825, coverlets could be woven seamlessly on fully mechanized looms.

The format of jacquard coverlets had repeating elements, most often some version of flowers and/or stars. Borders featured figural designs such as the patriotic eagle, trees, deer, birds, and a variety of buildings. Referred to as "fancy" weaving, damask, carpet, or patent coverlets, these woven bedcovers reflected regional design characteristics such as color preference and motifs, the patterns for which might be shared among weavers in a locality.

Most weavers were European-born, emigrating from Germany or the British Isles to work in New York, Pennsylvania, Ohio, Indiana, Michigan, or Illinois. Their work reflects the influence of both European weaving traditions and American culture.

While most naturalistic patterned coverlets are thought of as and even referred to as "flowered," a surprising number of them included recognizable architectural motifs, either on the borders or in the corner blocks as trademarks to symbolize the weaver's name and identify the product as his or her own.

Although most quiltmakers remain unidentified, many corner blocks of jacquard coverlets reveal the name of the weaver and/or the person that the coverlet was made for, the town, and the date. Not all weavers signed coverlets with their name, though; sometimes they added only the client's name, since each custom element cost more to incorporate.

The Abby Aldrich Rockefeller Folk Art Center's study and reference, *A Checklist of American Coverlet Weavers*, identified the work of dozens of weavers and discovered an engaging wealth of building images—squat houses, fancy townhouses, churches with spires, pagodas, public buildings, and monuments with ornamental tops.[9] Weavers who used buildings in their borders include James Alexander, Orange County, N.Y.; David Haring, Bergen County, N.J.; Henry Frederick, Cumberland County, Pa.; D. Stamp, Wyoming County, N.Y.; J. S. Van Vleck, Gallipolis, Ohio; and Martin Hoke, York, Pa. The LaTourette family of Indiana, whose member Sarah is the only known female coverlet weaver, included painterly details of farmhouse, farmer, animals, prancing horses, flourishing trees, and fields of crops in the pattern they called "Farmer's Fancy" or "Peace and Plenty."

A two-story frame house in the corner block of the border served as a signature for the Gilmour Brothers and William Craig of Indiana. New York State coverlets "woven at the Ithaca Carpet Factory by Archd [Archibald] Davidson" included the Capitol in a corner block; other weavers incorporated it in their borders.

One border with several variations featured "the unlikely merger of a stylized New England town and an oriental village."[10] Symbolizing trade to China from Boston Harbor, it became known by the now politically-incorrect term "Christian and Heathen" or alternately as "Boston Town." When applied to the central field of a woven coverlet, this border treatment resembles the landscape of an entire community.

As the United States celebrated its Centennial in 1876, coverlet weaving was coming to an end, having flourished in several states over the prior half-century but falling victim to cheaper mass-produced household goods.

Two examples of jacquard coverlets, featuring patriotic landmarks are a double-cloth jacquard with repeat medallions of the U.S. Capitol Building, and a single-weave coverlet centered with the Memorial Hall of the Centennial Exhibition in Philadelphia (see page 62).

Jacquard coverlets are collected as folk art, even though many were woven on mechanized looms, due to the artistic imagination of the weavers who developed and combined complex techniques to create a variety of images. Intricate to compose and costly to purchase in the nineteenth century, coverlets remain available today because so many have been well cherished and preserved by the descendants of the original owners.

Bedclothes, specifically quilts and coverlets, are the largest surviving category of textiles from homes of the colonial period. They were often considered—and inventoried as—the most valuable household possessions, and were more costly and more time-consuming to make than the beds on which they rested.

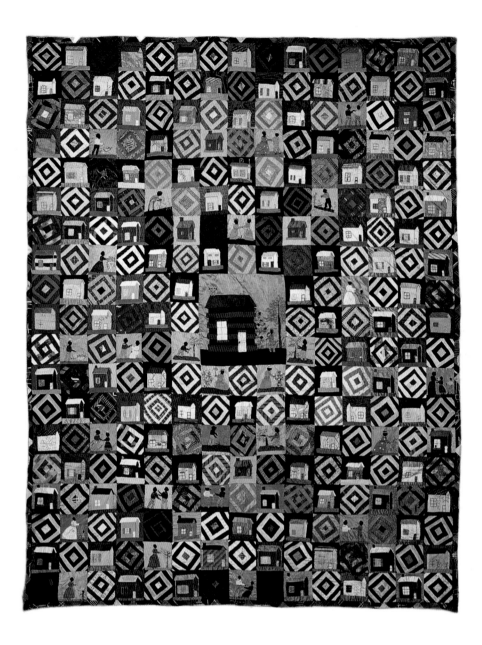

HOUSES AND COMMUNITY, c. 1870

Artist unknown; found in New Jersey

Silk; pieced, appliquéd, and embroidered, 76 x 62 in.

Private collection; Photo courtesy Woodard & Greenstein

(Detail shown on page 38)

More than one hundred small houses are featured in little blocks surrounding a large pictorial log cabin at the center of the quilt. Additional appliquéd and pieced blocks depict African-American people engaged in everyday chores and even proposing marriage (see bottom row).

The scenes and people portrayed seem to capture a particular time and place. When this enchanting quilt was shown at the 1989 Williams College Museum of Art exhibit *Stitching Memories: African-American Story Quilts*, curator Eve Grudin explained, "The specificity of this humble subject and its treatment suggest such a familiar attachment that it is hard to imagine that anyone but a person who lived here could render this property and this family so intimately." Grudin felt that the quilt's designer might have been a dressmaker because of the accomplished needlework, and that she was an African-American woman because the "depiction of blacks is casual and familiar and it never lapses into caricature."[11]

This rare quilt handily illustrates various definitions of the quilting term log cabin: there is a literal log cabin at the center; there are smaller pieced house blocks; and blocks constructed in the Log Cabin format in which the placement of light and dark fabric strips creates a geometric design set on point—in a "Barn Raising" variation—resembling a target.

LOG CABIN QUILT, c. 1940s

Artist unknown; found in New England

Cotton, pieced, 94 x 82 in.

Collection of Laura Fisher

This purchased house pattern was titled "Log Cabin Quilt" (#307) by the Ladies Art Company in the 1890s. This design features a horizontal band for the window area rather than the vertical fenestration seen in most other pieced house patterns. In the 1920s, the Joseph Doyle catalog called it "Western Block" (#26). Doyle stated, "The most popular patchwork of our great-grandmothers' day was that made in the so-called Log Cabin designs. Perhaps this was because of the several variations of the pattern . . . or it may have been the fascination with the name itself, for patchwork quilts and picturesque log cabins have always been associated in memories of pioneer days."

Today, quilters and collectors think of "log cabin" as a square made up of many narrow fabric strips as compared to the realistic pattern block shown here.

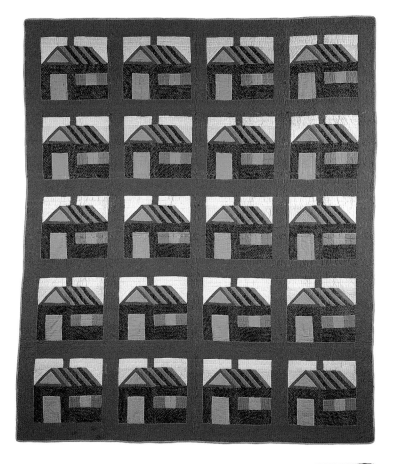

INDIGO HOUSES, c. 1910

Artist unknown; found in the Midwest

Cotton, pieced, 78 x 62 in.

Collection of Laura Fisher

This minimalist design, commonly referred to as "House," "Schoolhouse," or "Little Red House," creates a powerful graphic effect with its row upon row of identical dark blue pieced houses. One doorway, two stark windows, and creamy sashing strips separate the triangles and rectangles of the pattern pieces. Is it coincidence that pop artists of the 1960s adopted this same serial imagery in paint and other mediums, or were they influenced by the anonymous women quilters of nearly a century earlier who continually developed eye-catching visual effects by repeating and reorganizing motifs over a large surface? As early as the 1870s, some form of pieced house block caught the imagination of quilters, whether it had one chimney or two, or one, two, or three windows. The modernistic presence of this piece is softened by the quiltmaker's decision to surround her solid-color houses with a delicate sprigged floral print—perhaps a tribute to lawns and gardens. The architectural format presented here, in cloth, was a harbinger of the American residential developments that followed.

HOUSE ON THE HILL, c. 1931
Artist unknown; origin unknown
Cotton, pieced, 77 x 72 in.
Private collection; Photo courtesy
Judith & James Milne, Inc.

Blue, black, and golden yellow "skies" suggest this quiltmaker's intention to portray her neighborhood by day and by night. Furthering the realism, some residents appear to be at home with the lights on, as shown by yellow window patches, whereas dark windows indicate they are asleep or away. The block design is Ruby Short McKim's "House on the Hill," published in 1931, which she described as a "cunning, dumpy little cottage."[12] McKim advised three seamed pieces instead of one for a "more natural" roof, but this seamstress chose quilting stitches to define the roof and the house itself. The instructions called for twenty $12^{1/2}$-inch blocks assembled in five rows of four, divided by green or print lattice strips. These thirty-six houses are smaller and the clever placement allows the design to read from all sides when placed on a bed.

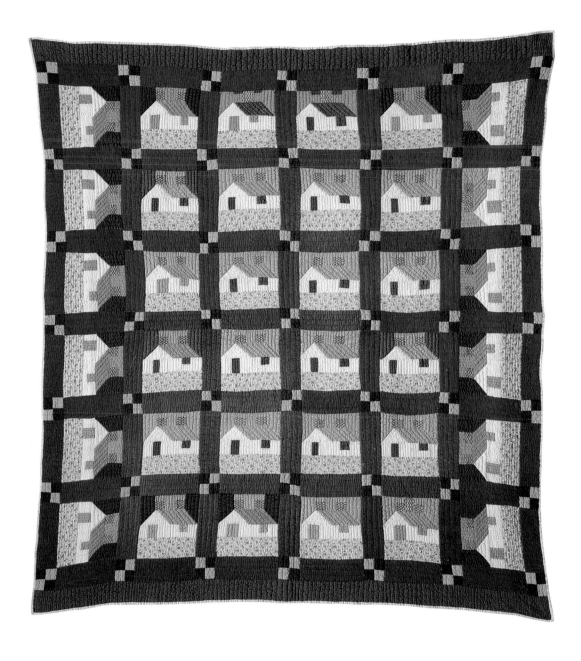

Opposite:
PASTEL HOUSES, c. 1940s
Artist unknown; found in Ohio
Cotton, pieced, 80 x 70 in.
Collection of Laura Fisher

Jewel-tone cottons give Ladies Art Company Pattern #108, "The Old Homestead," a stark and completely modern effect. A more nostalgic-looking quilt would have resulted if the maker had opted for pretty little calico prints. The positioning of complementary or contrasting colors causes some images to pulsate and others to dissolve. Another illusion resulting from the juxtaposition of the intense color choices is that some blocks read clearly as houses while others register more as abstract geometric shapes. Pastels are usually thought of in relation to light and cheery twentieth-century quilts; here, in grouped-together solids, they have a mysterious impact. This is believed to be one of several similar compositions made by a group of Ohio quilters.

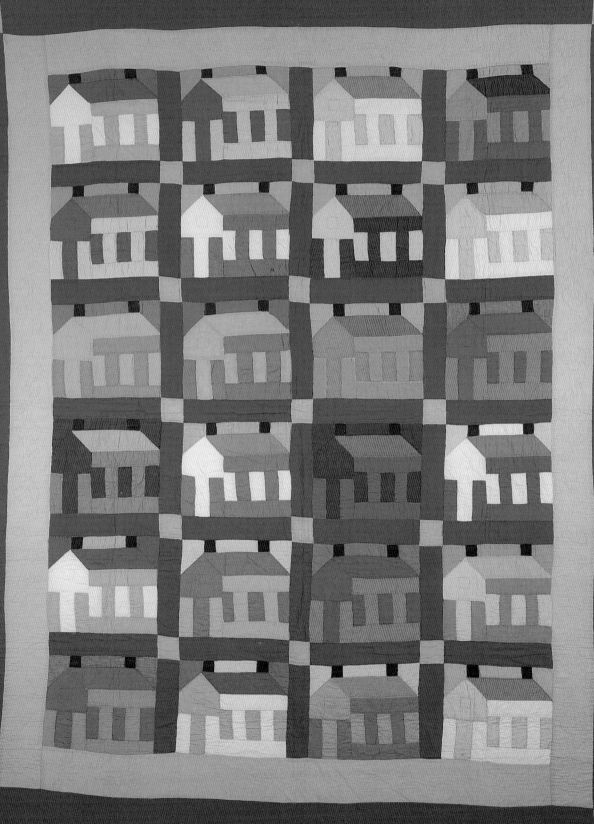
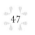

OLD KENTUCKY HOME, c. 1920s

Sarah Moore; Meigs County, Tennessee
Cotton, pieced and appliquéd, 84¼ x 79½ in.
Collection of McMinn County Living Heritage Museum, Athens, Tennessee;
Gift of J. Howard Hornsby, Jr., and family; Photo courtesy Merikay
Waldvogel; Photo by David Luttrell

A perpendicular house pattern with an elongated front section and three centered windows rather than a door, was published in the April 7, 1929, issue of *Needlecraft* as "Old Kentucky Home." Although this looks like that basic pieced block, Sarah Moore's interpretation diverges in several ways and could be an earlier pattern or even an original design: Embroidery defines the windowpanes; checked fabric indicates brickwork chimneys; a pieced, brown-check strip at the bottom of each house suggests a front step or foundation. Each house motif is framed within its block by a white strip at the top emphasizing the verticality, a brown base strip, and brown or gray side strips.

The squares are sashed in black with yellow corner blocks and there is a calico border. Rather than securing the top, backing, and batting with quilting, the layers are tied together with dark blue cotton thread, knotted on top.

Sarah Moore, from slave ancestry, worked for the Hornsby family and produced a number of quilts.

CHURCH OF GOD, Dated Dec. 25, 1948

Sister Patterson and Sister Chandler; found in Indiana
Cotton; appliquéd, pieced, and embroidered, dimensions unavailable
Private collection; Photo courtesy Susan Parrish Antiques

When Sister Patterson and Sister Chandler put a steeple above the front door of this house block, they transformed it into their local place of worship. If only the Sisters had taken a moment to stitch the name of the town or state where the church was located. The embroidered date and the writing on the gable ends and sides of some of the churches suggest that the quilt was made as a Christmas or "Welcome" present for Church of God's pastor Ray Morgan and Sister Morgan.

Although the basis for the design is a commercial pieced block, it appears to be appliquéd onto the background with embroidery stitches. Outlining seams with embroidery was a Victorian custom and is often found on 1880s redwork and crazy quilts. This briar stitching is also seen on some twentieth-century Pennsylvania Amish and Mennonite quilts.

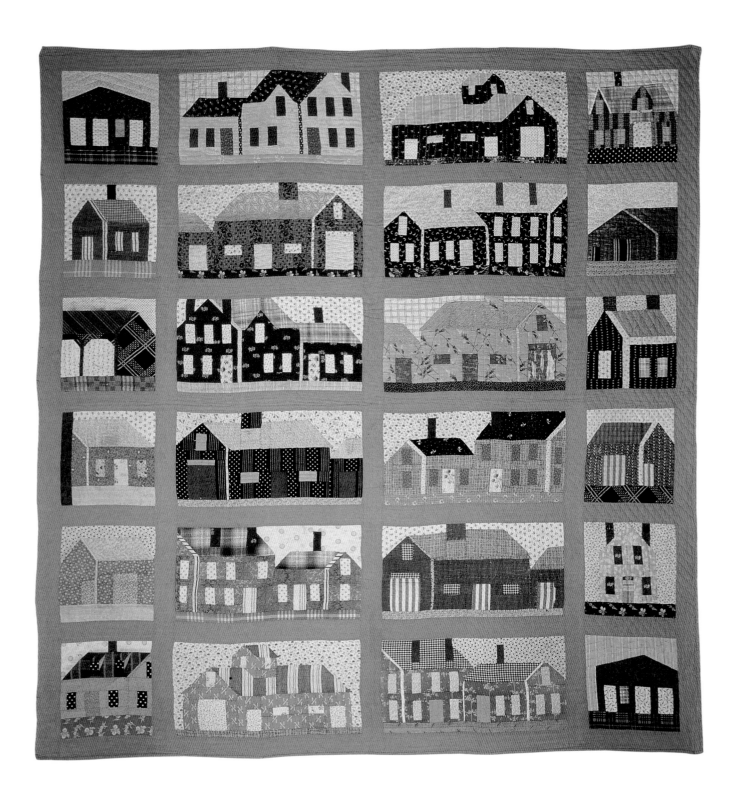

HOUSES AND BARNS,
c. 1910
Artist unknown; found in Massachusetts
Cotton, pieced and appliquéd,
88 x 84 in.
Private collection; Photo courtesy
Woodard & Greenstein

"Big house, little house, back house, barn." This nineteenth-century children's refrain recited in New England alludes to the architectural style of joining the main house and auxiliary buildings together for ease of access in bad weather and darkness. That verse could easily apply to some of these blocks; this quiltmaker produced quite a mélange of structural portraits. She has interspersed commercial house blocks with original renditions of joined structures that probably reflect the actual farming community in which she lived. The buildings face in different directions, as they would in real life; some are obviously residential while the more massive ones are barns and farm buildings.

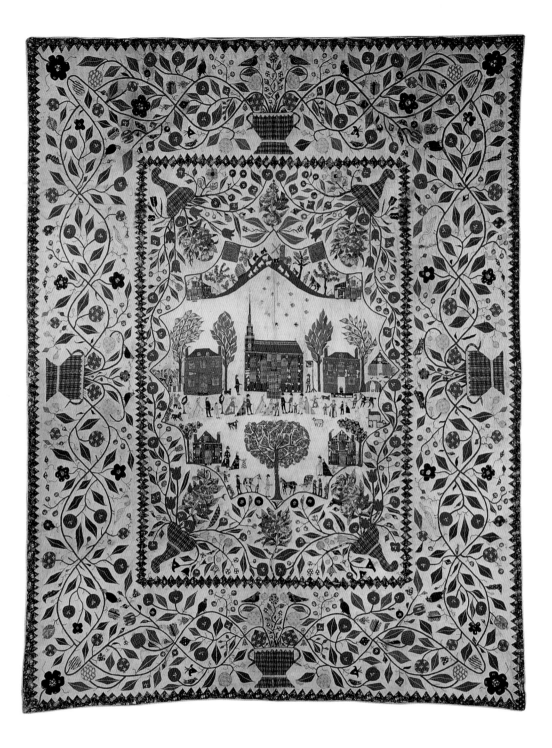

TOWNSCAPE, c. 1800–1820

Made by or for Sarah Furman Warner;

Connecticut or New York

Cotton, appliquéd and pieced,

105 x 84 in.

Photo courtesy Henry Ford Museum

& Greenfield Village,

Dearborn, Michigan

A tour de force in any medium but especially stunning in cloth, this appliqué quilt depicts the life of a town, supposedly Greenfield Hill, Connecticut, at the turn of the nineteenth century. Adults promenade in their finery and children and animals play along streets lined with early New England buildings. On a hill, sheep graze near a windmill and farmhouses flank the meadow. Cornucopia overflowing with flowers and trailing vines fill the corners of the central scene; baskets centered on each outside border sprout entwined floral vines that frame the entire composition. Nearly every inch of the quilt's top is layered with naturalistic details fashioned from late eighteenth- and early nineteenth-century printed fabrics. The quality of workmanship and the artistry are masterful, but it is the unique scenic treatment and the early date that make Sarah's quilt so significant.

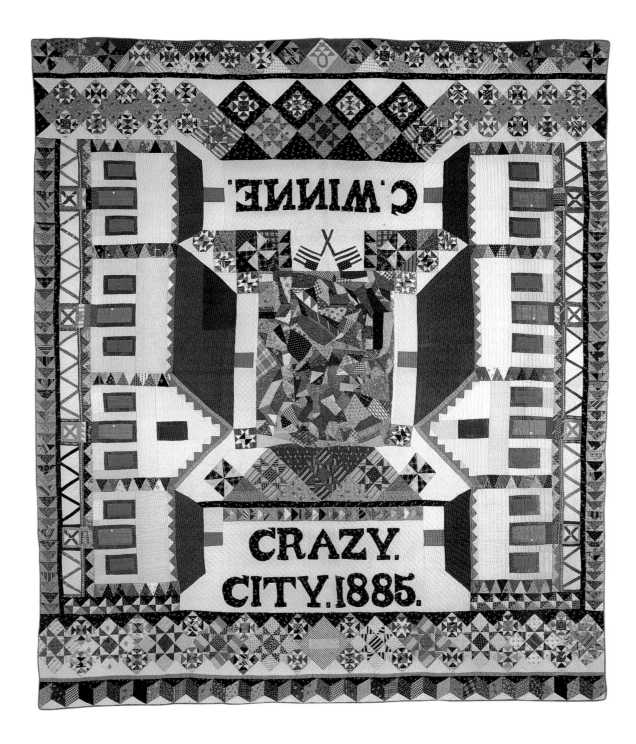

CRAZY CITY, Dated 1885
Signed C. Winne; found in the Finger
Lakes region of New York
Cotton, pieced, and appliquéd,
82 x 73 in.
Private collection; Photo courtesy
Woodard & Greenstein

Long regarded as one of the stellar examples of American patchwork quilting, Crazy City is a departure from earlier quilts in which houses were positioned in the middle as a focal point. Here, outsized houses dominate the sides of the quilt.

In a contrast of scale, the areas surrounding the houses are composed of very small, identifiable patchwork patterns. For example, the basket-centered top border is a sampler of several patterns. Triangles form vertical building supports and eaves. Rows of "Flying Geese" (or "Wild Goose Chase") border the sides and a "Ribbon" (or "Tumbling Blocks") variation is used along the bottom. There are also a number of "Ohio Stars" and "Pinwheel" blocks. Crazy quilt—style piecing creates the center medallion. American flags identify the nationality of the quilt.

VIRGINIA HOUSE AND YARD;
QUILT TOP c. 1880–90;
Completed c. 1950
Artist unknown; found in Virginia
Cotton with velvet accents, appliquéd,
76 x 70 in.
Collection of Oscar and Toby Fitzgerald;
Photo courtesy Stella Rubin

"The only thing missing from this appliquéd quilt is an apple pie," noted the dealer who found this cheerful fabric house portrait. "It has every symbol of 'home' you could possibly think of." There is a two-chimney house, picket fence, lush foliage and fruit trees, birds flying, a man on a ladder picking apples, a happy couple, a pony, even a dog with his own little house. Flowering vines, nearly as large as the house, wind their way around the wide borders that frame the house. The vines are accented with star shapes and American flags and shields that convey a patriotic pride in home and place. The only thing really missing is the maker's name.

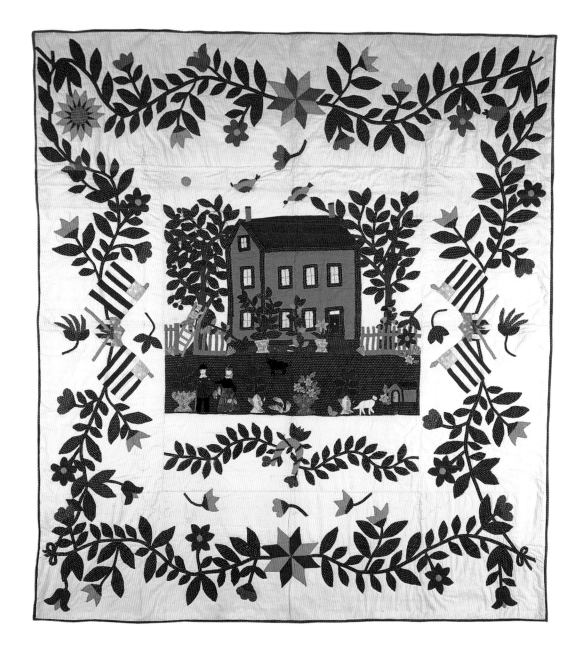

Opposite:
BALTIMORE ALBUM
QUILT, c. 1840
Made by Sarah and Mary J. Pool;
Baltimore
Cotton, appliquéd with inked details,
106 x 107 3/8 in.
Photo courtesy David A. Schorsch
American Antiques, Inc.

This masterpiece made by mother and daughter is composed of twenty-five appliquéd squares and contains blocks attributed to well-known Baltimore album designer Mary Simon. The quilt features five identifiable architectural images; two flags and two birds adorn the Baltimore Battle Monument at the upper left corner. The yellow colonial mansion at center top is believed to be either St. Paul's Rectory, the Mt. Clare Mansion, or a predecessor of the current Government House. On the right is the mid-nineteenth century Baltimore City Hall. The 1840s U.S. Capitol Building is at center bottom, and at left is the log cabin and cider barrel motif of the 1840 William Henry Harrison presidential campaign.

Other vignettes include the Baltimore & Ohio Railroad locomotive pulling a passenger car; the figures inside and the engine smoke are rendered in pen and ink. Above the train a swooping eagle carries an American flag, and a spread-winged eagle with a flag and trumpet fills the center block. Another bird perches on a red book appropriately inscribed "Album." The entire work is enclosed within a meandering stylized rose border.

The quilt brought $176,000 at a 1987 auction.

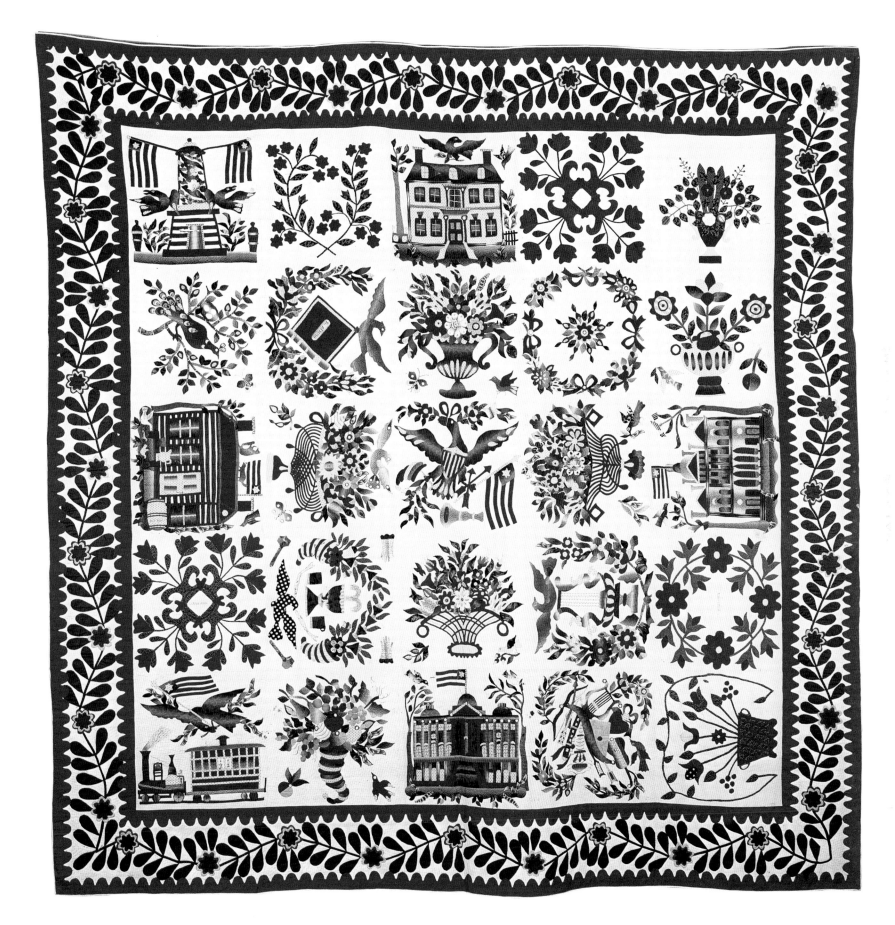

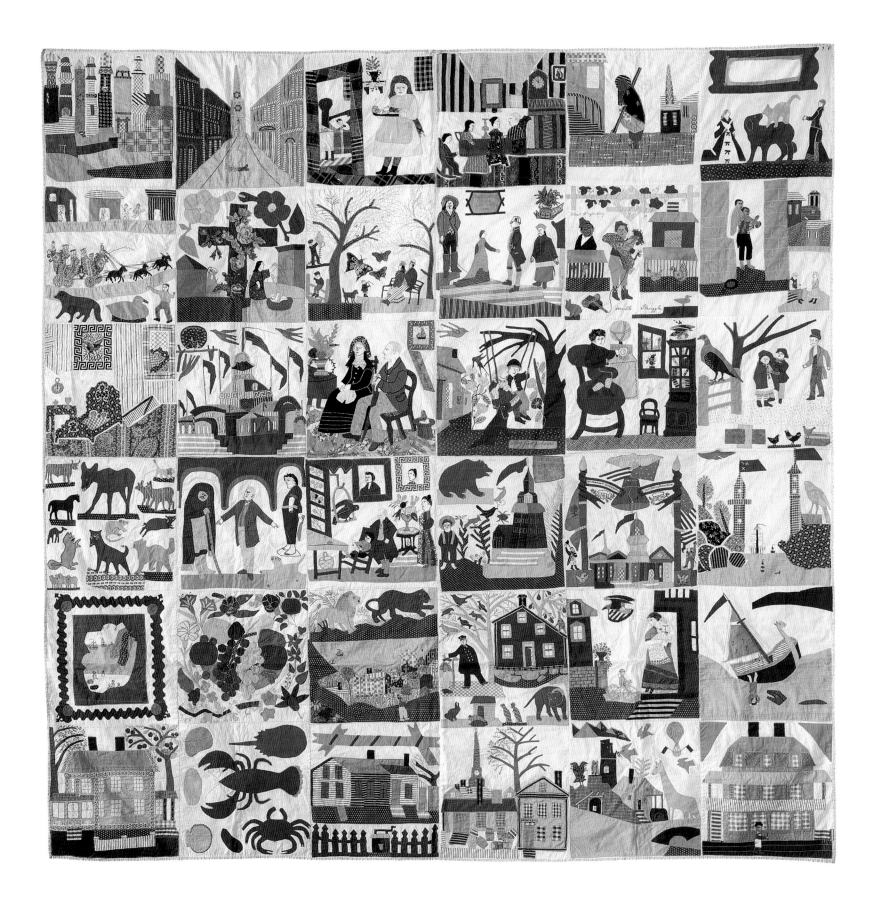

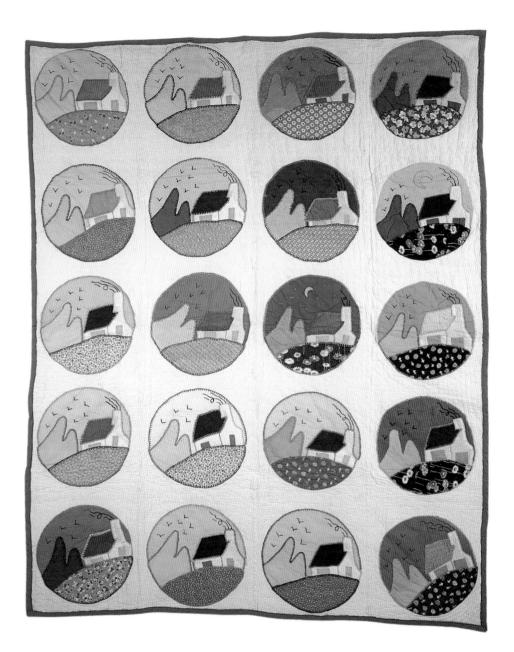

One jaunty cottage is imaginatively depicted at various times of day and night. Sunshine, noon, twilight, and evening are defined by the clever use of color in the sky-section appliqué in each of the circles. The front lawns of these dream homes range from autumnal bare to flower-filled by means of the quiltmaker's selection of Depression-era printed fabrics. During the 1930s, this design appeared in *Prize Winning Quilts* from Aunt Martha, a company with a mail-order needlework catalog that offered patterns for quilt blocks, sofa pillows, and tablecloths. Rather than create just one round pillow or doily, this quiltmaker used her pattern to compose a novel quilt.

Period fabrics are appliquéd in thirty-six blocks to illustrate a scrapbook of family life at the time of the American Centennial. Seventeen blocks on this album quilt feature exterior architectural vignettes and a number of others showcase interior rooms decorated with exquisitely detailed period furnishings. Small-scale printed fabrics were carefully selected to emulate building, furnishings, and clothing materials.

Building settings and styles vary and include cityscapes; a North Adams, Massachusetts, street scene (top row, second from left); domestic dwellings ranging from a New England saltbox to a Federal-style house to a Georgian mansion. A block in the fourth row (fourth from left) is embroidered "The Globe Theatre Built A.D. 1598." Scenes identified with the American Centennial celebration are the red-bannered buildings in the third row (the predominant one has been matched to an engraving of the Woman's Pavilion) and the grouping under a Liberty Bell in the fourth row, with banners that read, "Declaration of Independence," "Centennial Anniversary," "1776," and "1876." Almost every pictorial block tells a story, some of which are humorous and anecdotal.

Opposite:
HOUSES AND SEASIDE
VIEWS, c. 1880
Made by Celestine Bacheller;
* Wyoma, Massachusetts*
Silk, velvet, and silk yarn; pieced,
* appliquéd, and embroidered,*
* 74 5/16 x 56 7/8 in.*
Museum of Fine Arts, Boston;
Gift of Mr. and Mrs. Edward J. Healy in
* Memory of Mrs. Charles O'Malley*

One dozen lushly detailed and painterly quilt blocks provide a realistic sense of architecture and place along the patchwork hills and shore of what is believed to be Wyoma, Massachusetts. This intriguing collection of pieced and appliquéd textile vignettes is constructed with silks and velvets in the manner of Victorian crazy quilts. Easily discerned are three-story mansions with formal gardens, a vine-covered cottage, and Victorian townhouses with curtained windows reflecting the town's development over time. Elaborate details of the houses, gardens, and even the whitecaps on water are embroidered. Natural irregularities of the landscape are created by randomly shaped patches, while the buildings, boats, foliage, swans, and girl in red are rendered quite specifically.

Luminescent materials convey light shining on water, darkening skies, silvery rain, and a sunset. Most likely these fabric remnants were obtained from Celestine's father, a silk dyer by trade.

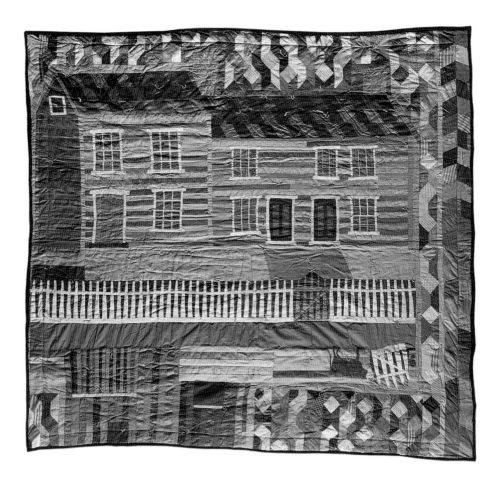

LOG FARMHOUSE AND
BARNYARD, c. 1870–80
Made by Sarah Goforth; Weymouth,
* New Jersey*
Cotton, pieced and appliquéd,
* 70 x 66 in.*
Collection of Laura Fisher

Using one monumental house to fill most of the quilt surface is an unusual composition for its time. In a constructionlike manner, the chimney is "bricked" with tiny appliquéd rectangles; the roof is "shingled" with parallelogram tiles; the two-door main house with its taller wing is built up of long strips that emulate logs or clapboard siding; the graphic fence is composed of distinctive white pickets. Pieced in cotton across the "dirt" road is a fenced field, where an upside-down cow grazes near a patchwork barn. The cow is deliberately upside down because Sarah used a dual perspective to portray both sides of the lane at the same time. Rows pieced of diamond shapes frame the scene.

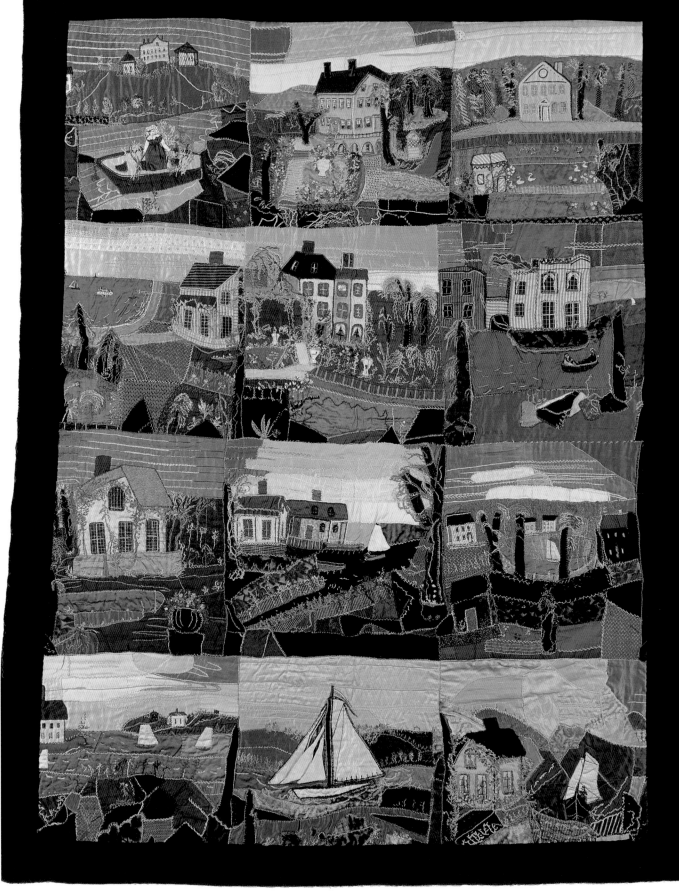

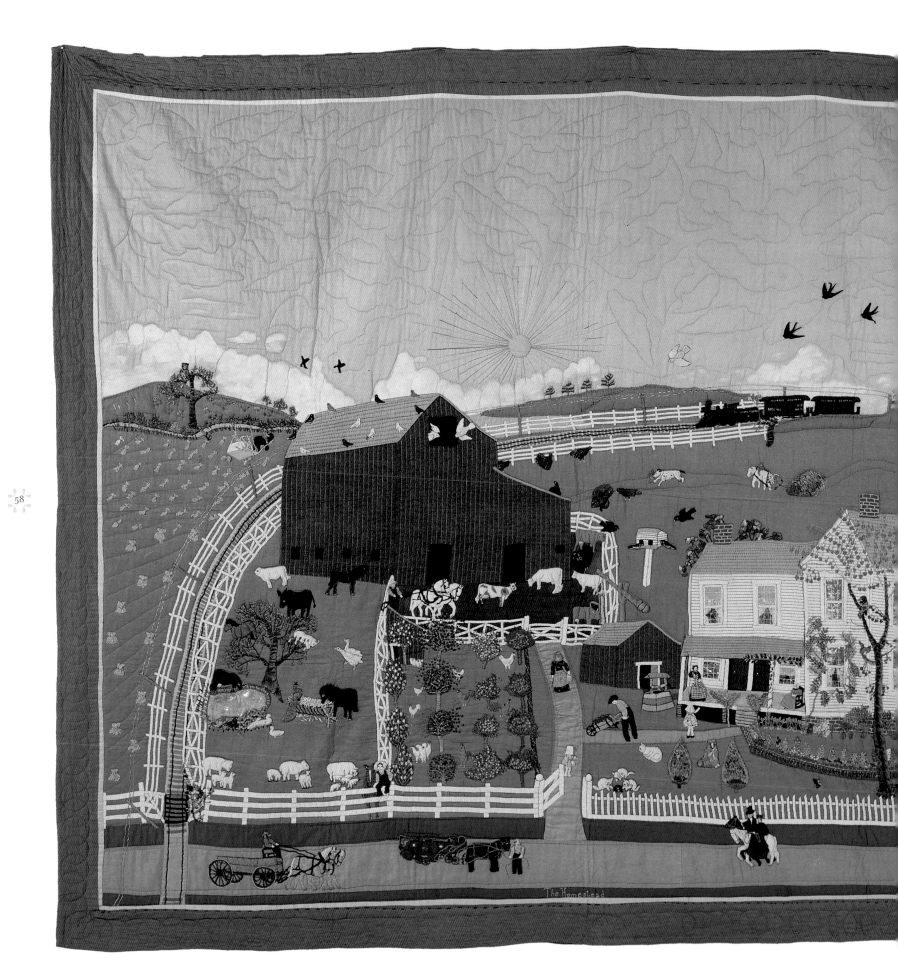

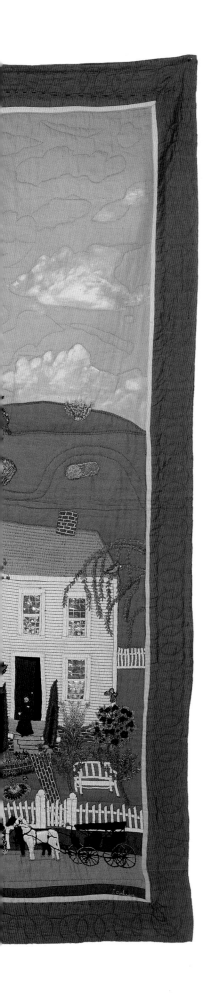

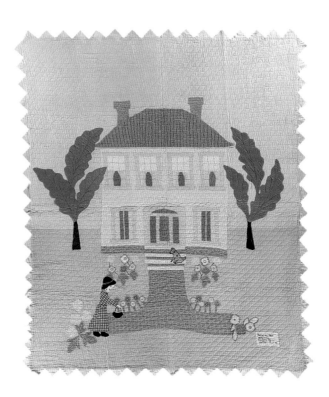

THE HOMESTEAD, c. 1925
Signed F. Cochran; origin unknown
Cotton; appliquéd, pieced, and
embroidered, 92 x 72 in.
Private collection; Photo courtesy
Sotheby's, New York
(Detail shown on page 6)

As detailed as a painting but far harder to execute as a fabric collage, this delightful quilt pictures the early morning lifestyle of American home and farm activity. Depicted in cloth are the family, the farmer with his wheelbarrow, neighbors and tradespeople in wagons, animals grazing near the barn, fertile fields, birds flying overhead, and several well-defined types of fencing enclosing the substantial property and bordering the railroad tracks. An orchard blooming with embroidered fruit trees is filled with chickens; nearby, a horse and peacock breakfast from a feed crib, and birds gather at a birdhouse. Details on and around the farmhouse include colorful flowerbeds; a brickwork walk, foundation, and chimneys; clapboard siding; a well; kittens at play; and a collie dog. Actual cellophane serves as windows.

THE MOTHER-IN-LAW
QUILT, c. 1930
Made by Lulu Bennett; St. Louis
Cotton; appliquéd, pieced, and
embroidered, 83 x 70 in.
Collection of Shelly Zegart

A joke heard on the radio inspired Lulu Bennett's quilt. One man said to another, "I cut off my dog's tail this morning." The other man said, "What did you do that for?" The first man replied, "Because I don't want him wagging his tail, showing how happy he is, when my mother-in-law comes up the walk!" Lulu communicates the opposite sentiment, because the dog sitting on the front steps of her grand yellow house has its tail intact and she appliquéd a label on the front lawn that reads: "The Home that Tenderly Greets the Mother-in-Law."

Motifs familiar to Depression-era quilts include blanket-stitched appliqué flowers, the gingham-clad figure, and the "prairie points" triangular border.

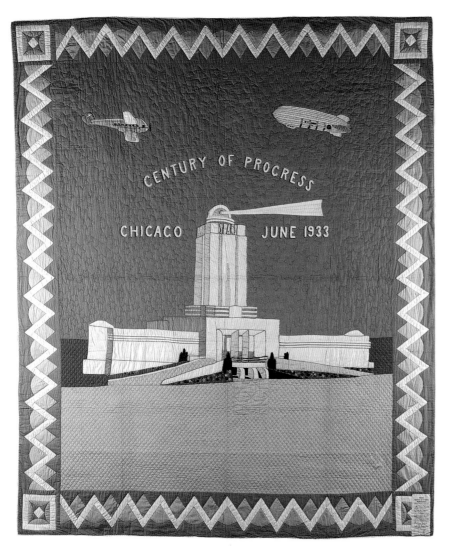

CENTURY OF PROGRESS, Dated 1933

Anna Hansen; Chicago
Cotton, appliquéd and pieced, 84 x 72 in.
Collection of LeRoy and Maxine Armstrong; Photo courtesy
Merikay Waldvogel; Photo by Gary Heatherly

Sears, Roebuck and Company sponsored a "Century of Progress" quilt contest to tie in with the 1933 World's Fair in Chicago. Twenty-five thousand entries competed for the $1000 grand prize, resulting in some of the most innovative quilt designs of the twentieth century. Many unique theme quilts illustrated the buildings of the fair. The Sears Pavilion, shown here, appears most often on these commemorative quilts.

Anna Hansen's quilt is based on an illustration rendered by her husband and adapted from the contest entry brochure.[13] She appliquéd an airplane and a zeppelin above the building in keeping with the fair's salute to science and technology. Needlework details include star-shaped quilting and embroidered flowers. Note that Anna's entry tag is still attached to the bottom right-hand corner. Although this contest entry is dated June 1933, the actual opening date of the fair was moved up to May 28, 1933, in order to accommodate the schedule of President Roosevelt.

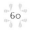

Opposite:
CIVIL WAR
RECONCILIATION QUILT,
Dated November 18, 1867
Lucinda Ward Houstain;
Brooklyn, New York
Cotton, wool, and silk; appliquéd
and embroidered, 100 x 88 in.
Private collection; Photo courtesy
America Hurrah Archive,
New York

This extraordinary album quilt presents black and white figures in genre scenes relevant to the Civil War. Domestic activities as well as historic moments are illustrated. Appliquéd vignettes show a man driving a "Dry Goods" wagon, a black street vendor selling ice cream from a cart (the date appears on the cart), a woman doing her wash, a farmhand carrying buckets, men decorating a Christmas tree, a woman riding sidesaddle, sailors leaning on anchors, pantalooned Zouave soldiers (a New York State regiment), animated sailors, and traveling figures on horseback.

The quiltmaker's attitude about the war is evident in two blocks: in the third row, a black man faces a top-hatted white rider next to the inscription "Master I Am Free," and in the second row,

Jefferson Davis, president of the Confederacy, is met by his daughter on his release from prison in Fort Monroe, Virginia. Flags and other patriotic symbols are abundant.

A distant cousin of abolitionist *New York Tribune* publisher Horace Greeley, Lucinda made this quilt in 1867. The two-story townhouse with rooftop dormers in the center panel is believed to be her residence, and below it is her church. Unusual building images include a windmill, a columned structure sheltering a Liberty figure, and even a doghouse. The originality, historical commentary, artistry, workmanship, and provenance of this piece qualify it as one of the finest examples of American quiltmaking. It sold for a record auction price of $264,000 at Sotheby's in 1991.

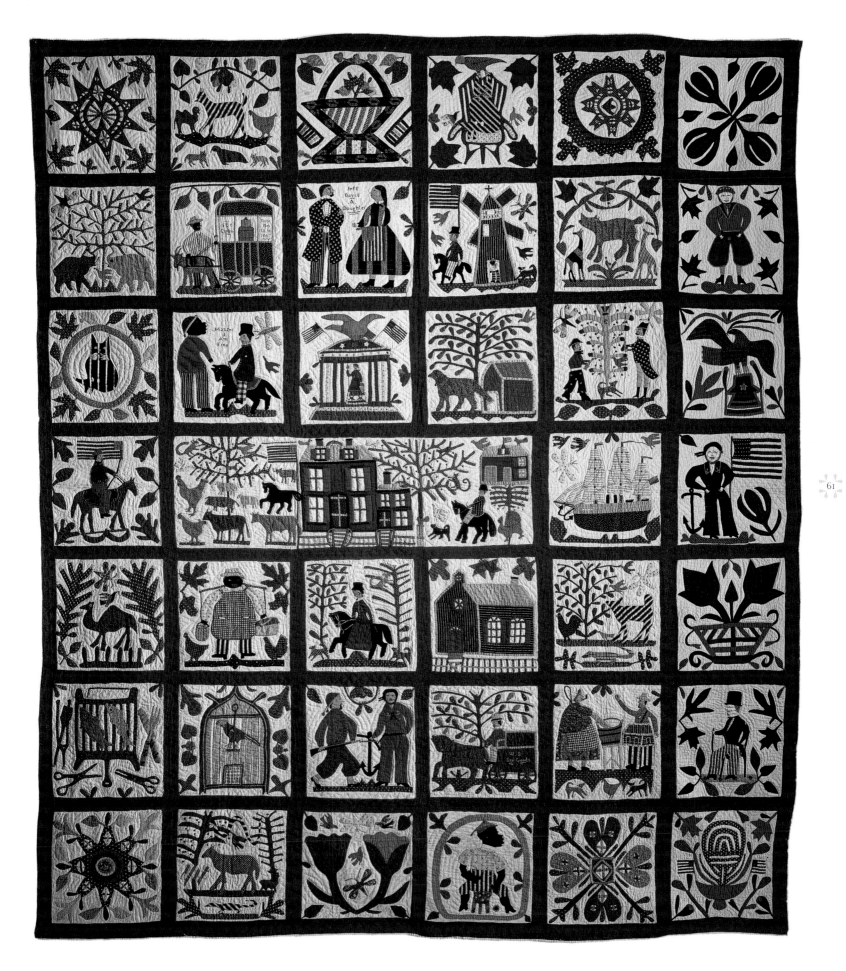

61

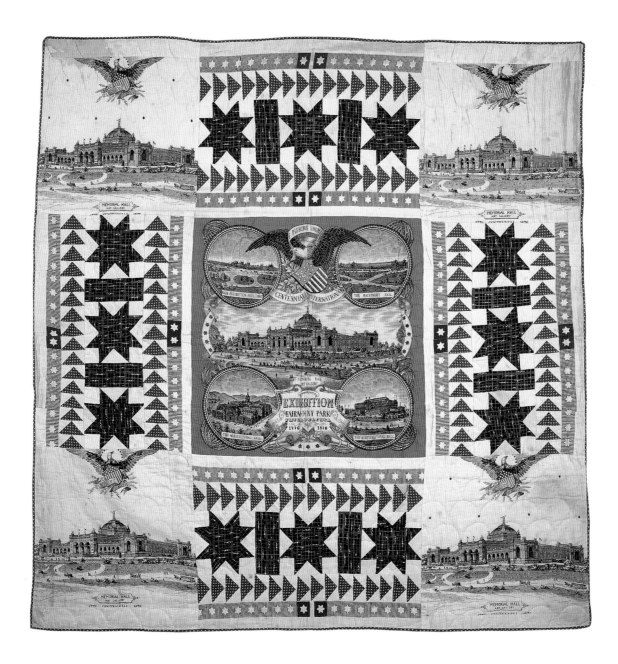

CENTENNIAL KERCHIEFS QUILT, c. 1876

Artist unknown; found in the Midwest
Cotton, pieced, approximately
68 x 68 in.
Private collection; Photo courtesy
Laura Fisher

Two different souvenir kerchiefs printed for the United States Centennial Exhibition in Philadelphia were combined with red, white, and blue simulated-patchwork-printed yardage, perhaps to commemorate a visit to the fair or the maker's patrotic sentiments. The centerpiece kerchief, captioned "Exhibition, Fairmount Park, Philadelphia 1776–1876," depicts the five principle edifices. At the center is Memorial Hall Art Gallery, and in circular vignettes surrounding it are the Main Exhibition Building, the Machinery Hall, the Horticultural Hall, and the Agricultural Hall. Although depicting an American event, the

kerchief was actually printed in Frankfurt, Germany, by P. Ballin and exported to the United States. The other kerchief, which is used for the four corners, shows Memorial Hall Art Gallery, with a large eagle and patriotic shield dominating the sky above. The detail is so precise as to resemble a lithographed print; indeed, by the time this kerchief was sold, the technology of printing fabric mechanically had advanced to such a degree that manufacturers were able to produce great quantities and varieties of these goods cheaply. Including such textile ephemera in a quilt was a successful way to preserve these kerchiefs.

BUILDINGS OF THE PAN AM, Dated 1905

Jennie Johnson; New York
Cotton, embroidery, 80 x 62 in.
Photo courtesy Susan Parrish Antiques

Redwork embroidery (a form of outline stitching with red thread on a white background) enjoyed great popularity at the turn of the twentieth century. Applied to a variety of domestic linens, colorfast Turkey red thread was chosen because it could withstand repeated laundering. Stamped muslin blocks known as penny squares, to be worked in this technique, were sold at the 1901 Pan American Exposition in Buffalo, New York; many of them pictured the buildings at the fair.

Jennie Johnson's quilt incorporates twenty-two of these building blocks, including two of the most popular images: House Upside Down (fourth row) and Temple of Music (third row), where President McKinley was assassinated. Jennie did not include the souvenir blocks of President McKinley and his wife but did use the ones of his successor, President Theodore Roosevelt, and Mrs. Roosevelt. Bordered with a handsome grapevine design, this quilt was completed in 1905, four years after the "penny squares" were purchased.

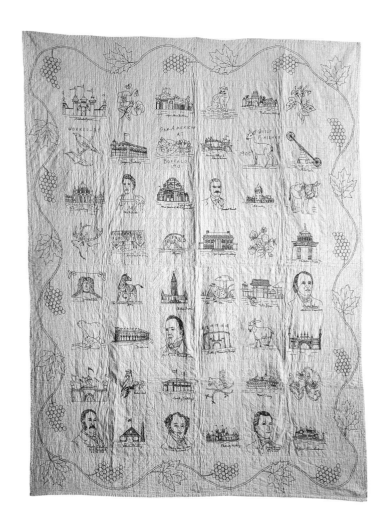

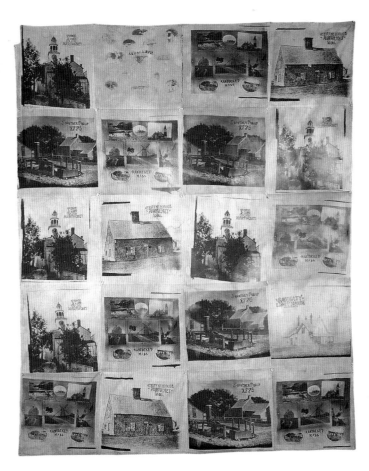

NANTUCKET LANDMARKS, Late 1800s

Artist unknown; Nantucket, Massachusetts
Cotton; cyanotypes, pieced, 70 x 83 in.
Private collection; Photo courtesy Laura Fisher

Twenty photographic kerchief-size blocks are combined in this unique summer spread showing Nantucket Island landmarks. The cyanotype process—which renders a blueprint-like image—is used to print the pictures on cloth rather than paper. Enamored with the novelty of making photographs outside of a studio setting, people experimented with printing on all types of surfaces. Clever entrepreneurs recorded vacation scenes and historic vistas to sell to potential customers. According to the Nantucket Historic Association, no other examples of these fabric blocks have ever been found, making this quilt's existence both a mystery and a rare historical record.

Structures include the 1636 Coffin House (the Oldest House), a rare saltbox dwelling dating from the time of Nantucket's first settlement; the town clock in the belfry of the Unitarian Church on Orange Street; the 1776 Sconset Pump that supplied fresh water to that island village; the Old Mill; and the Brant Point Light, all of which stand to this day.

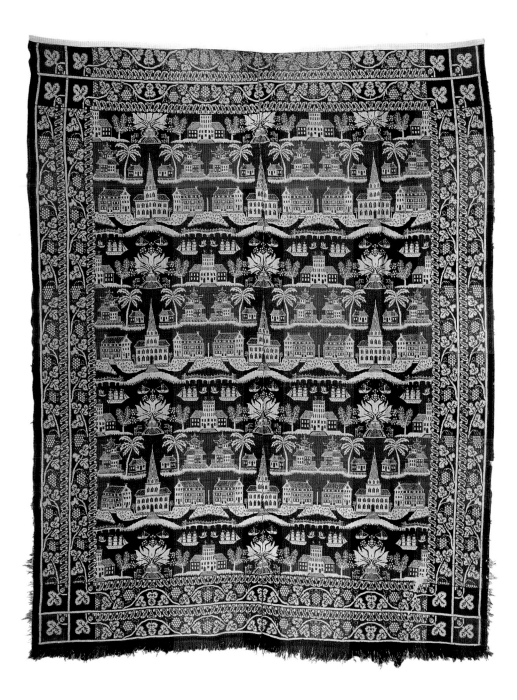

**TRUE BOSTON TOWN AND
CHRISTIAN AND HEATHEN
COVERLET, c. 1840**

Artist unknown; probably Ohio

Wool and cotton, jacquard

doubleweave, 92 x 73 in.

*Collection of the Museum of American
Folk Art, New York; Gift of
Margot Paul Ernst in Memory of
Susan B. Ernst*

This scenic double-cloth jacquard coverlet is intriguing because the central field features building pictorials that are usually woven only in the borders. Here, rather than the traditional clusters of lilies or starbursts, horizontal rows of architecture and landscape dominate.

Rows of large public buildings with a church represent the Boston harborside in the pattern known as "True Boston Town." This New England shorefront combined with design rows of an Oriental village depicting pagodas and smaller buildings has long been known as "Christian and Heathen." A river of sailing ships further enlivens the folky composition. A fascination with Oriental imagery developed in the United States as a consequence of both the China trade and the opening of Japan to the West. This rare coverlet was woven in two narrow panels on a draw loom fitted with an attachment enabling the weaver to achieve this almost documentary result. It might have been manufactured in any of the principal weaving centers in Ohio, New York, or Indiana, locales in which a similar border design is known to have been featured by area weavers.

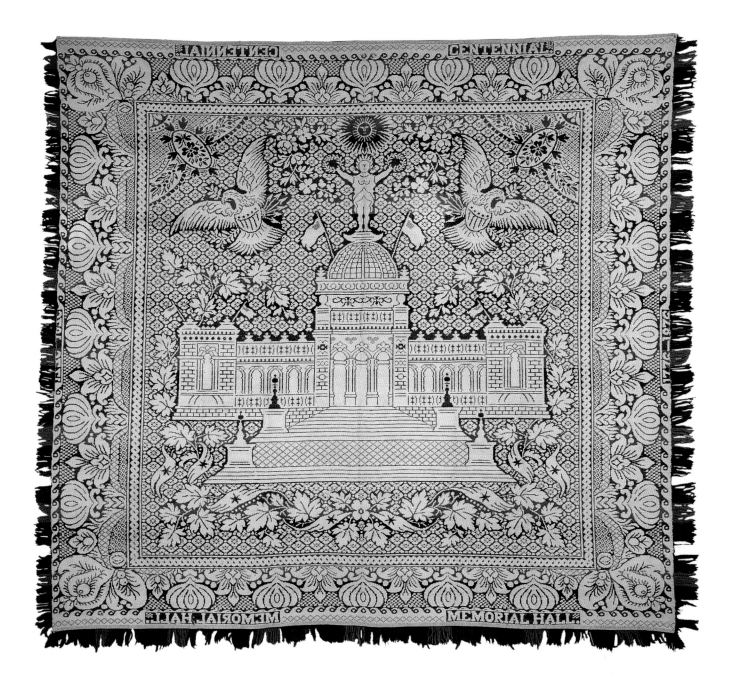

MEMORIAL HALL
COVERLET, c. 1876
Artist unknown; probably Pennsylvania
Wool and cotton, jacquard
singleweave, 96 x 70 in.
Collection of Laura Fisher

This type of coverlet demonstrates a time in American textile history when the demand for handmade goods was ending, supplanted by commercially available, affordable bedding.

The Philadelphia Centennial Exhibition showcased goods and technologies that influenced American manufacturers. Memorial Hall, a significant building there, was immortalized in coverlets as well as souvenir kerchiefs. Details of the edifice include arched windows, the grand staircase, and the majestic dome. Eagles, leaves, flowers, and starred ribbons are woven into a diamondlike ground. Made on a full-width mechanized loom in single weave, the coverlet features a multicolor palette suggesting a Pennsylvania origin. Borders are inscribed "Centennial," "Memorial Hall," and "1776–1876"— in mirror image, a result of the loom limitations of the time.

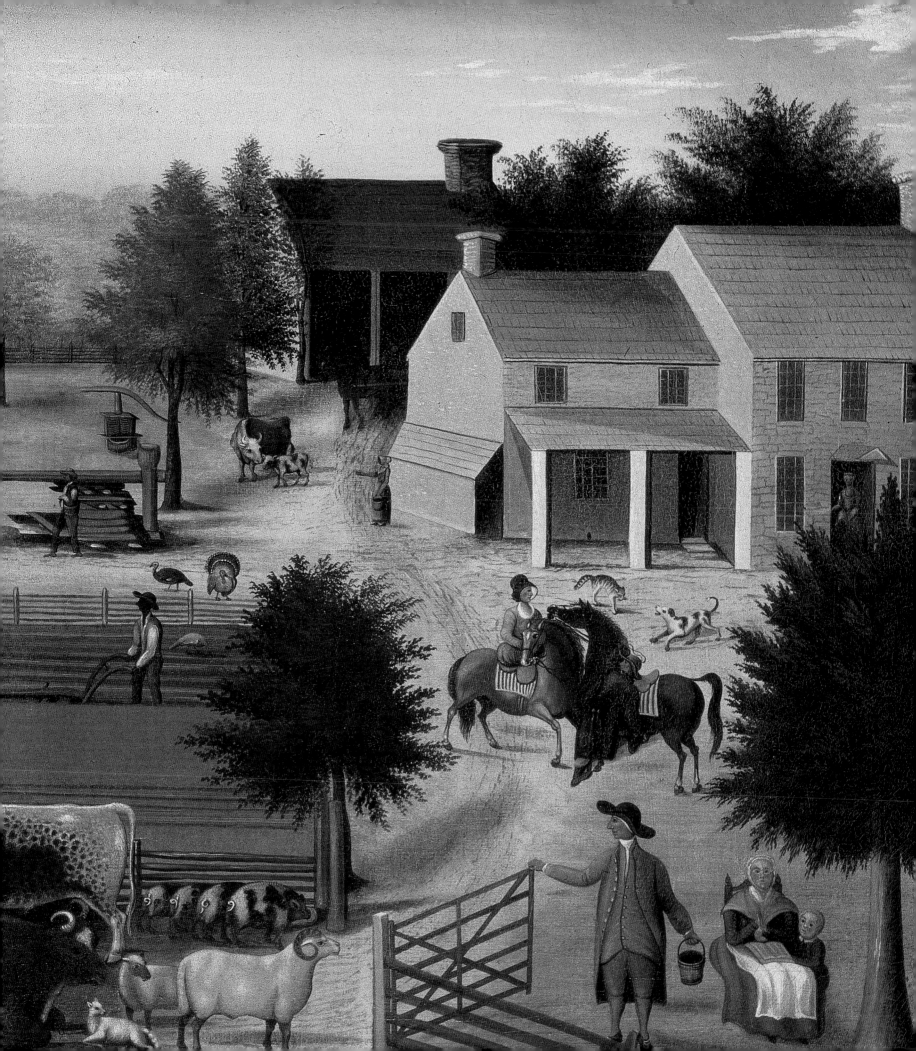

"One of the reasons that American folk painting has attracted such popular interest is that much of it depicts the common man—the backbone of American experience—and the farms, towns, and cities of this nation prior to changes in lifestyle that came about as a result of the Industrial Revolution," wrote the late Bob Bishop, director of the Museum of American Folk Art from 1977 to 1991. In referring to early nineteenth-century genre pictures, Bishop added, "People with a sense of belief in America rushed to record the land they loved in its every aspect. The rustic farm and its people and animals, the thriving town with its new industries, and the bustling city with its busy harbor were all captured in paint at one time or another by the naive artist."[1] ❊ Frequently, these likenesses were a bit idealistic. "While nineteenth-century views of towns and houses may appear to portray actual places faithfully, such scenes are usually devoid of trash piles, dilapidated outbuildings, and other elements that might suggest social neglect or even poverty. Typically, middle-class, work-ethic values of accomplishment and growth pervade American house portraits and townscapes," explains

Carolyn Weekley, director of museums at Colonial Williamsburg. ❊ One of the most intrinsic and appealing aspects of folk art paintings is that scenes and objects are often depicted from a nonoptical approach. Artists show what they know or want to be presented in a picture, not necessarily the actual visual appearance. For example, we will see the front and the side of a seemingly flattened house in equal detail. The size of people and/or animals inhabiting the landscape may be determined by their importance to the artist or to the scene being portrayed, with little consideration of the scale of the things around them. ❊ In the last half of the nineteenth century, as photography developed, these artists had to compete with this new medium, but they had an advantage in that they could adjust the perspective to suit their purpose. In the days before wide-angle lenses, it was difficult to capture a house and barn in the same photograph if they were hundreds of yards apart from each other. The artist, however, could include it all in the same impressive picture, and could imaginatively position buildings to highlight certain characteristics, and depict or exaggerate details that the homeowner wanted to accentuate.

chapter three

PAINTINGS
& DRAWINGS

The artisan's own life experience and interpretive view of a subject makes each work unique and conveys a social commentary of the period. These painters, these visual diarists, recorded the specificity and nuances of everyday life—the life of ordinary people like themselves. Many of the known artists whose work is now held in high esteem actually earned their livelihood or reputation in other professions. Edward Hicks, although trained as a coach and sign painter, was a much-admired Quaker minister. Joseph Hidley, renowned for his upstate New York townscapes, earned his living as a house painter, a carpenter, and a taxidermist. Francis Guy, born in England and trained as a tailor, worked as a silk dyer. Rufus Hathaway became the town doctor in Duxbury, Massachusetts. Less fortunate examples are Charles C. Hofmann, John Rasmussen, and Louis Mader, associated with their minutely detailed portraits of Berks County Almshouse, where they were all on-and-off residents for reasons recorded as "intemperance" or "pauperism." Rasmussen's work was so admired by the administrators there that he was given his own room to use as a studio.

The term *American folk art painting* encompasses a diverse range of styles, subjects, and techniques. The variety of materials used by these nonacademic artists, frequently referred to as limners, includes oil and tempera on canvas, board, glass, and even tin; watercolors on paper, cardboard, and silk; marble dust, pastels, pencil, and ink on paper; reverse painting on glass; and theorems (stencil work) on paper and velvet.

Whatever the technique, private homes, general stores, schoolhouses, and factories were all memorialized in pencil and paint with as much respect as Mt. Vernon or the White House, no matter what their regional significance, economic level, or architectural style might have been. These house portraits, street scenes, and townscapes represent a valuable contribution to the preservation of our national heritage.

HOUSE AND FARM PORTRAITS

As America grew and prospered, proud homeowners were eager to have a visual record of the places where they lived and worked. By the beginning of the nineteenth century, this could be accomplished by hiring an artist to depict the home or business establishment. Many of the artisans employed for this task were ornamental painters who specialized in signs, murals, and the more practical form of painting houses—inside and out—but they were versatile enough to add house and farm portraits to their list of services. Some of them established shops and conducted businesses within a single community, others took to the road during the summer months to sell their services, and still others were itinerant artists who traveled year-round selling or bartering a variety of talents. The result of their work is a pictorial diary of domestic architecture. House portraits, commissioned or sometimes painted by the homeowners themselves, were displayed in the home with pride, safeguarded, and passed down in families or between homeowners, which explains why a number of them still exist, as do many of the buildings that they depict.

Portraits of stores, hotels, hospitals, municipal buildings, and mills were also in demand. Factory portraits such as the one of the Oswego Starch Factory (page 86) were shown at major public events to attract workers. It's not unusual to see a commercial building surrounded by less impressive edifices as a means of emphasizing the subject's economic or humanitarian importance to the community. These likenesses, often prominently displayed on the premises, could also be used for advertising purposes and/or developed into prints.

Nineteenth-century house and farmscape artists sold their work for just a few

dollars or traded their skills for food and a couple nights' lodging.

Some of these paintings are still displayed in the buildings they portray but the majority of them have been snapped up by private collectors, museums, and historical societies for tens (or even hundreds) of thousands of dollars.

While many of the artists remain anonymous, others have been identified or were known in their own time. Francis Guy (1760–1820) painted country estates in Maryland, characterized by distant views of imposing homes with elegant landscaping. A trademark of his Baltimore-area works is the inclusion of one or more pairs of people in Empire dress.[2] A few years before his death, Guy moved to New York; there he painted the precise topographical scenes of village life in New York and Brooklyn for which he is best remembered. In 1856, Rembrandt Peale described Francis Guy's method of landscape painting: "He constructed a tent which he could erect at pleasure, whenever a scene of interest offered itself to his fancy. A window was contrived, the size of his intended pictures—this was filled up with a frame, having stretched on it a piece of black gauze."[3] He goes on to explain that Guy drew the objects in view on the gauze with chalk. He then placed the gauze on his canvas and transferred the outlines by pressure from the back of his hand.

Jurgan Frederick Huge (1809–1878) painted watercolors, sometimes embellished with gilt, of public buildings and private residences in the area of Bridgeport, Connecticut. His signed works are dated 1838–78 and city directories list his occupation as "grocer," then as "grocer and artist," and after 1871 as "teacher in drawing and painting." Huge also painted city views of the same area.

Little is known about Fritz G. Vogt (1841–1900) except that during the last decade of the nineteenth century (also the last

decade of his life), he produced hundreds of architecturally detailed pencil drawings of houses, farms, factories, stores, churches, and grave sites in upstate New York.

As the story goes, Vogt preferred to sleep out in the barn on buffalo pelts, wore shoes made from carpet remnants, and came inside only when he was invited to play the organ. According to Vogt collector Frank Tosto, "There is a pleasant, optimistic, atmosphere in Vogt's house portraits. His distinctive trees remain in full leaf all seasons of the year, flowers bloom, tools or other signs of toil are usually absent, and smoke rising from the kitchen chimney conveys cozy domesticity."

"At about this same time," Tosto explains, "atlas companies employed artists to go into the countryside to do drawings of farms and houses from which etchings could be made for use in a city directory or county atlas. Property owners were charged a fee for this service. It is probable that Vogt, influenced by these publications, borrowed their format, and decided that he could offer homeowners even more flattering renderings of their property. His accurate penmanship and intricate line drawing, similar to the engraving on banknotes, suggests that he may have had some training in, or at least exposure to, lithography. Vogt's sketches were usually completed in a day or two. The back of one of his drawings is marked '$1.85' with the German words for 'on credit.'" Sadly, Fritz Vogt is believed to have ended his days in an almshouse.

German-American Paul A. Seifert (1840–1921) created large-scale watercolor farmscapes in Wisconsin at the end of the nineteenth and early part of the twentieth centuries. He traveled by foot from one farm to another and sold his pictures for no more than $2.50. Seifert's main livelihood was raising fruit, vegetables, and flowers for sale and he picked up extra money in his travels by helping farmers plant groves of fruit trees.

Rufus Hathaway (1770–1822), a Massachusetts portrait artist, painted at least one landscape: the well-known picture of the home and property of his father-in-law, Joshua Winsor. Hathaway was commissioned to provide portraits of Winsor's two daughters and in the process fell in love with and married the younger one, Judith. After marriage, he studied medicine, earned his living as a doctor, and continued to paint only occasionally.

Edward Hicks (1780–1849) is famous for his Peaceable Kingdom series. However, "his farmscapes (The Twining Farm, Leedom Farm, Cornell Farm, and Hillborn Farm) painted in the last decade of his life are considered by many to be some of his most important work because he was pursuing a new form of painting with some passages more realistic than before. As is the case with many artists of the time, sections of some of the earliest Peaceable Kingdoms can be linked to images inspired by, or even copied from, prints. The farmscapes, on the other hand, appear to be mostly original work although some individual elements may be inspired by print sources," explains Hicks expert Carolyn Weekley.

Hicks's role as a Quaker preacher provided little, if any, income and he supported his family through his ornamental work painting signs, fire buckets, and carriages; graining walls and decorating furniture; and even gilding weathervanes.

More often than not, Hicks gave his easel art to friends and family members, but records indicate that he may have sold (or received a grateful contribution) for one of his four Twining Farm paintings, probably an amount in the area of $25 to $50, which was the same price that he charged for his signboards. This would certainly have been a very wise investment, considering that a Twining Farm painting by Edward Hicks brought almost $1.5 million dollars at a 1999 Christie's auction in New York.

City and Townscapes

A number of nineteenth-century paintings portray views of entire towns and small cities in precise detail. The location, architectural style, and purpose of the buildings are clearly defined. Rivers, bridges, trees, gardens, roads, and other geographical details are included. In some examples, people can be seen going about their daily activities. As house portraits symbolized individual success, townscapes represented collective accomplishments: the development of civilized and industrialized communities in what was once wilderness.

One explanation for this proliferation of town views is that in the years between 1840 and 1880, more than 2400 lithographs were made of towns and cities. These engraved prints served as references for the paintings. Affluent businessmen or town residents could commission a painting to be made from a print of choice; families moving westward could purchase a keepsake of their hometowns.

In the early 1800s, William Birch and his son Thomas published a series of twenty-eight views of "The City of Philadelphia," Joshua Shaw followed with "Picturesque Views of American Scenery," and William Guy Wall published "Hudson River Portfolio." Drawings for lithographs were made by a number of artists including Fitz Hugh Lane, W. H. Bartlett, and Edwin Whitefield. In some cases the preliminary drawings themselves remained after the lithographs were destroyed. More common, however, are the painted townscapes and city views that were inspired by these prints.

John Lewis Krimmel (1789–1821), sometimes referred to as "the American Hogarth," painted views of Philadelphia influenced by the prints of William Birch. In 1821 Krimmel was elected president of the Association of American Artists but drowned in an accident just six months later.

Joseph Henry Hidley (1830–1872) gained wide acclaim for his series of meticulously executed townscapes of upstate New York, including Poestenkill, Glass Lake, and West Sand Lake, painted in oil on wood or canvas. Hidley's work, showing all of the buildings and geography in crisp detail, was so admired that the process worked in reverse and lithographs were made from his paintings.

Another recognized townscape painter (and lithographer and portrait painter) from the Finger Lakes region of upstate New York was Henry Walton. From 1836 to 1850, Walton's watercolor and oil wide-angle views recorded towns such as Pickaway, Painted Post, and his hometown of Ithaca. He also branched out to paint a view of Athens, Pennsylvania, and, after traveling to California with a Gold Rush party, a mining town in California called Grass Valley.

"American folk townscape paintings offer much more than artistic significance," explains Paul S. D'Ambrosio, chief curator of the New York State Historical Society at Cooperstown. "They are often abundantly rich in specific and accurate detail of the kind that is not recorded in the written word or in photographs. These humble paintings are, in fact, important historical documents of patterns of life as expressed in the material environment, in buildings, fences, tools, vehicles, clothes, and many other aspects of everyday life in the past."

SIGNBOARDS

Hand-painted signboards were a familiar sight as early as the mid-seventeenth century, when court orders in 1645 required Salem tavern owners to prominently display an identifying sign. This was not surprising, since aside from serving refreshments and providing lodging, taverns functioned as stagecoach stops and meetinghouses. A number of painters now recognized for other aspects of their work started or supplemented their careers as sign painters. It was a lucrative and competitive business. During the Colonial period, tradesmen and tavern owners were willing to pay a good price for a sign that would attract attention—and customers.

One of the first forms of advertising art, these outdoor signs came in two forms: a one-sided wooden sign mounted flat against the framework of the building, and a two-sided version suspended from brackets at a right angle to the street and either attached to the building or to a post. The later swinging signs, usually shaped, displayed a design on each side to attract travelers coming from either direction.

Before the American Revolution, inn and tavern signs reflected their English counterparts and displayed symbols of sovereignty, such as crowns on lions' heads. After the Revolution, these symbols were quickly painted out. Design choices varied from the obvious to the whimsical. Signs for taverns and inns often illustrated the name of the establishment, such as the White Stag, the Red Lion, the Anchor, the Eagle's Nest, or Bird in Hand. Others portrayed a coach and horses to signify a stagecoach stop, but some illustrated the building itself along with the lettered name of the proprietor and the date that the business was founded.

Shop and tavern signs are one of the largest surviving groups of early American commercial art. By the last quarter of the eighteenth century, taverns and inns flourished in urban centers with more than a hundred establishments in New York City and even more in Philadelphia. Stagecoach travel linking these hubs of commerce to rural areas began in the 1750s and was fairly commonplace by the 1770s. Although many of these signboards were originally signed by the artist, most signatures have been lost since signs were repainted while in use due to weather damage or painted over with new innkeeper's names.

SCHOOLGIRL ART

In addition to needlework, young ladies were taught a variety of painting techniques. Oil painting was considered too messy for proper young ladies, but other options existed.

By the 1830s, watercolor painting on both paper and silk had begun to replace the more time-consuming embroidery. As with samplers, these watercolor compositions were seldom completely original. In that age of Romanticism, prints featuring Bible stories, mythological tales, and historical themes served as the main sources of inspiration. Scenes could be copied as a whole, or enterprising girls could combine elements from different prints to create their own picture. This mix-and-match style sometimes resulted in motifs that were out of scale to one another or that were selected from different time periods, geographic regions, or architectural styles.

Buildings pictured included recognizable landmarks such as Mt. Vernon, as well as the schools attended by the students, or small townscapes in the background of a mourning or patriotic picture. Even these distant background buildings are important because they often identify a locale or an indigenous style of architecture.

Scenes from prints were also adapted for "sandpaper paintings." This process involved applying glue to a thick paper or bristol board, and coating it with finely ground marble dust. After the marble dust dried and excess chips were shaken off, charcoal and chalk were used to draw on the surface.

Girls could also learn the art of theorem painting, which involved the use of stencils to create a design on velvet or paper. Still lifes showing bowls of fruit or flower arrangements were the usual subject matter. Sophisticated examples demonstrate freehand painting combined with stencil shapes. An image of a house in a theorem is rare and may be as subtle as a framed house portrait shown on a wall above a bowl of fruit.

Another acquired skill was reverse painting on glass. In some instances, this technique involved the use of a sheet of crinkled tinfoil, which was placed on the back of the painted picture for a sparkling effect.

Many of these picture-making techniques developed into popular hobbies for young women and housewives, whether they had attended private schools or not. From the 1830s on, patterns and instructions were printed regularly in illustrated weeklies, ladies' magazines, and art manuals.

FRAKTUR

Folk art and religious customs came together in the work of German-American artists in Pennsylvania who combined watercolor painting with quill drawing on paper to produce birth, baptismal, confirmation, and sometimes marriage and death certificates. Particularly popular during the last half of the eighteenth and much of the nineteenth century, these decorated documents composed of calligraphy and stylized motifs are known as *fraktur* or *fractur*, a name derived from that of an early German typeface.

These illuminated family records were originally provided by schoolmasters and, occasionally, ministers. Additional fraktur items include bookplates, valentines, family registers, house blessings, and presentation pieces (fraktur-style drawings exchanged by Pennsylvania Germans on special occasions). Schoolchildren sometimes practiced their penmanship by filling in bookplates and songbook plates under a teacher's watchful eye. House blessings were prayers for the well being of the homeowner and his family but seldom include an illustration of a house.

Text on frakturs is often contained within a border or framework, known as a reserve, and from the end of the eighteenth century the heart was a favored choice. Although varied in content and design, some motifs such as hearts, colorful flowers

(particularly tulips), numerous birds, astronomical symbols including suns and moons, unicorns, mermaids, and a few geometrics appear frequently.

While some historians define a fraktur as a watercolor and quill document that contains some form of writing, current use of the term has broadened to incorporate stylistically similar watercolors from this time period, with or without words.

"Houses and buildings are fairly rare on Pennsylvania-German watercolors. Henrich Engelhard put houses on some of his house blessings, Durs Rudy used them to illustrate biblical stories such as that of the Prodigal Son, and we occasionally will find a piece with a church or other identifiable landmark," says Massachusetts fraktur dealer David Wheatcroft.

"Unusual elements such as architectural images, cats, and people add to the value of a piece. It is likely that many nineteenth-century fraktur artists earned as little as 25 or 50 cents for their work at the time but today at least twenty frakturs have sold for over $100,000, and a birth certificate with an alligator by a known artist set the record at $180,000," adds Wheatcroft.

SHAKER DRAWINGS

Fraktur certificates recorded specific events in the lives of individual people. Shaker village drawings recorded the lifestyle of communal societies seen through the buildings in which members resided, worked, and worshipped: the architecture of Shaker life.

Shaker Believers discouraged decorative art, considering it superfluous. Nineteenth-century Shaker maps and village views were therefore created as functional documents—intended to be used, not displayed.

Their unique gridlike diagrams map a panoramic view of a village and methodically record densely grouped buildings often lettered, numbered, and matched to a key.

Originally, monochromatic pen-and-ink plans, colored inks and watercolor washes were introduced into their work in the 1830s and at about the same time, some village views started to become more pictorial, showing a built environment. Unlike the work of most Shaker artisans, which remain anonymous, village view drawings are often signed and dated. Joshua Bussell, for example, is known for his renderings of Maine and New Hampshire communities, particularly Alfred, Maine.

Another category of graphic Shaker art is the group of religious pictures known as gift drawings. Explains Sharon Duane Koomler, curator of collections at Hancock Shaker Village in Pittsfield, Massachusetts, "During the mid-nineteenth century members of the United Society of Believers in Christ's Second Appearing, more commonly known as Shakers, experienced an intense, internal religious revival. They received a great outpouring of spiritual 'gifts,' including music, songs, poetry, prose, and drawings. The most unique, perhaps, were the 'gift drawings.' Thousands of songs were recorded in manuscripts and shared between communities. The drawings, however, were fewer in number and usually kept in the village of their origin. The drawings are reminiscent of the vernacular design seen in nineteenth-century painted textiles, needlework, frakturs, and Masonic art. They include worldly and spiritual images of trees, bowers, furniture, doves, crowns, and angels." While maps and village views are attributed to Shaker brethren (often teachers), the gift drawings are believed to be the work of Shaker sisters.

Whether motivated by religious beliefs, artistic expression, or practical need, the vast variety of known and unknown artists who created village views and townscapes, signboards, sandpaper paintings, and house portraits have blessed us with a rich visual legacy of an expanding country and an emerging democracy.

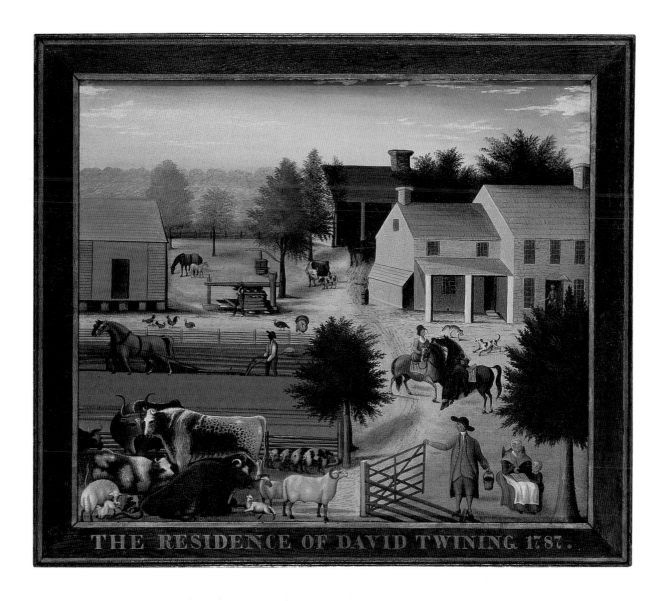

THE RESIDENCE OF DAVID TWINING. 1787.

THE RESIDENCE OF DAVID
TWINING, 1787, c. 1846–47
Edward Hicks; Bucks County,
Pennsylvania
Oil on canvas, 16½ x 31⁹⁄₁₆ in.
Collection of the Abby Aldrich
Rockefeller Folk Art Museum,
Williamsburg, Virginia
(Detail shown on page 66)

Although the date 1787 appears on the frame, Hicks actually painted this scene sixty years later. His Twining Farm paintings are memory pictures of life as Hicks chose to remember it during his childhood years spent with David Twining and his family in Bucks County, Pennsylvania.

Family members portrayed include David Twining, in typical Quaker clothing, standing with his hand on the gate and his wife, Elizabeth, who, somewhat incongruously, has decided to place her ladder-back chair in the middle of the lawn, and in broad sunlight, to read her Bible. The boy standing by her side represents Edward Hicks. One of the Twinings' four daughters, Mary, is shown on horseback, and mounting the horse beside her is her husband-to-be, David Leedom. At the plow is

Caesar, a black freeman who worked for the family, and the woman in the doorway is the Twinings' youngest daughter, Beulah.

As Hicks authority Carolyn Weekley, director of museums at Colonial Williamsburg, points out, "The buildings in the Twining Farm paintings are closer to the viewer and not spread out on an enormous landscape as is the case with Hicks's other farmscapes such as Leedom Farm. And not only are there numerous buildings, but there are people—ploughing fields and going in and out of the buildings—involved in everyday life activities." She adds, "In these farmscape studies, Hicks portrays everything in a pristine, idyllic way. The orderliness is most interesting. In this Twining Farm painting, even the pigs are arranged in graduated sizes."

GEORGE WASHINGTON, c. 1810

Artist unknown; southeastern Pennsylvania
Gouache, watercolor, and ink on paper, 8 x 9 3/4 in.
Collection of the Museum of American Folk Art, New York;
Promised anonymous gift

After the 1799 death of George Washington, likenesses of him appeared on all manner of prints (many produced in England for the American market), paintings, and souvenirs. Our first president and his home, Mount Vernon, were favorite subjects for artists in all mediums. This frakturlike watercolor features a cityscape behind the central figure. The German inscription at the top translates as "General Washington and the city built in his name." Presumably the city in mind was Washington, D.C. However, some scholars think that the artist may have relied on familiar Pennsylvania buildings to create his skyline, since the tall building (left) with the words "Con Gress House" bears a resemblance to Philadelphia's Independence Hall, where Congress met from 1790–1800. An unusual touch, especially for fraktur artists whose religious beliefs scorned any unnecessary embellishment, is that there are gold sparkles used on the epaulets, buttons, and the buckle on the hat.

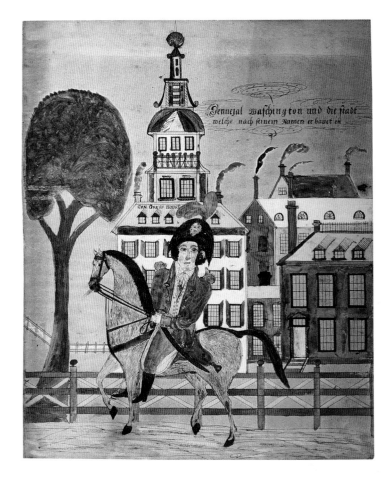

73

VILLAGE DRAWING, c. 1840

Artist unknown; Montgomery County, Pennsylvania
Watercolor on wove paper, 10 x 8 in.
Collection of the Schwenkfelder Library and Heritage Center,
Pennsburg, Pennsylvania

The Schwenkfelders emigrated to southeastern Pennsylvania in the 1730s. Many of them collected engravings that depicted the German towns of their homeland. Their nineteenth-century German-American relatives reflect this affinity for architectural images and portray their Pennsylvania communities in village drawings with layers of brightly-colored, multistoried houses. Childlike in its execution, this watercolor—complete with a variety of trees and shrubs and a front yard full of fancifully drawn birds—is a good example. Several different styles of domestic dwellings are represented; window shapes and a bell tower on the building in the foreground indicate a church.

A handwritten note on the back of this piece reads "Anna Kriebel's vendue." Although this painting bears a resemblance to Phebe Kriebel's embroidered townscape on page 16, genealogical records show that the two were not related.

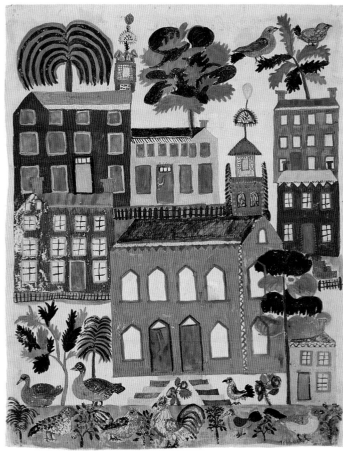

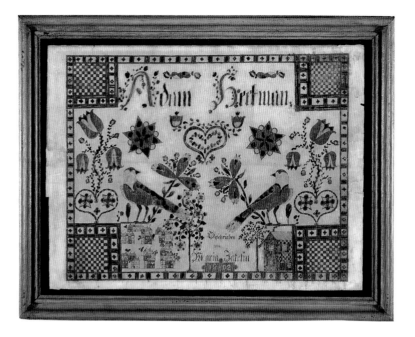

FRAKTUR FOR ADAM HECKMAN,
Signed and Dated 1802
Maria Jakelin; Pennsylvania
Watercolor and ink on wove paper, 13 x 16 in.
Photo courtesy David Wheatcroft Antiques

Star shapes enclosed within hearts, such as the ones shown here, and the use of a checkerboard motif is characteristic of Schwenkfelder frakturs of this period.

However this Schwenkfelder fraktur is a rare example for several reasons: the unusual use of the checkerboard motif as corner blocks, the multiple house images, and the fact that it is the only known fraktur by this person.

As with Schwenkfelder townscapes (page 73), the colorful houses at the bottom left are depicted in a layered format. The fanciful house at right, with multipaned windows, cutout shutters, and a fanlight above the front door, is decorated with a variety of checkerboard designs.

Rather than a birth or marriage certificate, this is a presentation piece given to Adam Heckman and "Written [translated from the German] by Maria Jakelin" perhaps to recognize a birthday, Christmas, or other cause for celebration. As a rule presentation pieces are considerably smaller, which is another reason why this fraktur is unique.

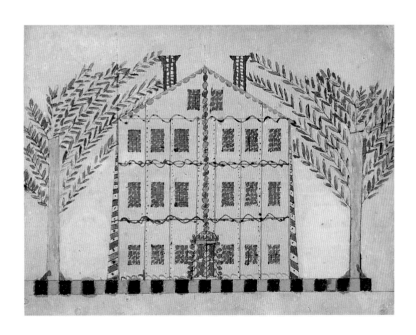

FRAKTUR, c. 1830
Artist unknown; southeastern Pennsylvania
Watercolor and ink on wove paper, 8 x 9 ½ in.
Photo courtesy David Wheatcroft Antiques

As we have seen with the buildings on the Schwenkfelder presentation piece (above), the few houses found on frakturs are rendered as abstract dwellings rather than realistic structures.

Stylistic elements used to paint this charming three-and-a-half-story house include barber-pole-style supports at either side and a black-and-yellow checkerboard walk along the front. Dots and dashes decorate the building's surface: a red and yellow string-of-beads design is drawn straight up the middle and then extends, in yellow only, along the gables of the roof.

Fine red lines and black running-stitch-like dashes divide the windowed areas and brick chimneys are delineated with crisscross markings. A pair of yellow-trunk trees protectively flank the house and leaflike shapes frame the doorway.

HOUSE AND GARDEN DRAWING, Dated 1818

Attributed to Susanna Heebner;
Montgomery County, Pennsylvania
Watercolor and ink on laid paper,
12 1/2 x 7 3/4 in.
Collection of the Schwenkfelder
Library and Heritage Center,
Pennsburg, Pennsylvania

This is one of a series of house and garden drawings believed to be the work of the Schwenkfelder fraktur artist Susanna Heebner (1750–1818). An unmarried daughter of Hans Christopher Heebner, Susanna made this drawing during the last year of her life for her nephew Abraham Heebner. His initials are elaborately formed at the top sides of the piece. Eighteenth-century homes of these German-American settlers were built with one central chimney for the kitchen fireplace, whereas this two-story, two-chimneyed brick house is characteristic of their nineteenth-century dwellings, many of which still exist. This house and garden motif, with a fence-enclosed six-bed garden, is peculiar to Schwenkfelder folk art. In their hymns, Jesus is referred to as a garden or a flower in a garden, and many historians believe that this representation of flower gardens is symbolic of Christ. Susanna is known for working with brilliant colors and for including spiritual signs in her pictures. An almost identical house and garden image, with calligraphy, appears on a "House Blessing" fraktur of the same period.

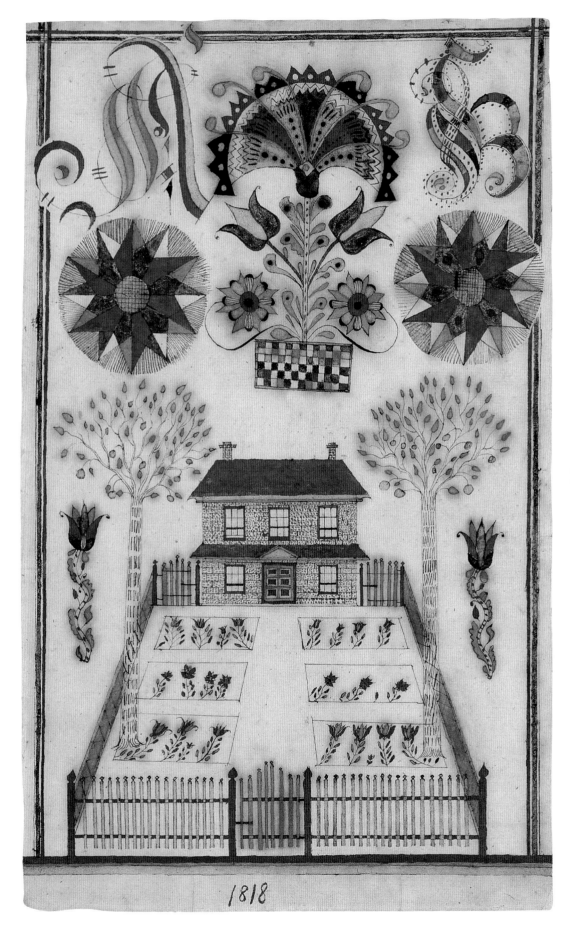

View of the Berks — County — Almshouse. 1881.
Directors: Francis Roland, John H. Bower, Elias Obold.
Steward: Benj. Anderson. Under Steward: G. E. Wisner.
Insane Hospital Steward: James W. Sallade. Clerk: J. B. Knorr.

VIEW OF THE BERKS
COUNTY ALMSHOUSE,
Dated 1881

John Rasmussen; Pennsylvania
Oil on zinc, 39 x 46 in. framed
Collection New York State
 Historical Association,
 Cooperstown, New York;
 Photo by Richard Walker

Three different artists are identified with their paintings of the Berks County Almshouse in Pennsylvania: Charles Hofmann, John Rasmussen, and Louis Mader. Hofmann and Rasmussen died there and were buried on the property.

Hofmann was the first of them to paint views of Berks County. His most successful view was painted in 1878–1879; in it he framed the complex within an oval, surrounded it with a decorative ribbon, added the State Seal of Pennsylvania at the top, and divided up the corners to showcase individual areas.

A house painter by trade, Rasmussen was at the almshouse during the last few years of Hofmann's life and this work is closely based on Hofmann's

painting. Working on zinc- or tin-coated sheet iron, the artists were able to execute very fine details and their paintings provide a precise visual record of the institutional architecture of the time.

The main building at Berks was completed in 1825; the "insane building" followed about fifteen years later, and then came the "hospital" about 1871–74. By all accounts these places were far from cheerful, yet all of the paintings portray a sunny, lively, immaculate scene. They depict bold-colored buildings (many were brick with ornate wood trim), flowers in bloom, well-tended gardens ripe with produce, even the arrival of a bakery wagon. People are busily engaged in outdoor activities.

ALMSHOUSE AND INSANE
HOSPITAL, c. 1840
"G.F."; possibly Baltimore County,
Maryland
Watercolor on paper, 22 x 28 in.
Private collection; Photo courtesy
David A. Schorsch American
Antiques, Inc.

A number of almshouses have been memorialized in paint, usually by someone who was a resident there, as seen in Rasmussen's view of Berks County (page 76). It is interesting to compare this almshouse work to Rasmussen's realistic architectural renderings, which convey a more positive attitude and include a flurry of activity.

This artist, unknown except for the initials "G.F.," portrays the buildings as if they were cardboard cutouts in an architect's model. All of the structures are drawn in great detail and significant ones—"the alms house," "smllpox [*sic*] hospital," and "insane hospital"—are neatly labeled. The unusual perspective extends even to the trees and the pump at the almshouse, which are painted flat against the building rather than as freestanding objects.

There is a sense of imprisonment and hopelessness: an intricate brick wall surrounds the entire property, all fences and gates are closed, doors are shut and even bolted, the steps outside the almshouse and insane hospital do not reach the street. The only sign of life is a bird perched atop the gazebo, unless, of course, it is a weathervane.

The stylized trees and shrubs are similar to those found in needlework pictures of the same period. That thought, combined with the choice of pastel colors, suggests that the artist G.F. might have been a woman.

East View of the Brick House, Church Family Hancock

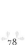

EAST VIEW OF THE BRICK
HOUSE, CHURCH FAMILY,
HANCOCK, c. 1870

Artist unknown; Massachusetts

Watercolor and ink on paper,

11 1/2 x 14 in.

Collection of Hancock Shaker Village,

Pittsfield, Massachusetts

Drawn from the vantage point of the front porch of the trustee's office, this Shaker village view documents a row of shop buildings between the 1830 brick dwelling (center) and the trustee's office. Shop uses varied over time, but included here are the Brethren's and Sisters' Shops, the Tan House, and the Hired Men's Shop, all of which were used by Shakers who lived in the brick dwelling. The view remains pretty much the same today although some of the buildings no longer exist.

Form and placement of a building were determined by its purpose and followed the Shaker concept of orderliness. There is little ornamentation on the buildings, which reflect the building traditions of the region. Guidelines in the 1821 Millennial Laws dictate colors for buildings both inside and out. Meetinghouses, the focal point of the Society, should be painted white. Variants to these laws occurred over time but most meetinghouses remained white. The people depicted in this drawing are in mid- to late-nineteenth-century clothing. Two Sisters ride in the carriage and a third stands near the Hired Men's Shop. One Brother drives the carriage, one rides inside, one stands in the doorway, and another seems to be en route to the trustee's office.

Residence of Lemuel Cooper Plain Wis. By P. A. Seifert 1879

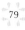

RESIDENCE OF LEMUEL COOPER, Dated 1879

Paul A. Seifert; Wisconsin

Watercolor, oil, and tempera on paper,
21⅞ x 28 in.

Collection of the Museum of American
Folk Art, New York

Museum of American Folk Art purchase

This is an excellent example of one of the exquisitely rendered Wisconsin farm scenes painted by Paul Seifert from the late 1870s to about 1915. An interesting aspect of Seifert's watercolors is that he often worked on colored papers, a practice that affects the dominant tones of the overall painting.

Lemuel Cooper's property appears to stretch as far as the eye can see, with numerous ploughed fields, miles of fencing, several roads, extensive outbuildings, fenced-in cattle and pigs, haystacks, a carefully tended garden, shrubbery, and hills in the distance. One wonders where Seifert could have set up his easel in order to achieve this view.

There is a great deal of attention to detail in the buildings, from the log cabin structures at left to the stone-foundation wooden barn complete with hinged doors and lightening rods, to the curtained and shaded windows in the house. The only area that looks a little sketchy is the pathway leading from the main house to the gate.

This same meticulous approach can also be found in the people and animals presented. Note, for example, the harnesses on the horses, the wheels on the plough and on the wagon, the horns on the bulls, and the man in the foreground shooting a bird and accompanied by a spotted hunting dog.

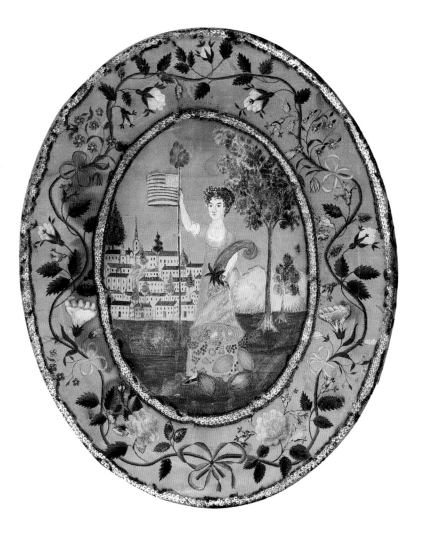

LIBERTY, c. 1809

Artist unknown; South Hadley, Massachusetts
Watercolor on silk with purl and spangles, 16 3/8 x 13 1/4 in.
Collection of the National Museum of American History, Smithsonian
Institution; Gift of Eleanor and Mabel Van Alstyne

This picture of Liberty, wearing an Empire-style dress and hairdo, is typical of studies made to celebrate America's independence. Most combine embroidery with painting. This one, however, is worked entirely in watercolor. In her right hand, Liberty is holding a staff on which flies the American flag with eighteen stripes and sixteen stars. The hatlike object on top of the flag staff is thought to be a "liberty cap." Borrowed from the Roman tradition of awarding a similar cap to freed slaves, the liberty cap became a symbol to the English after their civil war and the custom was adopted by Americans during the Revolutionary War period. In some of these schoolgirl paintings, Liberty is holding a banner that reads "I Am Free."

In her left hand Liberty holds a cornucopia encircled with a cluster of laurel leaves; on this piece the upended cornucopia brims with pears, cherries, grapes, apples, peaches, and melons, symbolizing prosperity for America, the land of plenty.

This oval pictorial was painted by a student at Abby Wright's school in South Hadley, Massachusetts. The cluster of buildings to the left depict the town of South Hadley, with a number of houses as well as several churches.

The background at right, with clouds and mountains in the distance, symbolizes the vastness of America.

Opposite:

PASSING TRAINS, c. 1870

Artist unknown; origin unknown
Oil on canvas, 33 1/2 x 26 in.
Collection of David Wheatcroft

These days, not many people would choose to live too close to the railroad tracks, but at the end of the nineteenth century a location such as the one shown here was considered a status symbol. Rural homeowners wanted house portraits to emphasize and even exaggerate their proximity to modern technology. Not only was it a convenience for visitors, it allowed them to be among the first to receive mail and freight, was believed to increase land values, and generally linked them culturally to large, important cities. County atlas illustrations from this period depict a number of impressive residences, such as this nine-bay house, situated very close to the train lines. And here we have two steam engines passing each other, which infers an important route indeed!

The lighting in this painting is a typical folk art dichotomy. While the sky in the background is darkened and the sun appears to be setting, the front of the picture is shown in full sunlight as if at noon.

The artist has painstakingly drawn the picket fence on the gated garden and the wrought-iron fencing beside the tracks in relatively accurate perspective, whereas the train tracks appear to be almost vertical. The horse-drawn cart and the horse-shaped weathervane atop the barn cupola stand in contrast to the "iron horses," one car with the words *West Shore* chugging down the tracks.

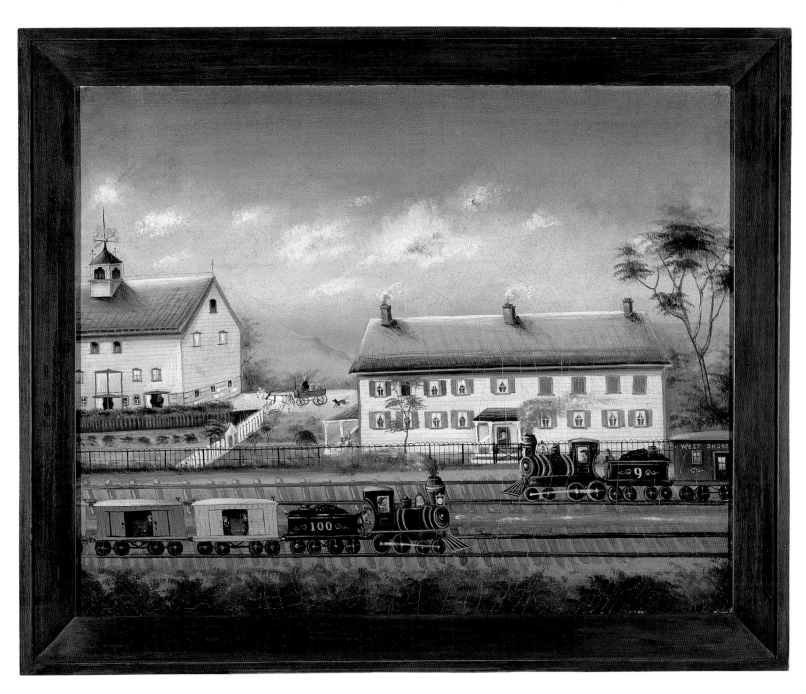

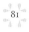

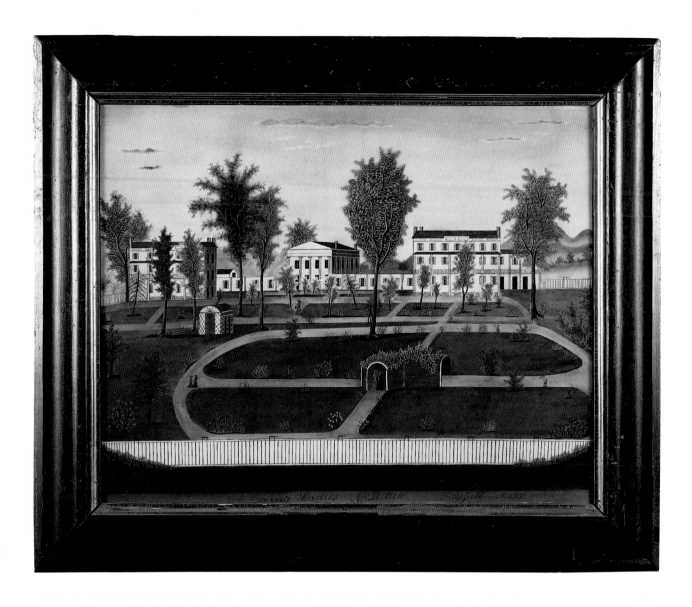

YOUNG LADIES
INSTITUTE, PITTSFIELD,
MASSACHUSETTS,
c. 1846–54

Artist unknown; Pittsfield,
Massachusetts
Charcoal and chalk on prepared bristol
board, 18 x 22 3/4 in.
Collection of the New York State
Historical Association,
Cooperstown, New York;
Photo by Richard Walker

According to an 1876 book on the history of Pittsfield, Massachusetts, the Pittsfield Young Ladies' Institute was established by Rev. Wellington Hart Tyler in the fall of 1841.[4] When Mr. Tyler arrived in Pittsfield, his credit rating was so low that he was denied credit for a barrel of flour. Nevertheless, he managed to rent buildings for a school and by 1845 he purchased seven and a quarter acres of property for nine thousand dollars. Soon after, he built a brick chapel and the classic buildings shown here.

The two-story gymnasium, an eighteenth-century converted Congregational church-meetinghouse designed by Charles Bulfinch, was moved to the school grounds in 1851. Architectural drawings of the original church bear a resemblance to the two-story edifice shown in the center, but this one is

missing the belfry and there are discrepancies in the window placement, perhaps as a result of the remodeling process. Concerts and exhibitions of students' work were held in the chapel and in the gymnasium. It is likely that artwork on display included sandpaper paintings such as this one of the school and grounds. These "sandpaper" or marble-dust paintings were achieved by coating paper or board with marble chips and then drawing on the roughened surface with charcoal and chalk. Not only is the school's name written in script, along the lower margin of this piece, but a paper label on the back identifies the source of the bristol board as "S. WOOD Jr's/ Monochromatic Boards,/for sale, wholesale and retail, by EAYRS & FAIRBANKS,/136 Washington Street,/Boston, Mass."

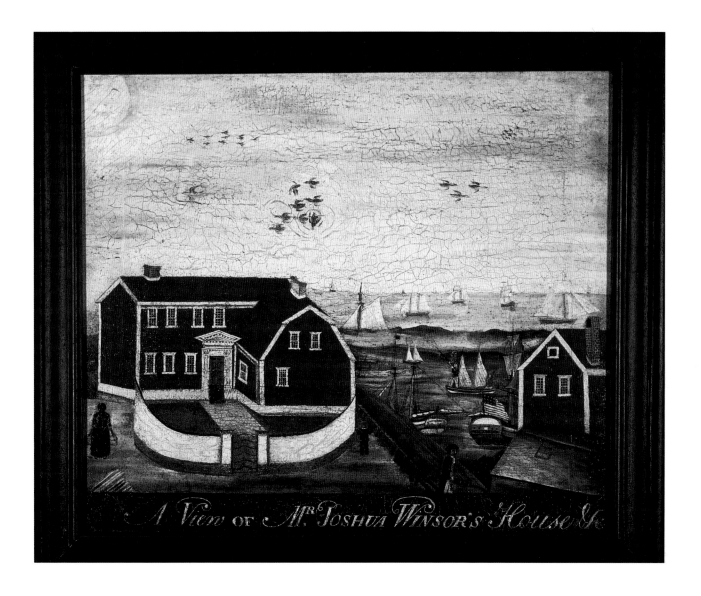

A View of Mr. Joshua Winsor's House &c.

A VIEW OF MR. JOSHUA WINSOR'S HOUSE & c., 1795

Rufus Hathaway; Duxbury, Massachusetts

Oil on canvas, original black molded frame, 23¼ x 27½ in.

Collection of the Museum of American Folk Art, New York

Promised anonymous gift

One of the most acclaimed portrait artists of his time, Rufus Hathaway painted at least one landscape; this house portrait of the residence of his father-in-law, Joshua Winsor. Hathaway's picture shows not only Winsor's home but also his wharves, boats, and fish storage buildings as evidence of his significant stature in the commercial fishing industry. The gambrel-roofed cape, its side facing the viewer, was the original house; the newer Federal structure, with its elegant front door, was added at the back. Merchants' houses of that period and locale were usually enclosed by a white picket fence and it's likely that Hathaway took a little artistic license by painting a less time-consuming solid white enclosure. In Hathaway's portraits, the men tend to face left and hold some object relative to their business interests. Here the man holding a bunch of keys in the foreground is thought to be Winsor. The men in the boat are not as important or as well defined. Hathaway came from a family that worked in carpentry and shipbuilding trades and he was also skilled at wood carving and made many of his own frames; the black painted frame shown here is original to the painting. After his marriage, probably the same year as this picture was completed, Hathaway felt obliged to pursue a more lucrative profession and he limited his painting to part-time, studied medicine, and devoted his life to being a country doctor. Winsor's impressive red house, built in 1768, was destroyed by fire in 1886.

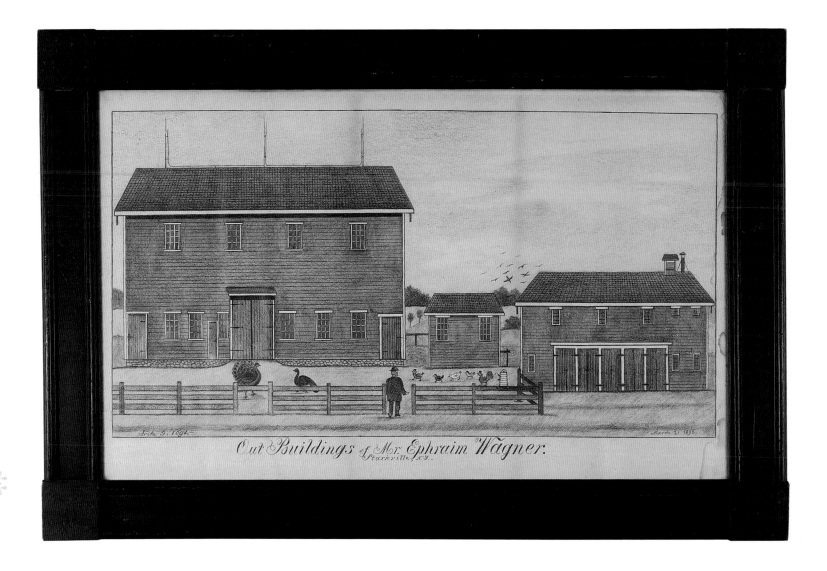

Out Buildings of Mr. Ephraim Wagner.
Starkville, N.Y.

OUT BUILDINGS OF MR. EPHRAIM WAGNER,

Dated March 21, 1896

Fritz G. Vogt; Starkville, New York

Graphite and colored pencils on paper,

17 x 27½ in.

Collection of Frank Tosto

As a rule, Vogt dated his works in the lower left-hand corner and signed them in the lower right-hand corner, with the name of the property owner centered and written in florid script. This piece is an exception—Vogt's signature appears on the left.

This drawing is an unusual example of Vogt's work for other reasons as well. The buildings are portrayed as flat, one-dimensional images. There are no side views or extensions of any kind. Instead, Vogt focuses on an interplay of linear graphics in the directional woodwork of the building surfaces, the doors and hardware, even the lightning rods on the barn roof.

Missing are his usual stylized trees in the foreground, although two very small ones can be seen in the distance between the buildings, perhaps not surprising since farmland is generally cleared land.

Signs of a sense of humor and subtle unexplained details surface in some of Vogt's drawings. In this case, a man stands where the gate should be but there is no gate to keep the barnyard fowl in place. Curiously, the man is walking toward the chickens and yet he is already holding a single egg in his hand. Also, in the yard near an open section of fence is an unlikely pair of peacocks. And as is the case with a number of Vogt's drawings, a flock of birds is flying overhead.

One might think that Vogt would have delighted in drawing intricate feather patterns on the rooster and chickens but, in fact, they are almost childlike in their outlined simplicity.

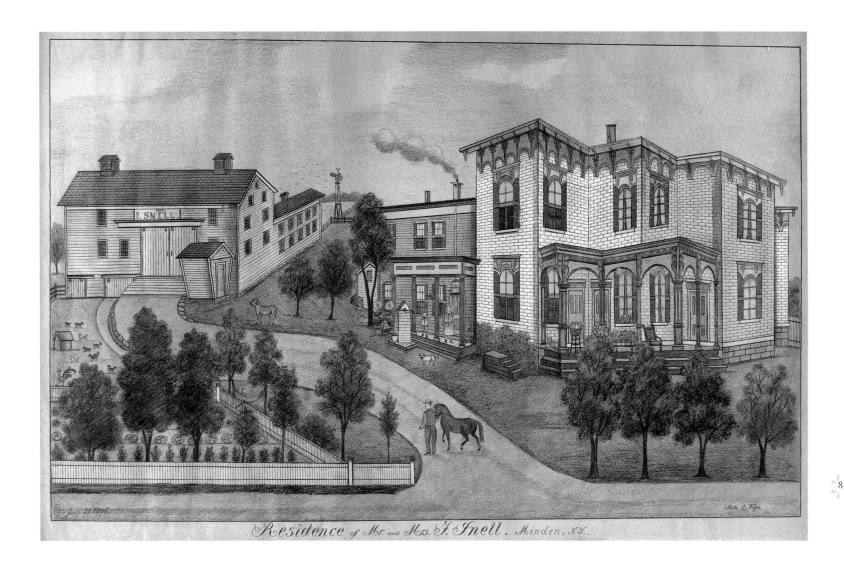

Residence of Mr. and Mrs. F. Snell. Minden, N.Y.

RESIDENCE OF
MR. AND MRS. F. SNELL,
Dated July 31, 1896
Fritz G. Vogt; Minden, New York
Graphite and colored pencils on paper,
28 x 40 in.
Collection of Frank Tosto

It has been established that, on some occasions, Fritz Vogt made more than one drawing of the same scene, often within days of each other. That is the case with this one; an almost identical copy of the Snell residence, dated a week later (August 4, 1896) is in the collection of the Abby Aldrich Rockefeller Folk Art Center at Colonial Williamsburg.

This drawing identifies the residence as belonging to Mr. and Mrs. F. Snell, whereas the later one says Mr. and Mrs. I. Snell, which matches up with the name on the barn sign. In the July version, shown here, the building at the right is painted two colors, white and brick color; the boards between the steps are blue. In the August version, this house is all one color (similar to the barn) and the color in the stairs is the same green as the shutters. Other subtle differences include the

addition of stripes to the dog near the barn and a variation in the shape of one of the trees.

The animals and people remain the same and include a mother and her son, on the porch, presumably waiting to meet the man coming up the walk with a horse. Another boy is shown near a hammock at left. Did Vogt make a mistake and need to redo the drawing? This is unlikely, since pencil errors can easily be corrected. Perhaps another member of the Snell family shared the property and wanted their own picture, or the second one was a gift to a relative who had moved away.

Practical signs of everyday life can be found in Vogt's work. Many drawings have wells in them and this one also boasts a water windmill with a weathervane. Once again, he has included a group of chickens—this time with their own house.

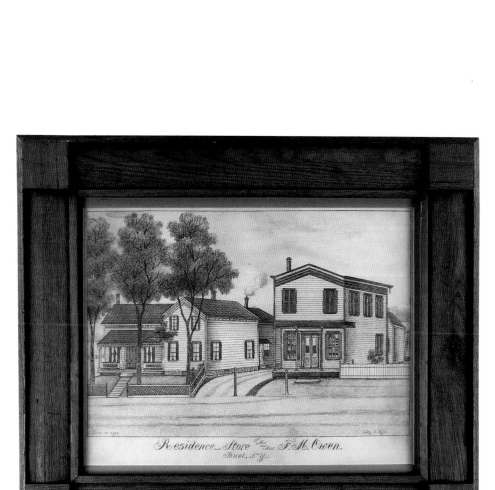

OSWEGO STARCH FACTORY,
Possibly c. 1877
Artist unknown; signed "AJH/77"; Oswego, New York
Watercolor, pen and ink on wove paper, 36 ⅛ x 53 ¼ in.
Collection of the Museum of American Folk Art, New York
Museum of American Folk Art purchase

This wonderful bird's-eye-view watercolor of the Kingsford family's corn starch factory in Oswego, New York, depicts and labels all the buildings in the complex. In addition to the main factory building at left there is the "Barrel Factory" and the "Box Factory." This factory portrait is one of the slice-of-life vignettes that were so popular in America after the Civil War. Smokestacks are billowing black smoke and a number of industrious figures are going about their daily work: transporting goods from building to building by hand, in horse-drawn carts, over bridges, and even on a small train. Boats are on the river and a horse and carriage at upper right is headed into town. This painting would have been displayed in a place of honor, probably Mr. Kingsford's office or a board room.

RESIDENCE AND STORE OF MR. AND MRS. F. M. OWEN, Dated Dec. 18, 1894
Fritz G. Vogt; Buel, New York
Graphite and colored pencils on paper, 17 x 23 in.
Collection of Frank Tosto

The year, 1894, is when Vogt began to introduce color into his work and this example illustrates both his black-and-white style and his use of colored pencils. Even when using color, Vogt chose to limit his palette to muted tones, which makes the bright yellow seen in the window shades of the house and the eaves of the store roof a little surprising.

Dated just a week before Christmas, Vogt's trees remain in full leaf even in this winter month.

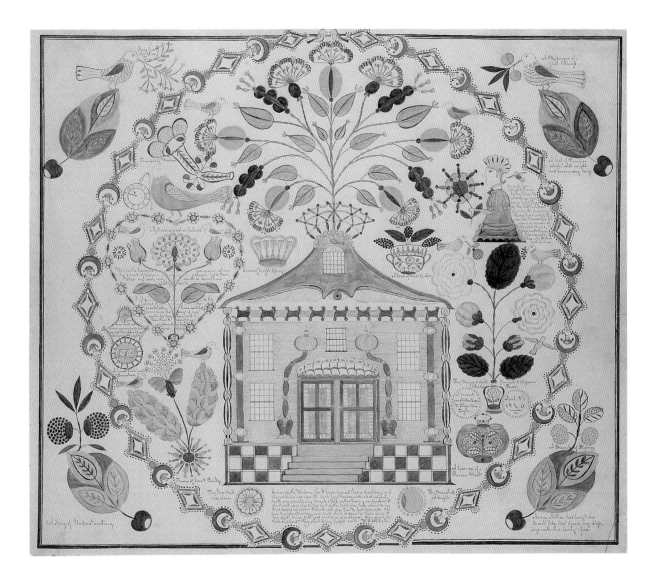

A PRESENT FROM MOTHER LUCY TO ELIZA ANN TAYLOR, Dated 1849

Polly Jane Reed; Mount Lebanon, New York

Watercolor and ink on paper, 14 x 16 3/8 in.

Miller Collection, Hancock Shaker Village, Pittsfield, Massachusetts

Shaker gift drawings were religiously inspired works of art, rarely displayed but rather viewed in private. Messages from the spirit world were neatly penned inspirational text, sometimes embellished with pictures. This example was drawn by Polly Jane Reed, who, according to Shaker beliefs, received a spirit message to create this work. The symmetrical balance of the design, characteristic of many of these drawings, is evident in the depiction of the house; there are two doors, two windows on each side, and two vertical center windows. The house motif illustrates the first lines of the message written beneath it: "Come saith Wisdom, for I have formed thee a dwelling. . . ." This is an exceptional piece, with so many individual messages and motifs contained within it. Note, for example, the bird in the upper right-hand corner, "A messenger of glad tidings"; the angel, "Go forth thou angel"; and the leaf, "A leaf of promise which will unfold."

This house portrait is noteworthy not for what it tells us about the house but for what it tells us about the artist, who seems more at home with landscape painting and more intent on portraying the leaves and branches on the trees than the shingles or shutters on the house.

The house and outbuildings and the post-and-rail fencing are relatively accurate in terms of scale, but it is the artist's perspective with figures that deserves attention. Note the man on horseback, who is minuscule in contrast to the gate he is crossing. The little girl walking her dog is so tiny that she is practically lost to sight and the women at each end of the picture are barely as tall as the fence. This is a prime example of a folk artist injecting people and animals into a scene without concern for their relation to the things around them.

Opposite:
HOUSE IN
YARMOUTHPORT,
C. 1800
Artist unknown; Massachusetts
Oil on canvas, 17¼ x 25⅛ in.
Photo courtesy Christie's Images
© 2000

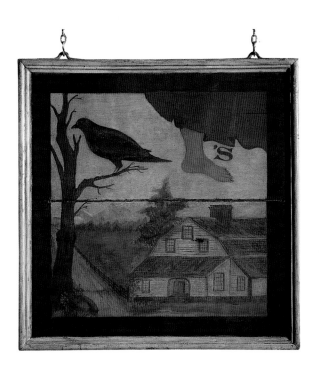

CROFUT'S INN
SIGNBOARD, c. 1892
Artist unknown; southwestern
Connecticut
Oil on pine board, 37¾ x 37¾ in.
Collection of the Connecticut
Historical Society, Hartford,
Connecticut

This two-sided sign hung outside the Oxford, Connecticut, inn of George E. Crofut and possibly even before that at a boarding house run by his father, in Middlebury, Connecticut.

The goal of this type of sign was to picture objects that revealed at a glance the type of services available, a practice of particular advantage to customers who were not able to read. Humor and puzzles became popular and memorable. This innkeeper chose a rebus to spell out his name phonetically. There is a crow on a tree branch, a lady's foot peeking out from under the hem of her dress, followed by an apostrophe and the letter *s*, and finally there is the inn itself—and just to be certain that the building's use could not be misinterpreted, the word *inn* is painted in large red letters on the roof, all adding up to Crofut's Inn (Crow-Foot's-Inn).

HOUSE PORTRAIT,
c. 1880–1920
Artist unknown; New York
Watercolor on paper, 22¼ x 30¼ in.
Photo courtesy Olde Hope Antiques,
New Hope, Pennsylvania

This cozy scene all but cries out for the caption "There's no place like home." As is the case with many house portraits, the builder, the homeowner, and the artist remain unknown. However, several other works by this same hand have been discovered in recent years. Paintings by this apparently itinerant artist have been found in upstate New York, lower Canada, western Maine, and parts of New England. Recognizable characteristics shared with one from Westernville, New York, include the same shape and style of shortened buildings. Each has a two-chimney main house with basically the same roof treatment presented from the same view;

doors and windows vary slightly, as does the color of the house itself. In this painting, the house seems to be constructed with vertical barnsiding.

Both paintings share an intricate pattern of fencing; this one is a white rail fence (inset with wire) and the Westernville one is stylized wrought iron. Most distinctive of all is the stippling technique used to create the grass and bushes. In each case the landscaping is relieved with one or more clumps of flowers incorporating a red-orange color as well as another object of the same color. This one features a swing set out on the front lawn and the other painting shows a water pump.

WINTER SCENE IN
BROOKLYN, c. 1817–20
Francis Guy; Brooklyn, New York
Oil on canvas, 58 ¼ x 75 in.
Collection of the Brooklyn Museum
of Art, Brooklyn, New York
Gift of the Brooklyn Institute of Arts
and Sciences

Francis Guy sailed to New York from England in
1795, and in 1797–98 he relocated to Baltimore.
Shortly after a fire destroyed his silk dyeing busi-
ness in 1799, Guy devoted himself to painting.

This street scene (the original on which there
would be later renditions) was enthusiastically
reviewed in the June 1, 1820, issue of the Washington
Gazette: "It is a winter snow scene, taken from Guy's
paint room window in Front Street, Brooklyn. . . .
The painter has a view upon three different streets,
not two buildings to be seen alike, either in size, shape
or color, and the stables, barn and old back buildings
of Mr. Titus stand well contrasted with the handsome
buildings of Mssrs. Sands, Graham, Birdsall & c."[5]

The large, light-colored building at front right
is the home and store of Thos. A. Birdsall. The

darker brown building behind it with the deeply
sloping snow-covered roof is Mr. Titus's house and
his brown barn is directly across the street. The
buildings and most of the people portrayed have
been identified, including Mr. Birdsall and Mr.
Titus. Critics were especially impressed with Guy's
ability to work with so many white subjects such as
the snow, the sky, the clouds, and even the smoke
rising from the chimneys and to add just enough
tints and shadows for definition.

"Despite the ravages of time, damage by fire
and reduction in size, the Brooklyn Snow Piece
remains as one of the great monumental works
of early nineteenth century American landscape
painting," proclaims Guy historian, Stiles
Tuttle Colwill.

POLITICAL PIN, c. 1840
Artist unknown; New England
Watercolor on ivory, ink inscription,
3/4 x 5/8 in.
Collection of the Museum of American
Folk Art, New York
Museum of American Folk Art purchase

The same artists who painted full-size portraits and landscapes often painted miniatures as well. These small works of art, painted on paper or ivory and usually worn in lockets or pins, were fashionable from the mid-eighteenth until the mid-nineteenth century, when they were replaced by daguerreotypes. Some miniatures were used to commemorate special events and to support political candidates. This brass-framed political pin inscribed "Harrison and Reform" is a souvenir from the 1840 election of William Henry Harrison and depicts the symbols of his "Log Cabin and Cider Barrel" campaign slogan. Harrison is portrayed as "The Ohio Farmer" greeting a disabled comrade in arms. Some quilt scholars credit this log cabin image as a source for the popular house and cabin designs found in quilts.

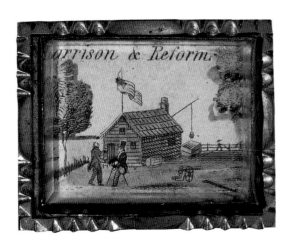

Opposite:
POESTENKILL, N.Y.,
Dated "May the 10, 1862"
Joseph H. Hidley; Poestenkill,
New York
Oil on wood panel, 19 x 31¼ in.
Collection of the New York State
Historical Association,
Cooperstown, New York;
Photo by Richard Walker

Joseph Henry Hidley is recognized for his finely detailed portraits of rural life in upstate New York. He painted some of the same scenes—Poestenkill, for example, over a span of twenty years.

Hidley's maplike townscapes are so precise that one can follow the growth of the community: new homes and businesses and even subtle changes to existing buildings such as the addition of a front porch, a spire on a church, or a new color of exterior paint. To highlight these points, buildings are rotated to display more than one facade with doors and windows delineated. Townspeople and farmers are seen in the midst of small-town daily activities. Clothing and other details such as wagonloads vary according to the season.

This particular springtime painting, the first of the series, shows the town from the east view and is painted from a relatively natural point of elevation, Snake Hill. In later versions, the viewer looks directly into the center of town and the vantage point is more elevated. A few buildings such as the Poestenkill Union Academy (far left with belltower) and the Eagle Hotel (white building, far right) still stand today.

The ingenuity of early Americans is particularly evident in the way that even the most utilitarian household objects were often decorated by gifted or industrious craftsmen. Everyday items, now highly valued as folk art, reveal the material culture of the time and the individuality of the homeowner. ❋ "The engaging charm of folk art objects is irresistible," relates Gerard Wertkin, director of the Museum of American Folk Art in New York City. "Whether inspired by utility or by themes of religion, patriotism, daily life or ethnic heritage, self-taught artists followed their impulses to embellish practical items, create whimsical new ones, or express deeply felt ideas and emotions." ❋ Jean Burks, curator of decorative arts at the Shelburne Museum in Shelburne, Vermont, explains, "Architectural images are represented on decorative and folk art such as wall murals, furniture, ceramics, and even toys. The building structures are depicted in varying degrees of accuracy; they include generic log homes and New England farmhouses as well as identifiable grand public buildings such as the White House and Independence Hall, and recognizable symbols of American industry like the famous Flatiron and Woolworth buildings in New York City." Architectural images frequently ornamented the

chapter four

FURNISHINGS
& ACCESSORIES

decor, furnishings, and the accessories of many American homes. Miniature dwellings were created to house dolls, birds, and other pets, to safeguard money, or to simply adorn a cupboard shelf. In general, these household items can be divided into two categories: decorated surfaces and building-shaped objects. ❋ DECORATED SURFACES ❋ A sense of pride in home and place was illustrated on a variety of painted surfaces from walls and floors to overmantels and fireboards, furniture, window shades, clock faces (and sometimes cases), blanket chests and trinket boxes, looking-glass panels, game boards, pottery, and picture frames. Even leather fire buckets, required for homeowners and firefighters, did not escape the artist's paintbrush. After being used to fight fires, buckets were reclaimed by the lettering and scenes painted on them—such as the owner's house. ❋ Portrayed on these many surfaces were familiar landmarks, houses of worship, government buildings, allegorical and mythological architecture, or perhaps a picture of the residence in which these belongings were used. A visual history gleaned from details of interiors seen in period portraits shows us that homes were not as somber as might be expected. In fact, bold patterns and bright colors were commonplace.

WALLS AND FLOORS

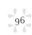

Eighteenth-century walls, floors, baseboards, and wainscoting were painted in shades of pumpkin, blue, red, yellow, rose, or green. Light-tinted plaster walls were adorned with stenciled borders and/or overall stencil designs. Faux finishes were favored: mottling simulated marble, graining mimicked rare woods such as mahogany, oak, rosewood, and bird's-eye maple. After the Revolution, wallpapers imported from France and England influenced design choices for decorating walls. Few rural households could afford this fashionable city luxury, but designs painted directly on plaster walls were an affordable and popular substitute and scenic vistas were frescoed in freehand. Wall spaces, divided into sections, encompassed a variety of painting techniques often featuring landscapes bordered or accented by stencilwork and/or faux painting.

The rage for interior painted walls flourished in New England farmhouses and spread to surrounding areas settled by New Englanders and as far west as Ohio, Kentucky, and Texas. By the second quarter of the nineteenth century, landscape murals—which originated as a cheap and practical decorating solution—had blossomed into a unique art form and occupation. House and tavern walls were decorated by local craftsmen and occasionally by the proud owner himself. But in most instances wall painting was done by journeymen artists.

Rufus Porter (1792–1884), who worked in Maine, New Hampshire, and Massachusetts, was one of the most outstanding wall painters of his time. He was also a portrait painter, silhouette cutter, sign and drum painter, editor, author, schoolteacher, and inventor. Porter's publishing ventures included his *New York Mechanic* and *Scientific American* periodicals as well as how-to art books instructing readers on painting landscapes with architectural details on their own walls. Porter wrote, "the

painting of houses, arbors, villages &c., is greatly facilitated by means of stencils . . . for this purpose several stencils must be made to match each other; for example, one piece may have the form of the front of a dwelling house . . . another the form of the end of the same house . . . a third cut to represent the roof; and a fourth may be perforated for the windows. Then by placing these successively on the wall, and painting the ground through the aperture with a large brush . . . the appearance of a house is readily produced, in a nearly finished state."[1] Curiously, the stylized, stenciled houses in Porter's paintings were usually quite small in scale compared to such other elements as fanciful fruit and flower trees. Like the work of most of his contemporaries, Rufus Porter's frescoed walls combined stenciling with freehand painting and he is known for a stippling effect achieved by applying paint with a cork top (rather than a brush) to depict foliage.

Other recognized wall painters include Orison Wood, who was influenced by Porter; William Price; Michele Felice Cornè; Jonathan Poor, Porter's nephew, of Baldwin, Maine; Jared Jessup, from Long Island, whose wallpaper imitations decorated houses along the Connecticut River; and Moses Eaton, Jr., who painted hundreds of houses in Massachusetts, New Hampshire, and Maine. Eaton's original kit (and probably his father's before him), complete with stencils, is now in the collection of the Society for the Preservation of New England Antiquities in Boston. These artists did not limit their skills to wall painting but applied their considerable talents to other areas of the home as well.

Floors and woodwork were usually painted by the same house painter who decorated the walls, and like the limners who painted house portraits, these artists worked for little more than bed and board.

Just as painted walls were a substitute for costly wallpaper, painted floors were a substitute for expensive carpets. Floor designs could include stenciled motifs with a wide border,

checkerboard patterns, or faux painting—particularly marbling, and occasionally freehand scenes. Canvas floorcloths made from sailcloth and stiffened with starch were painted with these same techniques and were the forerunners of affordable rugs. Spatter painting on floors was in vogue in the 1840s. By the mid-1800s, however, affordable patterned wallpaper and floor coverings were being manufactured in America, diminishing the demand for wall and floor painting.

OVERMANTELS AND FIREBOARDS

Many craftsmen who painted exterior domestic scenes on the interiors of homes extended their résumés to include overmantels and fireboards.

The most formal room in a house was the parlor and its fireplace was the focal point. It was customary, especially in New England homes, to have an elaborate painted scene over the fireplace, covering the chimney. Known as overmantels, these painted scenes were executed on wood or canvas panels and set into the woodwork. Detailed housescapes, landscapes, and townscapes were favored subjects for overmantels.

An important eighteenth- and nineteenth-century seasonal parlor decoration was a fireboard (also known as a chimney board). Custom-made to fit the fireplace opening, fireboards were used in summer months to seal off the fireplace and protect the room from dirt, soot, and errant chimney swallows. Some fireboards were decorated with trompe l'oeil floral arrangements similar to those customarily placed in an unused fireplace. A number of fireboards were decorated with landscapes both real and allegorical, although the scenes on fireboards were generally less sophisticated than those painted on overmantels. Constructed of wood or of mounted canvas and intended to be viewed from all angles of the room, fireboards were painted in bold

designs and strong colors with shapes often outlined for emphasis. Outlining was a familiar technique to sign painters and a number of ornamental painters worked on both signboards and fireboards.

Not only muralists such as Rufus Porter, but painters known for other types of work turned their attention to overmantels and fireboards: Winthrop Chandler of Wingham County, Connecticut, a portrait artist of some significance, painted scenes on overmantels. An overmantel featuring a pair of peacocks is attributed to Dr. Rufus Hathaway, and Joseph Hidley and Edward Hicks are credited with painting fireboards.

FURNITURE

The same people who hired house decorators to paint their floors and fireboards turned to them for painted chests, chairs, and tables with which to furnish their homes.

Early American painted furniture includes the ornately decorated Dutch cupboard known as a kas. "These pieces found in many parts of the Hudson River Valley and other Dutch holdings have carefully painted architectural motifs and seem to be translations of Dutch Baroque carving into paint."[2]

Painted chests, boxes, and highboys were plentiful in New England, Pennsylvania, Connecticut, New York, and New Jersey. Before the mid-eighteenth century, furniture was often decorated by the carpenter "joiner" who made it, but after that the common practice was to give the wooden pieces to a decorator or itinerant artist to add the finishing touches. These painted designs were not only appealing to the eye but disguised humble woods such as pine or maple (or even combinations of homegrown timber used to construct a single piece) with faux and fanciful finishes.

Chests made in Connecticut included late seventeenth- and early eighteenth-century "Guilford Chests," with a single painted panel above a drawer and decorated side panels, and similar "Taunton chests" from Massachusetts, whose painted pictorial designs—composed of trees, flowers, and vines—have been compared to English crewel embroidery: There do not seem to be any recorded examples with buildings. Brilliantly painted Pennsylvania dower chests (similar to hope chests) feature many of the same German-influenced folk designs found on frakturs but few are decorated with building motifs. "Landscape with architecture is exceedingly rare on Pennsylvania-German chests: only two examples have been recorded. On both chests, the buildings are obviously derived from renderings of European structures."[3]

So-called "Harvard chests" were produced in the area around Boston. Jean Burks, of the Shelburne Museum states, "These chests from the first quarter of the eighteenth century were optimistically named because the brick buildings painted on the surface were once thought to depict those of the venerable institution of higher education. However, a comparison with the 1726 William Burgis view of 'the Colleges of Cambridge' confirms the fact that the eye-catching and fanciful buildings on the chests are hardly accurate."

In port cities such as Boston, New York, Philadelphia, and Baltimore, sophisticated painted furniture, referred to as "fancy furniture," became the fashion by the early nineteenth century. Baltimore was the hub of fancy furniture production from 1804 to 1840. Although these classic styles are by no means considered folk art, fancy furniture decorated with painted landscapes known as "views" did employ the work of ornamental painters, today considered folk artists. An 1804 advertisement by famed cabinetmaker brothers John and Hugh Finlay reads, "They now inform ladies and gentlemen that they can supply them with views on their CHAIRS & FURNITURE." Specific items listed included "Cane, Rush and Windsor Chairs; Tea, Pier, Card, Writing and Dressing Tables; Wash hand and Candle Stands; Horse and Pole Fire Screens; Bedsteads; Bed and Window Cornices; Brackets; Tripods, Looking Glass and Picture Frames, &c."[4] The Finlays specialized in architectural views of Baltimore residences and public buildings. One of the artists engaged by them was Francis Guy, known for his house portraits of country estates in the Baltimore area (and later for New York street scenes, as seen on page 91). Guy painted miniature house portraits on the crest rails (or top rails) of the Finlays' chairs and settees, and on tabletops.

The Finlays, and many other skilled furniture makers of the time, also sold "japanned" pieces. Japanning, a technique used to imitate Oriental lacquer, consisted of a black or dark brown base, metal dust decorations, and several coats of glossy varnish: In keeping with the Oriental influence, architectural images on japanned furniture were usually pagoda-shaped buildings.

Improvisations of the characteristics of sophisticated and imported furniture made their way into simpler, homier pieces throughout the eighteenth and first half of the nineteenth centuries. "As individual craftsmen interpreted these styles in their own way or blended elements from different periods, a unique type of folk furnishing developed."[5]

By 1821 Lambert Hitchcock was manufacturing stenciled black or dark brown, rush and cane-seated chairs in Connecticut. His metallic designs were an alternative to ornate and expensive gold-leaf decoration. Hitchcock was not alone. Other workshops produced chairs, tables, consoles, and even pianos decorated with metallic stencil designs. Cornices were precisely painted with house and farm scenes. Rocking chairs—an American invention—were graced with stenciled landscapes and other decorative and pictorial designs. Details were added by hand and freehand scenes were often combined with stencilwork.

Not all painted furniture was the province of professional craftsmen. Nineteenth-century students at a number of young ladies' academies, especially in the New England states, were taught to paint on wood as well as on silk and paper. Small household pieces such as boxes, chests, work and sewing tables, and even an occasional fireboard were decorated with academy art to be displayed by proud parents and young brides. As with samplers, building images were derived from print sources, art manuals, and illustrated books. George Washington's home, Mount Vernon, was a popular choice.

Marquetry, a centuries-old woodcraft, was another method of decorating furniture and accessories. Designs were created by cutting thin sheets of wood veneer into intricate shapes and inlaying these pieces onto wood surfaces of a contrasting color. In Europe, this intricate process was reserved for luxurious furnishings and included mother-of-pearl inlays and detailed floral, vine, and butterfly designs. Nineteenth-century American versions (made easier by the invention of the foot-powered jigsaw and the scroll saw) referred to as "men's quilting," tended to rely on more geometric shapes to embellish tables, frames, game boards, and boxes.

POTTERY, CLOCKS, AND BOXES

American potters produced everyday dishes and containers of earthenware, commonly referred to as redware, made from brick clay that fired to varying shades of red. "Although made for practical purposes, redware pottery could be far from ordinary," explains collector Vincent DiCicco of New York. "In rare instances, architectural images were painted in manganese slip onto jars. Still rare, redware objects in the shape of houses or other buildings are more often encountered and include mantel ornaments (by potter Daniel Clark of Concord, New Hampshire), figural

groups (by Levi Begerly and Theodore Fleet of Eberly Pottery, Strasburg, Virginia), as well as birdhouses and banks."

Redware was fragile, however, and was replaced by the more durable and less porous stoneware at the beginning of the nineteenth century. Produced throughout the Northeast and Midwest, this crockery was watertight when glazed with salt. Gray or tan in color and glossy when fired, utilitarian salt-glazed stoneware jugs and jars were decorated with incised designs or the more familiar cobalt blue slip. (Slip is liquid clay of one color applied to pottery bodies of a different color for decoration; the content of manganese, cobalt, iron oxide, etc., in the slip determines the color.) Building motifs on stoneware might be as simple as a single house or as complex as an entire village.

Abroad, nineteenth-century copper-plate engravings of national landmarks, colleges, and city views were transferred onto commemorative Staffordshire plates made in England for export to the American market.

Clock dials, faces, tablets (glass panels), and cases presented surfaces for painted genre scenes and patriotic designs during the first forty years of the nineteenth century. Especially suitable were banjo clocks (patented by Simon Willard), girandole clocks (patented by Lemuel Curtis), lyre, and tall-case clocks. A particularly talented group of clockmakers and ornamental painters were located in and around the Boston suburb of Roxbury. Building motifs in gold leaf and oil paints were also reverse-painted onto the glass of some wall clocks and on Federal-period looking glass panels.

Decorated boxes, especially prevalent in New England and Pennsylvania, were used to store everything from candles, silverware, or salt to important documents, books, or sewing supplies. Household inventories listed sizes and shapes (lidded, footed, hinged, dome-topped, and dovetailed) to suit every purpose. Surfaces were grained,

stenciled, painted with pictorials, carved, scrimshawed, and découpaged.

Hatboxes and bandboxes (nineteenth-century paperboard luggage) were covered with decorative papers including scenic wallpaper—some with architectural designs. Some painters decorated their own supply boxes (see John Avery's "Painter's Box" on page 111), and sailors decorated ditty boxes (used to hold sail and net repairing tools, naval papers, and valuables) with scrimshaw. Scrimshaw, a form of decorative carving applied to the teeth of sperm whales, whalebone, or the horn-like substance known as baleen, was popular from about 1815-1900. A pastime for sailors on long whaling voyages, designs were incised with fine-point tools or a jackknife; lines were then filled in with India ink or with carbon soot from a candle or lamp. These folk carvings depicted actual and imaginary buildings, landscapes of exotic ports or hometowns, ships, and whaling activities. Boxes, busks (corset stays), and pie crimpers (used to cut pie pastry) were some of the gifts engraved for sweethearts at home.

BUILDING-SHAPED OBJECTS

Few of us are as fortunate as American folk art collectors Electra Havemeyer Webb and Henry Ford. They were able to satisfy their interest in early American life and architecture by purchasing entire buildings and moving them to the grounds of their own museums. Some of Webb's acquisitions for the Shelburne Museum in Vermont included a stagecoach inn, a jail, a lighthouse, a country store, and a blacksmith shop. Ford moved Thomas Edison's Menlo Park Laboratories, the Wright Cycle Shop (where the Wright Brothers built their first airplane), and the Logan County Courthouse (where Abe Lincoln once practiced law) to his own Henry Ford Museum & Greenfield Village in Dearborn, Michigan.

Ordinary collectors must content themselves with miniature versions of beloved architectural styles and shapes. Thankfully the folk artists of early America have bequeathed to us a charming legacy of small-scale, three-dimensional pieces made in the form of buildings but originally intended as toys or as practical objects.

Crafted to house a doll, to shelter a bird, or to save a penny, such little buildings range from unadorned box-like structures of scrap wood to elaborate versions of actual residences or public institutions incorporating period details and materials. Additional folk art examples are architectural models, salesmen's samples showcasing building materials, and model buildings assembled for no purpose other than creative enjoyment. Few artists signed their work, but occasionally an inscription may indicate for whom or by whom a piece was made as a gift.

DOLLS' HOUSES AND TOYS

One of the most enchanting of childhood playthings is the dolls' house. The exterior shape and materials as well as the rooms and contents might have mirrored the actual home of the owner, but in most cases the toy dwellings simply provided a chance to fantasize.

Termed "baby house" in the seventeenth century, earlier versions sometimes had carrying handles and a lock. The open backs or removable roofs allowed children to reach inside and play with furnishings and figures.

Formats ranged from simple rooms, open side by side or back to front so two children could play together, to elaborate, multilevel houses with lavish furnishings. Made-to-scale decorations were artfully crafted from scraps of wallpaper, bits of carpet or linoleum, fabric, and wood. Toy catalogs offered miniature furnishings such as upholstered seating, mahogany and golden oak furniture, and even silver, china, and glassware that could be purchased in sets.

Scrap lumber or fine woods, roof shingles, and other real construction materials were used to make these toy buildings. Some dolls' houses were modeled on vernacular architectural styles—the New England saltbox, the gingerbread-trimmed Victorian, or the urban brownstone. Other choices included barns to shelter toy animals, stores to fill with toy goods, or entire villages to go with toy train sets.

By the 1850s dolls' houses could be bought ready-made in wood, fiberboard, or paper, and their furnishings assembled from the stock in toy shops. During the last quarter of the nineteenth century, the most well-known American manufacturer, R. Bliss Manufacturing Company of Pawtucket, Rhode Island, produced wooden houses covered with lithographed paper, reflecting the Victorian architectural styles that were rising rapidly throughout the country. However, many dolls' houses were still lovingly made by a child's father or a local cabinetmaker.

Flora Gill Jacobs, historian and Washington Dolls' House & Toy Museum founder, a collector for more than fifty years, believes dolls' houses "encapsulate major areas of American history—architectural, decorative arts, and social," and views them as "historic preservation in miniature."

Noah's arks, another kind of dolls' house, reigned as a favored toy from the Federal through the Victorian periods and were referred to as "Sunday toys" appropriate for play on a day of worship. The house boat, either flat bottomed or with a curving hull, was fashioned from wood and came with the requisite pairs of carved animals and figures. As in traditional dolls' houses, ark rooftops lifted to enable children to move the many figures about. In addition to handmade varieties, ark sets were often mass produced abroad, gaily hand painted or papered with lithographed wood staves and windows: even these commercial toy sets are collected today in the genre of American folk art.

Children were also encouraged to create their own forts, castles, and structures with building blocks. Earlier versions of these blocks were hand-carved and hand-painted. But beginning in Victorian times, building block sets made of wood or stone were sold by companies like Crandall, F. Ad Richter & Co., Milton Bradley, and McLoughlin Brothers. Children enthusiastically assembled houses, factories, churches, towers, arches, windmills, and bridges influenced by the architectural evolution taking place around them. Existing examples of these childhood constructions—or more sophisticated adult works created from children's toys—are now valued as folk art in their own right.

BANKS

Toy banks were created to teach children the value of thrift. Once coins were introduced into common use in the eighteenth century, banks followed. The nation's industrial progress was strengthened by the chartering of savings banks in the early 1800s, and was paralleled by the demand for toy banks.

Early banks were fashioned by hand from wood, tin, or pasteboard. Banks made in molds included redware and stoneware pottery examples as well as those made of chalkware (an early version of plaster of Paris that was sometimes colorfully hand decorated).

By the 1870s, cast-iron banks, made from hand-carved wooden molds, were widely manufactured. Every type of building came to be represented: actual bank buildings that, as the nation expanded, had become the crowning feature of most towns; bungalows; cottages; houses; towers; or log cabins. Famous buildings were favorite subjects: the White House, Independence Hall in Philadelphia, New York's Flatiron building, and Chicago's cast-iron skyscrapers. Toy banks had architectural details such as paned windows molded in low relief, the better to view accumulating contents.

Options in cast iron included *mechanical* banks, in which the placement of a coin activated a figure that deposited the coin, and *still* (nonmechanical) banks with a coin drop slot on the front facade or roof. Over three hundred different mechanical banks were produced in their heyday, many featuring buildings. Prominent manufacturers were the Connecticut firms of Patterson's of Berlin, J & E Stevens Company of Cromwell, and George W. Brown & Company of Forestville.

Today, some collectors seek out only handmade banks constructed of wood, metal, or hard-to-find pottery and chalkware, while others prefer cast iron, refining their choices to focus only on still banks, mechanical banks, or identifiable buildings. In August 2000, a never-manufactured, handmade prototype for the "Twin Bank"—patented by C.C. Johnson—sold at auction in Thomaston, Maine, for $154,000. It features a bank building with two men (cashiers) entering and exiting doorways.

PET HOUSES

Birdhouse styles varied as widely as architectural styles. Beyond the simplest—a box with an entry hole—construction could go to amusing extremes, featuring porches, towers, varied roof lines, and even stairs. Some structural differences were geared to the local bird population. Bird species such as robins have special nesting needs that require attention to the shape of the building (they don't like to be enclosed); wrens, woodpeckers, and chickadees are comfortable with entry holes of different diameters; sparrows require an exterior perch. Martins nest in colonies, which accounts for the large, multistoried, many-holed communal structures built to attract them (page 121).

The builder could be a schoolboy, a hobbyist, or an experienced whittler. How-to publications printed instructions. Certain materials and paint surfaces were preferable to ensure successful bird tenancy: metal roofs would become hot in the sun; natural bark coverings were favored over bright or glossy paints.

The outdoor rigors of standing on a post or hanging in the elements meant that relatively few nineteenth-century birdhouses survived. Twentieth-century examples abound, their numbers related to expansive home building across the country.

Birdcages began to appear inside American households by the Victorian era. As people increasingly left the farm and moved to cities, it became fashionable to exhibit various species of songbirds indoors, to remind people of a more bucolic life. Victorians kept birds in elaborate wood and wire constructions that held just one or a pair of birds, up to cages of enormous proportion that housed many birds. Examples have been found made of such unusual materials as fretwork (a thin, pierced decorative woodwork) and carved whalebone, as well as traditional fine woods. A cage in the form of a building or architectural whimsy offered an opportunity to exhibit artistry in the details, as was done with dolls' houses. After the Industrial Revolution, cages of pressed tin and wire became widely available.

Birds were not the only pets kept caged indoors. Squirrels had been domesticated pets for centuries and appear with children in many historic portraits. Their cages were outfitted with moving parts, such as an external enclosed wheel on which the squirrel could exercise (the precursor to today's hamster cage). The psychological illusion of the cage as "home" was furthered by making it look like a building, as in the Shelburne example painted with fanlight doorways and window facades (page 113).

TRAMP ART

The sculptural avocation of tramp art gave "new form and function to materials no longer in their original state."[6] Scavenged materials like the scrap wood of Honduran mahogany and cedar cigar boxes or pine crates were refashioned into decorative household objects, primarily frames, keepsake containers, and toy structures.

Tramp art was made by layering thin slats of wood that were notched or sawtoothed with a pocket or penknife to create a V-shaped triangle or a wavy edge. Using glue and an occasional nail, the chip-carved slats were stacked in squares, rectangles, or circles of increasingly smaller proportion. The result was a three-dimensional form in a geometric pattern that had both a visual and an actual texture.

The term tramp art is a misnomer, emerging from the folklore of the itinerant stranger—the hobo in the train yard—making and trading his recycled creation for a meal and a bed. In fact, much tramp art was made by men at home. Their boxes, frames, furniture, and unique objects—often crafted as tokens of affection—are increasingly regarded in the folk art community both as labors of love and sometimes obsessive creativity.

Tramp art was practiced wherever cigar smoking drew people together: immigrant neighborhoods, retirement homes, sanitariums, hospitals, and even prisons. At first whittlers worked without published instructions or plans, and techniques were passed along by word of mouth and imitation. As the twentieth century progressed, patterns appeared in men's how-to periodicals like *Popular Mechanics* and even schoolboys attempted the craft in shop class, resulting in pieces of varying skill levels and originality.

Though considered an eccentric North American folk art form appearing throughout the United States and Canada, tramp art has its origins in the centuries-old woodworking and carving traditions of eastern and northern Europe—Germany, Czechoslovakia, the Netherlands, and Scandinavia. It reached its peak of popularity in America during the early twentieth century.

"HARVARD CHEST," 1700–1725

Maker unknown; Essex County, Massachusetts
Painted pine, 34½ x 43 x 19⅛ in.
© Shelburne Museum, Shelburne, Vermont; Gift of Katherine Prentis Murphy
(Detail shown on page 94)

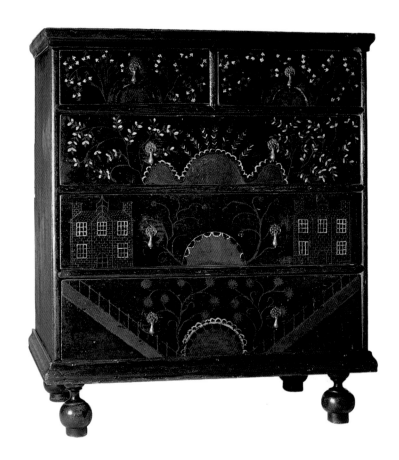

The artist who decorated this five-drawer chest chose to work in black, red, and creamy white, a popular color combination for eighteenth- and nineteenth-century painted furniture. The stylized designs, however, are quite unique: some variation of a sunrise embellishes each drawer front, fanciful flowering vines resemble embroidery motifs, and stairways lead to nowhere. But it is the pair of two-storied brick-faced buildings with cupolas that draw the most attention. At one time, these architectural renderings were believed to represent buildings at Harvard College in Cambridge, Massachusetts, and for that reason, a handful of similarly painted chests became known as "Harvard chests." Closer study, however, has indicated that the design source for these particular edifices is more apt to be the artist's imagination rather than any academic reference.

The brilliant color scheme unites the diverse elements of this composition and may well have been influenced by japanning, which was popular during the William and Mary period (1690–1720).

CHEST OF DRAWERS, Dated 1870

George Robert Lawton; Signed "Mr. G. Lawton"; Scituate, Rhode Island
Painted white pine with carved maple knobs, 58 x 43 x 16 in.
Private collection
Photo courtesy David A. Schorsch American Antiques, Inc.

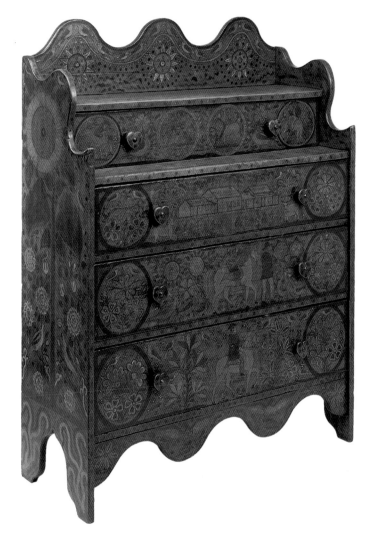

"With its extraordinary, highly stylized representational decoration, this chest is unique among nineteenth-century New England paint-decorated furniture," explains Connecticut dealer David Schorsch. "The vast array of designs and figures includes a series of buildings, numerous flowers, plants and trees, and animals and birds. Among the human figures is a self-portrait of the artist riding his horse and inscribed 'Mr. Artist' (bottom drawer): below each flower pot flanking this figure is the date 1870." The second drawer features a landscaped complex of four connected, gable-roofed yellow buildings.

For some time, the remarkable craftsmanship seen on this piece and other smaller objects was believed to be the work of nineteenth-century Rhode Island artist John Colvin. But the real artist was in fact another member of the same family—George Robert Lawton (1813–1885). This is the only known dated and signed piece, with "Mr. G. Lawton" inscribed under the two lions in the top drawer reserve (second from left).

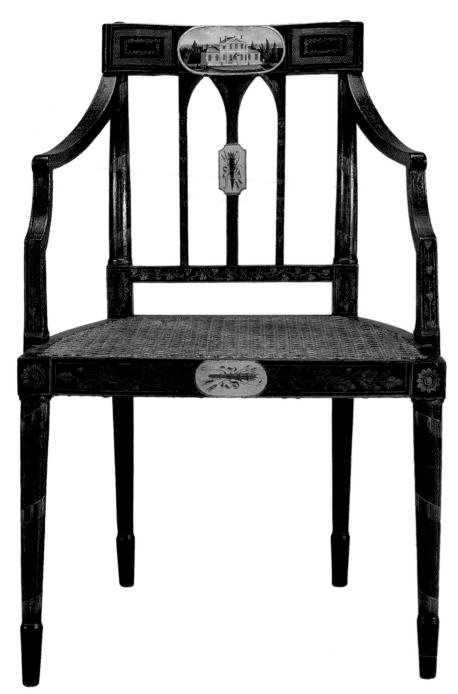

ARMCHAIR, c. 1805
Attributed to John and Hugh Finlay; Baltimore, Maryland
Wood painted black with gilt and polychrome decoration,
33 5/8 x 22 1/4 x 21 5/16 in.
Collection of the Baltimore Museum of Art
Gift of Lydia Howard de Roth and Nancy H. DeFord Venable,
in memory of their mother, Lydia Howard DeFord, and
Purchase Fund

Brothers John and Hugh Finlay were renowned Baltimore cabinetmakers known for the exceptional quality of painted decorations on their "fancy furniture." This cane-seat armchair is part of a thirteen-piece suite considered the most important and best-preserved set of early Baltimore painted furniture. The set's distinguishing feature is the architectural views that decorate each piece. Seventeen different Baltimore buildings are represented: one each on ten chairs, three on each of two settees, and one on a marble-topped pier table. Still extant is the original numbered list, identifying each public building and each homeowner, corresponding with numbers on the furniture.

House portrait artist, Francis Guy, is believed to have decorated this set with "city views" for the Finlays. Guy painted these miniature house portraits in much the same style as his larger pieces.

"Willow Brook," the private neoclassical-style residence depicted on the crest rail of this chair, was owned by John Donnell. Built in 1799, it was located at the corner of Mount and Hollins Streets until it was demolished in 1965. However, the interior of the oval reception room was preserved and it now exists as a period room in the Baltimore Museum of Art.

Wealthy merchant John Boucher Morris owned this furniture but the buildings do not seem to be of any particular relevance to Morris's life. One theory for this is that Morris acquired it from the owner of the Fountain Inn (formerly James Bryden's Coffee House, which had a room painted by Francis Guy). This important, local meeting spot would have been a logical place to display this diverse collection of architectural Baltimore scenes.

"TRIBUTE TO AMERICA" LAMP, 1931

Made by Christopher Moe; Portland, Oregon
Various woods; marquetry and sculpture,
* 66 in. high to top of Washington Monument*
Collection of Allan and Penny Katz

A record of historical events and places was fabricated from more than fifty thousand bits of scrap wood assembled by Christopher Moe into an extraordinary twelve-piece suite of furniture that is crowned by this "Tribute to America" lamp. A secretary desk; rocking, straight back, and arm chairs; a library table; a footstool; magazine rack; a bench; and six wall pictures were all made from 1919 to 1935 of precisely cut and planned pieces of Phillipine and Cuban mahogany, African rosewood, Alaskan birch, American sycamore, and other woods from around the world. The artist considered the lamp his masterpiece. It contains some eight thousand pieces of natural-colored wood and is as tall as a person, measuring five feet six inches from its base to the Washington Monument on top. The lamp incorporates the intricate geometric patterns Moe created for all the furniture, with pictorial inlays and three-dimensional sculptures of famous sites. A strong sense of patriotism was demonstrated in this unique assemblage, evident in the two views shown here. The Liberty Bell emerges in the base, along with a college building and a volcano. The domed Capitol Building, copied from a picture, has accurate architectural details plus windows and doors that are illuminated when the light is turned on. The White House is there too, as is the architectural treasure the Nidaros Cathedral of Norway, in homage both to the immigrant artist's new home and to his birthplace. (Moe emigrated to Sioux City, Iowa, at age twenty-five, where he learned to be a cabinetmaker.) The Statue of Liberty raises her torch above a scalloped apron inlaid with spiritual and democratic words and phrases. The lampshade also displays expressive marquetry: a cottage with glass windows set in a forest of tall pines.

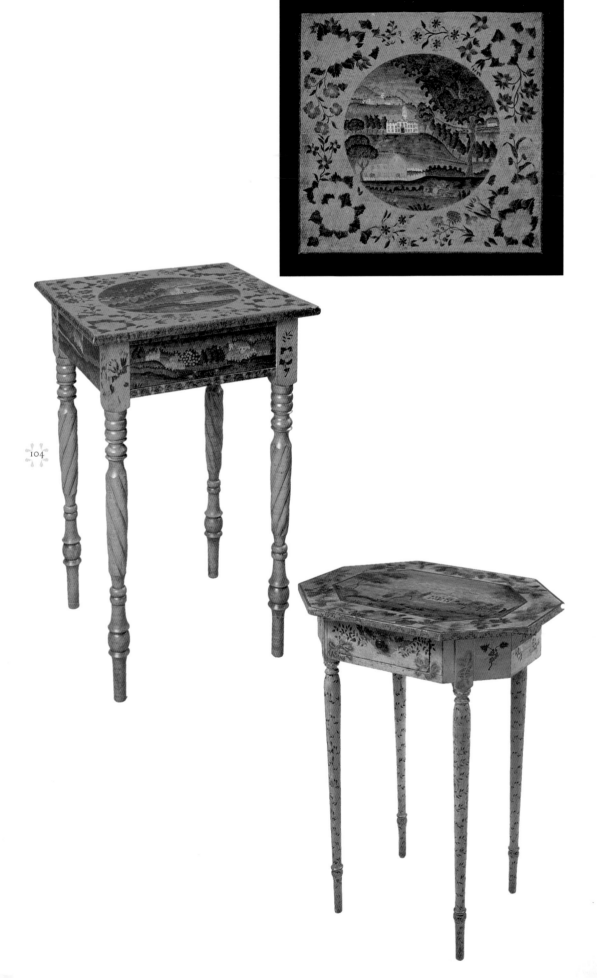

WORKTABLE, c. 1817
Artist unknown; New Hampshire
Watercolor, ink, and pencil on bird's eye maple,
29 x 19 x 18 in.
Collection of the Museum of American Folk Art,
New York; Promised anonymous gift

OCTAGONAL WORKTABLE, c. 1810
Artist unknown; probably Maine
Painted pine, 23½ x 17 x 28 in.
Private collection; Photo courtesy David A.
Schorsch American Antiques, Inc.

In eighteenth- and nineteenth-century America, proper young ladies were enrolled in finishing schools to learn needlework, watercolor painting, and appropriate social graces. While many of these female academies limited their painting lessons to works on paper, silk, or velvet, some schools (particularly in New England) provided instruction for painting on wood to decorate boxes and small sewing tables or worktables.

The central building painted on the tabletop (above) is the Concord State House, with a white-picket-fenced residence in the foreground and a townscape in the back. Sections of the same townscape as well as additional buildings are repeated on the front and side skirts. Stenciling for the floral border and leg accents is similar to that on theorems.

The scene on the octagonal worktable (left) is that of Mount Vernon. After Washington's death in 1799, memorial paintings depicting his image, his battles, and his home proliferated. This house portrait is framed with a pinecone motif and the table legs are masterfully encircled with delicate flowering vines. It appears that two people might have worked on this piece, since the painting on the legs is very precise whereas the designs at the drawer front corners are not as meticulously executed.

POLE SCREEN, c. 1825–35

Painted panel attributed to Edward Hicks;
* probably Bucks County, Pennsylvania*
Mahogany pole and frame with oil paint on
* yellow poplar panel, 57 1/4 x 22 x 18 1/2 in.;*
* framed panel 20 x 23 x 23 3/16 in.*
Collection of Abby Aldrich Rockefeller Folk Art
* Museum, Williamsburg, Virginia*

Pole screens were used to protect a lady's face from fireplace heat in the days when makeup, derived from wax, could actually melt if exposed to high temperatures. Very often, the screen section was decorated with silk embroidered needlework depicting bouquets of flowers.

This tripod base stand was probably made by a Bucks County cabinetmaker who then commissioned Edward Hicks to paint the tulip poplar panel. The bucolic landscape features a thatched-roof cottage with sheep grazing, a lady sitting outside the cottage door, and a farmer or herdsman beside her leaning on a staff. The scene does not reflect local building styles of that period and was most likely derived from a yet unidentified European or British print. Hicks was known to have used print sources either for individual elements or for entire compositions and chances are that he presented the client with a number of suitable prints from which to choose.

Scholars have known for years that Edward Hicks painted furniture, but none of the surviving records for his shop mention this particular form.

SITUATION OF AMERICA, 1848.

SITUATION OF AMERICA,
OVERMANTEL, 1848

Artist unknown; New York

Oil on wood, 34 x 57 in.

Collection of the Museum of American
Folk Art, New York

This overmantel, from a house on Long Island, represents a view of New York Harbor in the nineteenth century. The prominent building in the foreground is a warehouse; the disproportionately large flag-topped dome behind it is New York City's city hall on the other side of the East River; also on the far shore is the spire of Trinity Church. Black smoke billows forth from the chimneys of a paddle wheeler bearing the word "SUN." Two- and two-and-a-half-story gable-roofed colonial houses cluster the shoreline and symbolize architectural and economic development, while the sacks and crates loaded onto freight cars and the barrels on the wharf indicate successful commerce. Note the stylized nine-stripe flags with large center stars: the field is resting on a red stripe instead of the traditional white one. According to flag historian Dr. J. Kenneth Kohn of Elkins Park, Pennsylvania, this red "blood" stripe format was used in time of war to indicate that American blood was being shed. The date coincides with the Mexican-American war. What appears to be a separate frame decorated with a design of flowers and trailing vines is actually a border that is painted directly onto the panels.

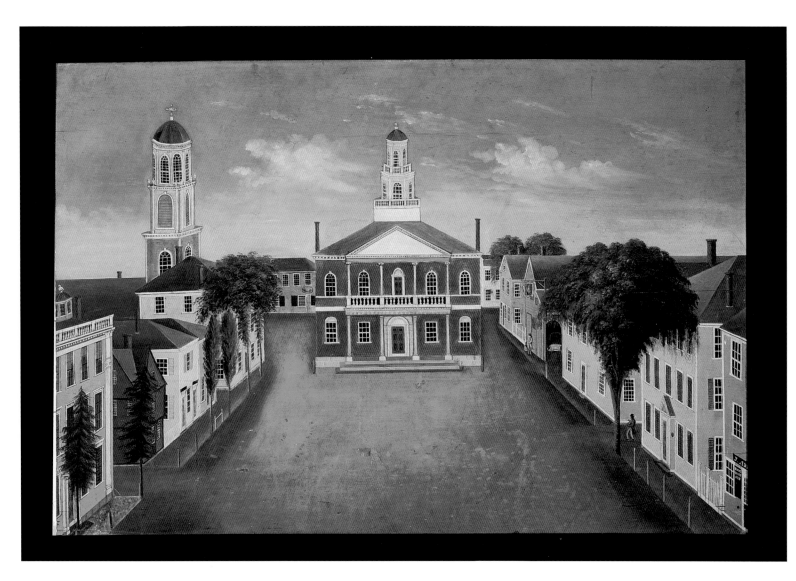

VIEW OF COURTHOUSE
SQUARE, SALEM,
FIREBOARD, c. 1810–20
George Washington Felt; signed
"painted by G.W. Felt"
Oil on wood panel, 35 x 52 in.
Collection of the Peabody Essex
Museum, Salem, Massachusetts;
Estate of B. F. Brown

This dramatic view of an urban scene depicts one of Salem's main thoroughfares of the time, Washington Street. The great courthouse seen at center was built from designs by Samuel McIntire in 1785. Kimberly Alexander, curator of architecture at the Peabody Essex Museum, describes the courthouse: "This building has all the hallmarks that we associate with classic Federal architecture: prominent chimney stacks, the hipped roof, graceful arched windows, fanlights over the doors, and pilasters. A two-stage cupola with a small dome tops the courthouse and forms the apex of the composition; a balustrade separates the first and second stages and

there are rounded arched windows on both sides. Elegance! Elegance! Elegance!"

To the left of the courthouse is the yellow Pickman-Derby House built in 1764, with a cupola added in the 1780s. Beyond that is the seventeenth-century Lewis Hunt House and the tower of the Tabernacle Church erected in 1805. The buildings on the right appear to be 1700s gambrel-roofed colonials.

George Washington Felt humanized this painting by adding figures (a man playing a violin and a father and daughter) to contrast with the stark geometrics of the architecture.

VAN BERGEN
OVERMANTEL, c. 1733

Attributed to John Heaten;
Leeds, New York
Oil on cherry wood, secured with
American white pine battens and
framed with black molding,
16¼ x 88¾ x 2⅛ in. (framed)
Collection of the New York
State Historical
Association, Cooperstown;
Photo by Richard Walker

Painted with a scene of Marten Van Bergen's farm-land, this is the most important visual record of period Hudson River Dutch lifestyle and one of the earliest American landscapes extant.

Van Bergen's residence, a Dutch rural farm-house, was constructed of limestone and the vermillian red roof suggests tiles. Double casement windows, borrowed from a contemporary Netherlands style (bolkozyn), include a leaded-glass sash and a single, hinged wooden shutter. Dormer windows are seen on the garret floor. The bright colors of the shutters and the front stoop are an example of Dutch tradition transferred to the New World.

In addition to the manor house is a Dutch barn, a blacksmith shop (the lean-to), the Old Dutch Church, and the gable of Van Bergen's brother's house. Hay barracks' roofs could be raised or lowered on jack poles as the amount of stored hay varied.

Marten Van Bergen, his wife, and four daughters stand before the house. The three horseback riders are their sons. Three Native Americans are clothed in blankets. Three African-American women and a man near the blacksmith shop are probably slaves and two men (with a bucket and in the wagon) are indentured servants. Coming up the walk is Marten's brother, Gerrit, and his two sons.

This house, constructed in 1729, was demolished in 1862 but its salvaged overmantel provides an excellent picture history of daily life there almost three centuries ago.

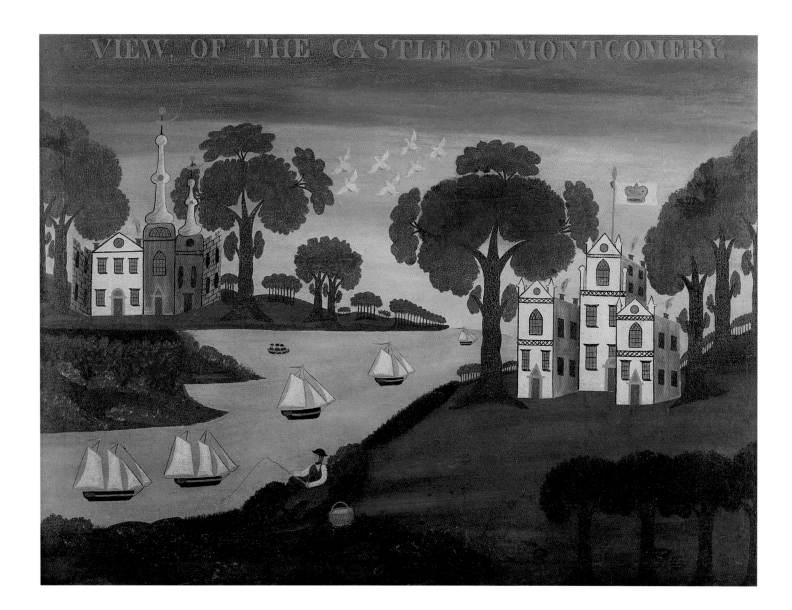

"VIEW. OF THE CASTLE
OF MONTGOMERY."
FIREBOARD, c. 1830–1840
Artist unknown; Woodruff,
 South Carolina
Oil on canvas on yellow pine stretchers,
 41½ x 55½ in.
Collection of the New York State
 Historical Association,
 Cooperstown; Photo by
 Richard Walker

The ornate castlelike buildings that appear on this fireboard, complete with Gothic windows and Turkish-style towers, bear little resemblance to the local architecture of the time. The "Castle of Montgomery" is probably derived from a print source or book illustration. It has been suggested that the artist's inspiration may have been a cardboard cutout; a close look at the buildings on the left of the river reveals notches at the top of the two brick walls where a roof section would fit. As a matter of fact, no roof tops are visible on any of the buildings even though smoke is curling out of chimney stacks. For example, how is the flagpole, bearing a white flag with a gold crown, secured at the base? Other imaginative touches are the trees,

both in shape and in scale (rows of miniature trees interspersed with large, dramatic ones).

Although the painter's name is unknown, some information about him is available. He was an itinerant artist, commissioned to paint this fireboard for the Frank Wofford house, and he painted at least one other fireboard almost identical to this one, for a house seven miles away; that one is now at the Abby Aldrich Rockefeller Folk Art Center in Williamsburg, Virginia. A descendant of the original home and fireboard-owner says that this same limner painted portraits of his family members, and of other local residents.

Fireboards, from southern states, with this much documentation are scarce.

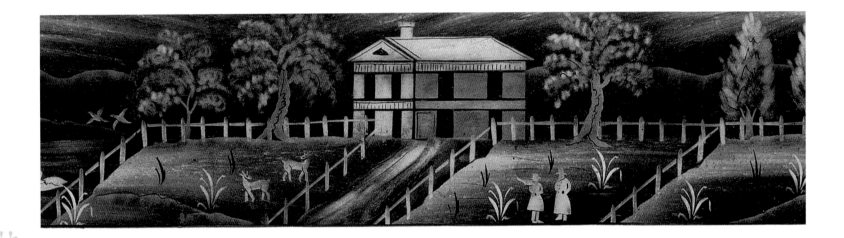

CORNICE BOARD, c. 1835

Artist unknown; New York State or
New England

Stenciled and freehand-painted wood,
7 ¼ x 42 ½ x 2 ½ in.

Collection of the New York
State Historical Association,
Cooperstown

At about the same time that Lambert Hitchcock's stenciled chairs were enjoying great success in Connecticut and surrounding areas, metallic paints and powders were stenciled onto other furnishings as well including cornice boards, used to conceal raised Venetian blinds. A living room or parlor with several windows would require several of these elaborate cornice boards, which were sold in sets. Window trim and paneling might be painted or decorated in a matching style.

Not surprisingly, artists along the Hudson River Valley chose to depict river tableaux on their cornice boards and showed houses on the banks, domestic animals on the lawns, and occasionally boats cruising on the water. The boats might be sailing ships or paddle-wheel steamboats from the Hudson River Day

Line. Center scenes are often framed with broad, gold border stripes and end designs, usually swans or other birds, surrounded by scrolls of stylized flowers or vines. Another common element in these paintings is dark mountains rising in the background.

This example combines all the above characteristics and depicts farm life along the river. There is a hip-roofed main building, a smaller gabled outbuilding, and even a distant townscape on the other side of the river.

Swans swim in the river, two sheep graze, and a pair of figures stand at the front perhaps to wave to passing boats. Realistic trees near the buildings contrast with smaller stylized plantings in the foreground. As a design tool, fencing divides the surface into almost equal proportions.

PAINTER'S BOX WITH SCENIC VIEW, c. 1825

Signed John Avery; New Hampshire
Painted wood, 8 x 15 x 4 1/2 in.
Collection of the Museum of American Folk Art, New York;
 Gift of the Historical Society of Early American Decoration

John Avery, born 1790 in Deerfield, New Hampshire, was an ornamental painter in the Wolfeboro area and known for his wall murals. This box held his supplies: paint powders, a palette, bottles of paints (one labeled "Our Favorite Gold Paint"), brushes, leather- and wood-graining combs, sponges, and chamois. The freehand landscape on this box lid is indicative of his mural style: there is a farmhouse flying an American flag, one outbuilding, a high fence around the residence, post-and-rail fencing enclosing the pastures, cattle, a dog, one or two men in the gateway and another with a horse, plus a variety of trees.

The hinged box opens with a brass ring. A horse is drawn between the hinges and a very faint outline of a man's face appears close to the left-hand hinge. Could this be a self-portrait of John Avery?

TRINKET BOX, c. 1835–1850

Jonas Weber; Lancaster County, Pennsylvania
Painted wood, 3 x 6 3/4 x 3 1/4 in.
Collection of the Museum of American Folk Art, New York;
 Gift of Jean Lipman

This wooden trinket box was decorated by Jonas Weber (1810–1876). There are a number of similar pieces from Lancaster County, namely rectangular black or dark green painted boxes and chests like this one.

Until recently, this group of work has been attributed to Jacob Weber rather than Jonas. But research compiled at the Heritage Center of Lancaster, Pennsylvania, found compelling reasons to change this opinion. Anna Weber (1796–1876), a seamstress living in West Earl Township, recorded in her ledger, "14 cents for a box from Henry Weber that his brother Jonas made on the first of January 1839."[7] Jonas Weber lived, with his parents, on a farm adjoining that of Anna's family. Jonas's father records the sale of nineteen objects between 1845 and 1852 at prices ranging from 4 to 30 cents—quite a bargain, considering that one of these boxes sold for $17,250 at a Christie's auction in 1995.

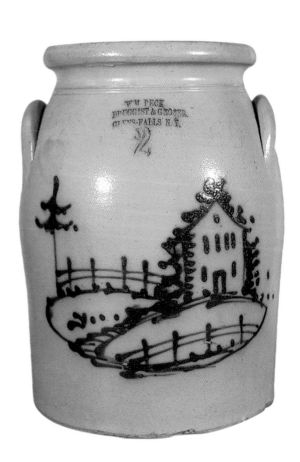

FIRE BUCKET, Dated 1851
Alvan Fisher; Portsmouth, New Hampshire
Oil on leather, 13¼ x 9¼ in.
Collection of Robert and Katherine Booth; Photo courtesy David A. Schorsch American Antiques, Inc.

Fires were terrifying events in colonial life and firefighting measures needed to be as organized and efficient as possible. Leather fire buckets, made by cobblers and harness makers, were mandatory in early American homes. These buckets were kept by the door, where a homeowner or volunteer firefighter could grab them quickly at the sound of an alarm. The men would form a "bucket brigade" between the fire and the nearest water source: buckets would be passed back and forth to be filled and refilled as water was poured on the blaze. When the fire was over, the buckets would be piled together to be reclaimed by their owners, thus some form of identification was necessary.

Usually decorated by professionals, the bucket might be personalized with the owner's name and house address, the name and insignia of a fire company along with the name and number of the volunteer, a patriotic symbol, or even a house portrait of the home from which it was borrowed. The same ornamental painters who decorated these varnished buckets also worked on fire wagons and on elaborate stovepipe hats worn more often for parades than for actual firefighting.

Some fire buckets, such as this one, commemorate a particular fire. In the oval is a townscape with a burning building; the lettering under the scene reads "Portsmouth Town Hall Fire Conflagration, Burned from Noon, April 27, 1850 Until Daybreak the Following Day." Adorning the bucket front, a splayed eagle painted in yellow with black shadows holds a gold banner with the name of the owner and the date 1851 in its claws.

STONEWARE JAR, C. 1859–85
Attributed to Fort Edward Pottery Company; Ft. Edward, New York
Salt-glazed stoneware with opposing handles, cobalt decoration, and stamped mark, 12¼ x 9 in.
Collection of the New York State Historical Association, Cooperstown

The rural scene rendered in cobalt slip on the front of this salt-glazed pot centers around a two-and-a-half-story, multi-windowed Dutch Colonial house framed in foliage. A path leads up to the house and the property is protected front and back by a post-and-rail fence with two horizontal rails.

A tall pine tree rises at the back as if to point to the incised inscription which reads "W. M. Peck, Druggist & Grocer, Glens-Falls N.Y. 2." The number denotes the jar's two-gallon capacity. Perhaps this is a picture of Mr. Peck's home, since it is hardly the setting for a village store. Or perhaps these utilitarian containers, with a variety of designs, were part of his inventory.

This type of stoneware pottery was popular in upstate New York after the 1820s opening of the Erie Canal, which allowed New Jersey clay to be shipped inexpensively to potters in central and western New York State.

A label inside this jug attributes it to Fort Edward Pottery.

NOAH'S ARK, c. 1880s
Artist unknown; Found in New England,
American or German origin
Painted and lithographed paper and
wood construction, 12 x 23 in.
Collection of Virginia Cave; Photograph courtesy
Northeast Auctions, New Hampshire

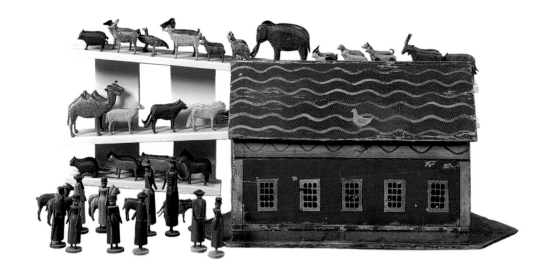

Noah's Arks were considered "Sunday toys," appropriate playthings for teaching children their Bible lesson. Whether homemade or purchased as hand-finished sets, some arks came with hundreds of animals as well as figures of Noah and his family. Most sets included a dove perched on top of the roof (as shown here) or a raven. These birds were symbolic to the story in the Book of Genesis for when the rains ceased, Noah sent out a dove and a raven to see if it was time to return to land. This example is a flat-bottomed model as compared to one with a curved hull. The majority of commercial ark sets were made with stenciled and chromolithographed papers defining the exterior details of the house rather than hand painting; more costly ones might even be decorated with woven straw.

SQUIRREL CAGE, c. 1900
Artist unknown
Painted wood construction, iron rods, and nails,
26 x 24 x 8½ in.
© Shelburne Museum, Shelburne, Vermont

This piece is a testament to the folk artist's ability to make even a functional item unique. Traditionally in a squirrel cage, an openwork wheel was anchored to the side of an enclosed structure to allow the pet to exercise in full view of observers. Here, the artist centered the wheel between boxy structures that were painted to look like townhouses. When the squirrel ran around the wheel, carpentry activities were activated in an upper story designed to appear under construction. The fanlight doorways, structural quoins, and paned windows of the painted sides mimic Federal or Georgian architectural styles.

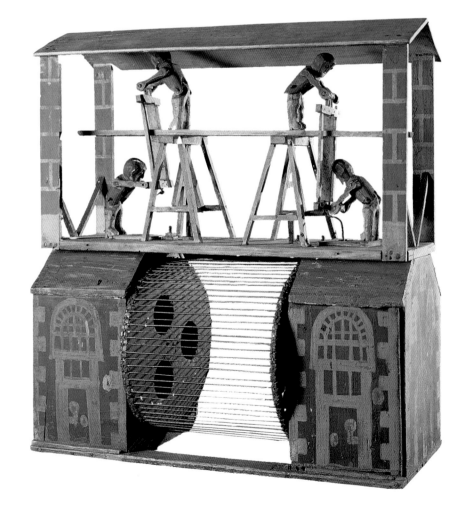

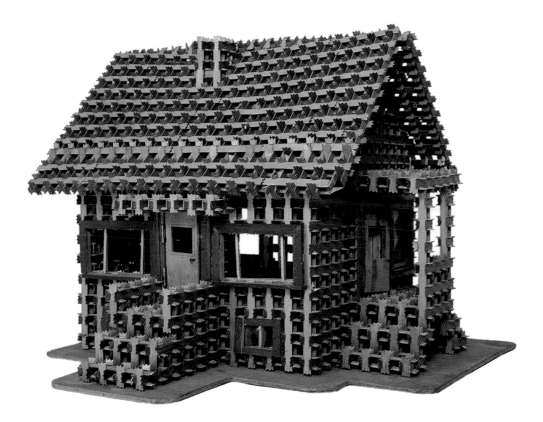

HOUSE, c. 1920s
Artist unknown; New England
Scrap wood construction, 19½ x 21 x 24 in.
Collection of John and Linda Sholl

A specialized type of tramp art made by interlocking (rather than layering) notched pieces of wood without using nails or glue is known as "crown of thorns" or puzzle work. It makes this rare three-dimensional whimsy seem transparent. The openwork structure appears solid but is delicate in reality. Compared to chip-carved tramp art, fewer "crown of thorns" pieces have survived intact. Frames and crosses are traditional choices for this work.

MODEL BUILDING, c. 1920
Stanislas Pichette; New England
Chip-carved cigar boxes, crates, and glass,
32¼ x 27⅞ x 22⅛ in.
Collection of John and Linda Sholl

Passage of the United States Revenue Act of 1862 mandated the sale of cigars in non-reuseable wooden boxes of standardized dimension. Tramp art thereafter flourished as millions of cigar boxes were added to the supply of scrap lumber from which traditional mementos had been carved. Tramp art houses are an unusual configuration, according to John and Linda Sholl, New York collectors and dealers. Churches were the most commonly crafted structures, perhaps made as a sign of reverence.

This artist assembled the windows like picture frames, rabbeted in with wood strips so that the sixty-two pieces of glass—etched, stained, and colored art glass—could be changed as needed or fancied. Pichette may have been one of the many French Canadian workers who labored in the mills of northern New England, where there was ready access to the material used to fashion tramp art.

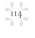

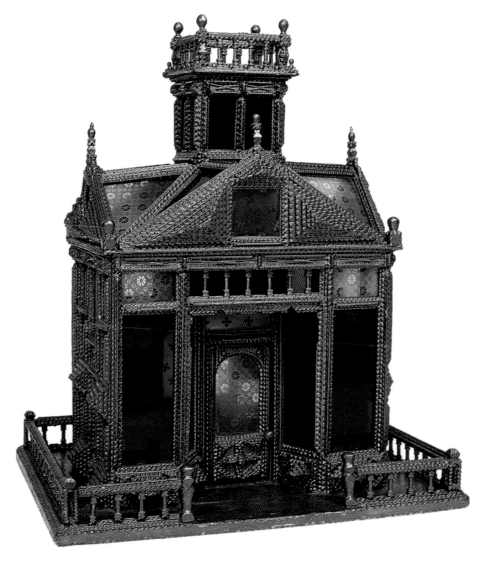

VICTORIAN HOUSE MODEL,

c. 1870–90

Artist unknown; Montgomery County,
* Pennsylvania*
Painted wood construction with some metal,
* 72 in. tall (with stand),*
* base approximately 54 in. square*
Collection of Greg K. Kramer

Constructed like a real dwelling, this is a
Victorian house model on a grand scale. It is
accurate in materials and details, from the
individually carved little wooden shingles to
the cast maiden statues of the fountain in
back, the brass Philadelphia gaslight fix-
tures, and the tin whale oil lamps intended
to be lit when the house was brought out for
display. The interior has open, finished, but
unfurnished rooms. The house was built in
four sections: the removable top spire or bell
tower, the residence, the surrounding ele-
ments, and the supporting stand. It is one
of two houses known, suggesting that to be
evenhanded one may have been made for
each child in the family whose house this
replicated, according to owner, Greg Kramer.
The house's exuberant polychrome finish
typifies painted Victorian high-style dwellings.
Excellence of workmanship extends even to the
working fountains located at the rear of the
house that operated using gravity-fed water
from a hanging bottle.

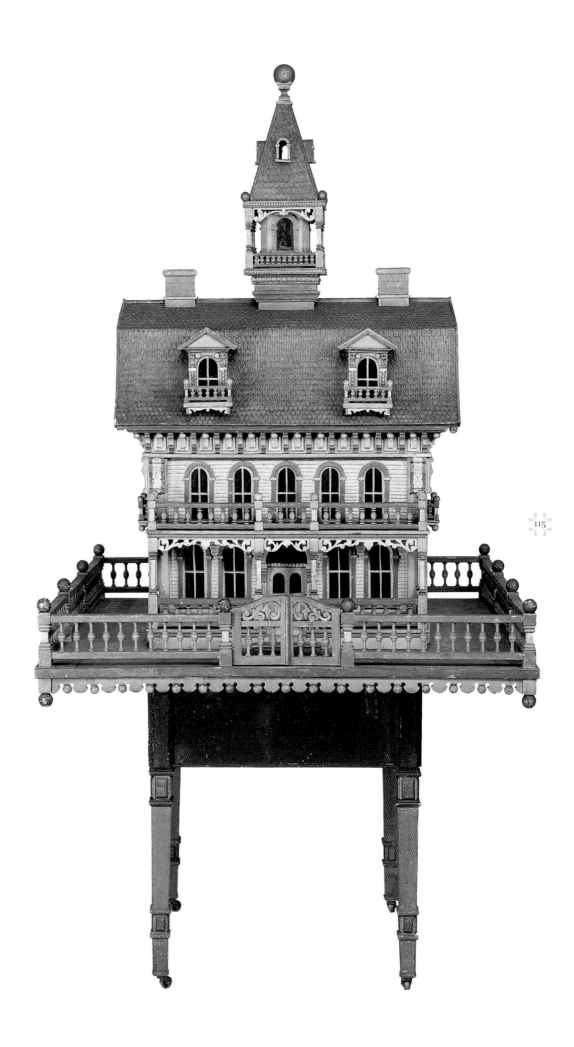

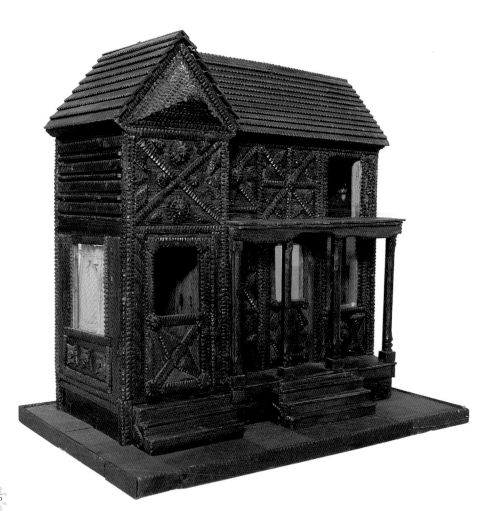

QUEEN ANNE–STYLE DOLLS' HOUSE,
c. 1915

Artist unknown; found in New England
Chip-carved cigar boxes, 24 x 26 x 16¼ in.
Collection of John and Linda Sholl

Chip carving distinguishes the exterior of this unusual dolls' house. The fussy sawtooth edging of the facade elements, including even the roof, lends the piece what is known as a "carpenter Gothic" appearance, unusual for tramp art, which was most often shaped into simple church or house models that were non-functioning, and into small decorative accessories like boxes and frames. The open back of this house permitted access for children to play. At one time the interior had been completely wallpapered, but over time the true cigar box construction of the dolls' house became exposed as the paper disintegrated. All the revenue stamps and label imprints of the cigar factories of origin are now visible.

MANSARD ROOF DOLLS' HOUSE,
c. late 1800s

Made by Herman Rush; Philadelphia
Painted wood construction, 26 x 23 in.
Private collection; Photo courtesy Northeast Auctions,
* New Hampshire*

This skillfully executed dolls' house is accurate in detail down to the lace curtains. The two-and-a-half-story building has a gray "limestone" foundation, a shingled mansard roof with sawtooth railing all around, "brickwork" surface, corbelled eaves, a center chimney, arched window cornices, and even dormer windows. The side porch and front entry shielded with shingled roofs were trimmed ornamentally with openwork railings. Access to the interior was through the open back.

Herman Rush emigrated on his honeymoon from Germany to Philadelphia, where he had a daughter for whom he made this realistic dolls' house. She passed away a year after it was made, and the Rushes moved to Ohio, where he worked as a cabinetmaker for a piano company.

BEL AIR DOLLS' HOUSE,
c. 1885
Made for the five Dibb Sisters;
Bel Air, Maryland
Painted wood construction, dimensions
unavailable
Collection of Washington Dolls' House & Toy
Museum; Photo courtesy of Flora Gill
Jacobs; Photos by Richard K. Robinson

"If only we could be five inches
high," says Ms. Jacobs, founder of
the Washington Dolls' House & Toy
Museum. "Wouldn't we like to live
here!" This dazzling house has all
the elements of a real Victorian
residence—from the capacious urns
flanking the front stoop, to the flag-
pole high above the front door, the
dormer windows jutting out, the
balustrade sitting atop, and the two
chimneys at the rear of the sloping
roof. Carpentry details abound in
the realistic corbel supports and gin-
gerbread woodwork trim, especially
at the tall pedimented windows, each
with its own balcony. The windowed
back of the house opens out from
the center to reveal lace curtains and
two floors of six rooms in which to
conduct much imaginative play. On
display, the Bel Air house is outfitted
with the figures of a mother, daugh-
ters, and family pets placed in room
settings filled with appropriate minia-
ture home furnishings and accessories
of the period, right up to the chan-
deliers. The figures could be situated
inside the house, on the balconies, or
in the surrounding fenced-in yard
as the Dibbs sisters played. Decorated
for the holidays, wreaths trim the
windows and a Christmas tree stands
in the front hall.

BANK MUSIC BOX, c. 1920
Artist unknown; found in Wisconsin
Painted wood and metal construction, 7 1/2 x 4 1/4 x 6 in.
Collection of Leon and Steven Weiss/Gemini Antiques

The red gingerbread trim and half-timbered construction details that decorate this two-story wooden house hark back to the architecture of rural Scandinavia and the Tyrol, perhaps the homeland of the immigrant artist who probably made this unique bank. An unusual feature is the music box built inside that is activated when a coin is dropped in a slot in the rear pitched roof—a creative attempt to compete with the exciting action of the then-popular cast-iron mechanical banks.

COIN BANKS, c. 1860s–1900
Various manufacturers
Cast Iron, Hall's Excelsior Bank: 4 x 5 1/4 x 4 in.
 City Bank: 4 1/2 x 7 x 4 3/4 in.
 Novelty Bank: 4 1/2 x 6 3/4 x 4 1/2 in.
Collection of Leon and Steven Weiss/Gemini Antiques

The earliest cast-iron mechanical bank was a building: Hall's Excelsior Bank, patented in 1869. Some three hundred different iron banks followed. In the Excelsior Bank (top right), a monkey pops up at the top when a coin enters the slot and in the Johnson Novelty Bank (below), the saver places a coin on the tray held by a cashier, then shuts the door, causing the coin to drop into a slot inside. Architecture in a variety of sizes and structures appeared also in "still" banks (coin boxes with no moving parts), where a coin was placed through a slot in the roof or the facade. The typical still bank (top left) had pierced windows, an overhanging roof, and a center chimney; was titled over the doorway perhaps "City Bank" or "Bank"; and was just small enough to fit a child's hand. Buildings took many forms in both bank types—the classical imposing public building, usually the bank, with columns and pediment that was a central feature of any small town in America; the log cabin; government buildings, either local or national, and later even skyscrapers.

CHURCH MAILBOX, c. 1880

Artist unknown; Maine
Painted wood construction, 26 x 11 x 19 in.
Collection of Liz and Irwin Warren;
 Photo courtesy Antiquarian Equities, Inc.

From its Gothic arched windows to its spire topped with a fish weathervane, this miniature piece of architecture with its unusual purpose echoes the attention to detail seen in realistic toy houses, birdhouses, and house models. This church style sprang up in hamlets throughout the country; the great condition of its surface and the existence of the original little vane suggest that it was mounted protectively on a porch. The mail is placed in front, beneath the steeple, and can be removed from the back. In block capital letters on the front it states U.S. MAILBOX, and in a semicircle above the arched window, "Dr. Barnes," perhaps the cleric for whom this whimsical yet functional piece was made.

VICTORIAN TOWNHOUSE MAILBOX,
Dated 1877

Manufactured by J.W. Fiske Company; New York
Cast iron, 19 ½ x 7 ½ in.
Collection of Barbara Israel Garden Antiques;
 Photo by Mick Hales

This unique piece impressed with the foundry mark for J.W. Fiske has not been found in any of the company's catalogs. From 1850 through 1900, John Winn Fiske was the country's preeminent purveyor of ornamental cast iron and zinc figural and animal garden statuary and furniture, as well as copper weathervanes. The mailbox, one of only two known, has architectural elements typical of the late Victorian era such as a mansard roof, pierced-work front door, and (simulated) brickwork exterior; the door section lifts up from its hinged top to reveal a niche in which to place the mail. The letters U.S.M. (for United States Mail) in low relief at the shaped top portion—where the box would be anchored to a building or post—indicate its intended legal purpose. It may have been made as a special commission for the owner of such a townhouse. By the mid-1800s, manufacturers were able to experiment with the possibilities of cast iron.

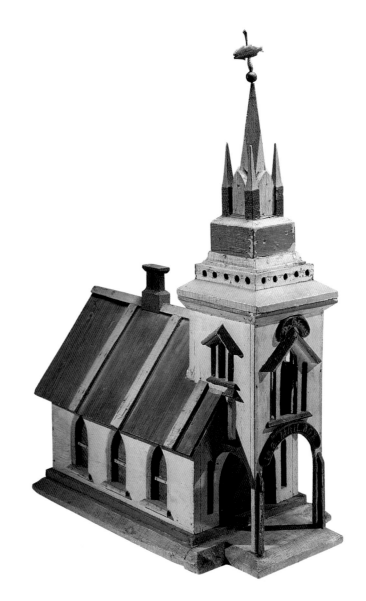

119

BIRD CAGE, c. 1876
Artist unknown; found in New York
Painted wood construction with metal,
 29 x 17 x 29 in.
Collection of Allan and Penny Katz

This pleasingly rounded cage represents the United States Capitol Building with its tall dome. Probably made to commemorate the U.S. Centennial in 1876, patriotic homage is expressed in the choice of paint colors for the circular bird swings and the shaped details around the cage that have no relevance to the type of bird housed. Traditionally, cages are straight sided and basically square or round; this architectural cage is also a wonderful open sculpture of impressive curved wires. Keeping birds in cages was a European custom popular in cities in France and Spain, for example, where outdoor markets that sold pet birds were commonplace.

BIRDHOUSE, c. 1890
Artist unknown; Pennsylvania
Painted wood, 22 in. wide, height unavailable
Private collection; Photo courtesy Woodard &
 Greenstein, New York

A European architectural and aesthetic sensibility is evident in this fanciful bird house, suggesting it was the nostalgic creation of an immigrant whittler. Ornamented with ornate pierced sawtooth trim, the steeply sloped roof areas have several openings through which birds could enter the house. The artistic roof of the birdhouse was painted in an intricate, colorful pattern. It is inspired, perhaps, by an actual residence of a member of Pennsylvania's large Moravian population in which such an architectural embellishment would have been executed in tile. Or it may have been influenced by the ancestral vernacular building style remembered by an immigrant from his hometown in Bavaria or Scandinavia.

MARTIN HOUSES,

c. late 1800s–mid 1900s

Artists unknown; found in various states

Painted scrap lumber construction, various dimensions

Private collections; Photos courtesy American Primitive Gallery

Martins are communal birds, so their houses must have multiple openings to accommodate a group of flying visitors. The Maine farmhouse (top right) has an attached barn and silo and realistic details of a country place, including a horse weathervane on the cupola roof. The tower sanctuary (bottom left) is six-stories high with surrounding decks on which to perch. It adjoins a gambrel-roofed structure with additional entry holes. The triplex (bottom right) has painted hearts to delight human observers at times when avian activity quieted down. Situated atop high posts, martin houses have exhibited an architectural variety that is extensive, perhaps because their larger scale offered woodworkers an opportunity to copy in detail many different, expansive building types. Whether they achieved considerable height or width, they did their job, as evidenced by the nests found in many vintage houses.

HOUSE SCENES WHALE'S TOOTH, c. 1890

Artist unknown; American

Scrimshawed whale ivory, 5⅝ in. long

Kendall Whaling Museum, Sharon, Massachusetts

An anonymous mariner carved highly detailed scenes of town and country on either face of a sperm whale's tooth. The house is of classic early nineteenth-century form, with symmetrically placed windows on two stories and a chimney at each end, within a brick wall accented with a gate and iron lantern arch. A couple out for a stroll encounters a neighbor. On the reverse, the buildings of a probable New England town stand across a river from an active farm scene. These skillfully designed landscape scenes are bordered on either side with imaginative rows of engraved leaves and flowers executed to look like embroidery stitches.

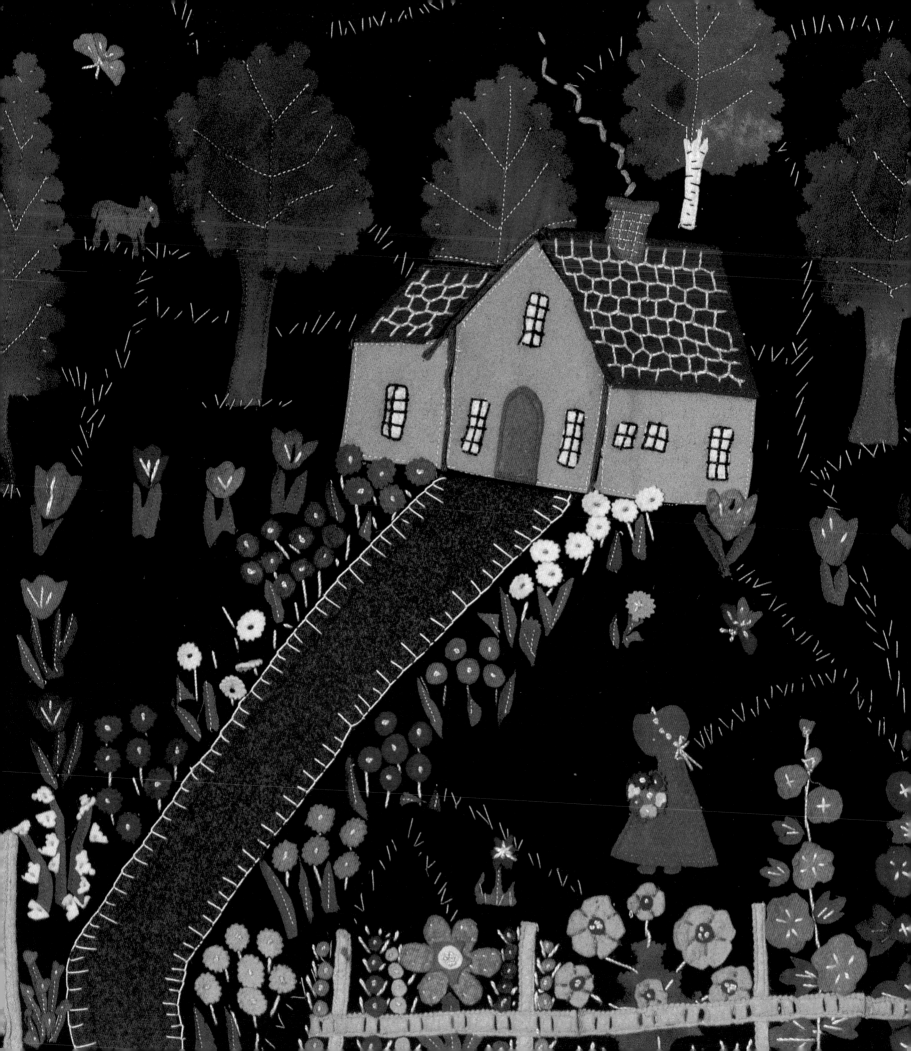

A long-standing question surrounds the North American origins of hooked and yarn-sewn rugs. Did hooking originate in coastal New England, where women emulated the work of sailors who sewed strips of material through sailcloth to make mats? Or did handmade rugs begin first in Canada, deriving from the tambour-work embroidery of French Ursuline missionary nuns? ❈ The farmers, fishermen, and their wives who emigrated from northern Europe—Scottish, English, French, Scandinavian, German—settled both regions of North America, in fact, and brought with them craft traditions and a common culture that led to the evolution of handmade rugs that are now considered a significant category of folk art. ❈ Then, as now, all that was needed was a hook, some rag strips or yarn, and a foundation material attached to a simple stretcher of four wood slats lashed together. It cost practically nothing to hook with rags, and required no special equipment beyond a bent nail pushed into a piece of wood shaped to fit the palm. By the early 1800s, as yarn-sewing techniques and then hooking began to be explored and refined by women living in both the United States and Canada, some remarkable pieces of textile folk art emerged. ❈

chapter five

YARN-SEWN,

SHIRRED, &

HOOKED RUGS

Seldom were architectural images seen in early-nineteenth-century hooked and sewn rugs. Instead, the motifs consisted of "vine borders and realistic baskets and sprays of flowers, drawn upon the background without attention to formal design . . . with a palette that relates to fine embroideries and early imported dress brocades."[1] Inspirations for design included one's natural surroundings as well as elements borrowed from Aubusson and oriental carpets, print sources, printed and woven fabrics, and china. ❈ By the mid-nineteenth century, houses on many hooked rugs were generic in form perhaps because a precise rendering was more difficult to finesse with a rug hook and rag strips than in paint or carving. However, the women who hooked and sewed rugs were not reluctant to employ perspective, scale, and detail even with cumbersome materials. Like paintings, rugs hooked with architectural images would have to be viewed from only one direction, unlike traditional utilitarian rugs whose geometric or floral motifs could be seen the same way from all angles. ❈ According to Joel and Kate Kopp, American folk art dealers and curators for the groundbreaking 1976 exhibition of

hooked rugs at the Museum of American Folk Art in New York City, "Rug collectors regard their cache as one of the most personal forms of folk art, full of originality, mystery, and often humor. When women made quilts they showed them off to family and friends. What other people thought about your piece was important; most of them were crafted from pieced patterns that were purchased either through catalogs or periodicals, or else swapped with other quilters. Rugs, on the other hand, could often be original compositions: the family dog might end up on a rug as a familiar form but made up of three colors, thanks to those varied materials and to the freedom and greater eccentricity of approach practiced by rug makers." As rugs were intended for floor use mostly, to be stepped on and worn out, the feeling was that no one could really pass judgment on them. Few women signed their rugs, as they did other forms of Americana; this underscores with what little significance people regarded their folk art creations underfoot.

In recent years, as significant rugs have begun to command record prices at auction, the attention to—and the prices paid for—this category of folk art has increased dramatically. Rugs originally intended for floor use, not just the uncommon room-size examples or the rare yarn-sewn rugs now preserved as wall art, have surged upward in value as awareness of their folk art quality and scholarship about their origin and techniques expands.

EMBROIDERED, SHIRRED, AND YARN-SEWN RUGS

The earliest forms of handmade rugs exhibiting pictorial motifs were embroidered, shirred, or yarn-sewn, rather than hooked. The wool and flax with which they were made were spun and dyed at home. The earliest sewn rugs were not used as floor coverings,

but rather were made to cover a small table or chest. They were also used at the fireplace, either to protect a costly carpet from ashes or to cover the hearthstone in summer. Floor coverings did not become popular in America until the early nineteenth century. Up to that point, homes had either bare or sand-covered floors. The wealthiest citizens imported carpets from Europe and the Orient until American textile mills began production in the 1830s.

EMBROIDERED RUGS
Threading wool yarn through a large needle and sewing loops through a background foundation with short, decorative stitches was the technique used to create these rugs.

SHIRRED RUGS
These rugs were made by gathering long, narrow cloth strips, cut either straight-grain or bias, and securing them to the supporting base material with needle and thread. Different effects could be achieved by the shaping and placement of the cloth strips. For example, strips folded to form tightly packed pleats resulted in a hard, dense pile formed by the tops of the pleats. Strips gathered to form shaggy-edged rosettes could be joined to a base by their centers. On the back of the foundation of shirred rugs, only the small stitches used to anchor the material are visible. Shirring was fashionable from about 1835–60. [2]

YARN-SEWN RUGS
The method used to make these rugs was favored during the late eighteenth and early nineteenth centuries when bed "ruggs" were used for warmth. The "rugges" or "ruggs," also used on small tables and occasionally on floors, had Scandinavian antecedents. With a sewing needle and a continuous running stitch, wool yarn was sewn through a foundation fabric such as hand-woven linen or

wool, canvas, or even a grain bag. This sewing technique created closely placed rows of loops on the surface. If clipped, the result was a soft pile.

Embroidered and unclipped yarn-sewn rugs sometimes resemble tambour work—a type of needlework in which the fabric is stretched on an embroidery frame and a hooked needle is used from underneath to work stitches on the surface that resemble a chain stitch.

APPLIQUÉ RUGS

Heavyweight wool and felt materials were cut into geometric shapes and anchored to a foundation to make "button" rugs or table covers. Imaginative needleworkers handled these fabric shapes with a variety of results. Some motifs for appliqué rugs were achieved by tracing the circumference of a coin (hence the name "penny mat"), a glass, or a cup. These shapes were organized and layered in graduated sizes on a background of wool, ticking, or sacking and sewn in place with a "tack" at the center and/or finished around the edges with a blanket or buttonhole stitch.

Appliqué was also used to accomplish pictorial design similar to appliquéd work in quilting. Representational shapes and images were cut from a variety of fabric scraps and stitched in place to compose a narrative scene. Pictorial appliquéd rugs served as table covers and even were hung on the wall like paintings.

Appliquéd rugs were often lined or backed with additional material and sometimes finished with either a handmade fringe, with a "fish scale" edging consisting of overlapping scalloped shapes, or longer "tongues," traced from the heel of a shoe. The delicate nature of their multi-layered composition made them unsuitable for long-term use as floor coverings.

Hooked Rugs

❋

Traditional hooked rugs were made by pulling a narrow strip of cut fabric up through a foundation material with a special tool tipped with a hooked head, rather than a needle. The materials used to hook were usually scraps of wool or cotton from worn clothing or blankets, cut into narrow strips about 1/4-inch wide. The foundation might be homespun linen or sacking stretched on a simple wooden frame.

"Hooked rugs form the largest and most varied group of early nineteenth century floor coverings"[3] and proliferated in regions where the winters were long, the climate cold, and the economy limited. At that time, both the hooking and foundation materials would have been spun and dyed at home, but by mid-century, as the practice of decorative rug hooking flourished, scraps from mill ends and factory manufactured fabrics, commercial dyes, and pre-stamped designs became popular options for the women who made rugs.

Rug hooking is also called pulled-in or drawn-in work, referring to the technique of maneuvering cut cloth strips through a loosely woven foundation. The rug maker could either leave the strips looped and uncut on the surface, or clip them in a process known as shearing to achieve a velvety surface effect. The two approaches might be combined so that the height of the loops and the surface texture varied, as in the sculptured raised-work from Waldeboro, Maine, and the Acadian provinces.

The way to distinguish hooked rugs from embroidered, yarn-sewn, or shirred rugs is to examine the back. In hooking, the surface design is echoed on the rug back because the strips have been pulled through the foundation, not sewn on top of it. Densely packed loops cover the back in the same pattern as the surface, masking the supporting foundation.

Designs for hooked rugs were drawn on a linen, tow, homespun, or ticking foundation. After outlining the images, the maker would proceed to hook those areas and then work the background. Motifs chosen were usually inspired by the hooker's natural environment. The maker might use a fallen leaf, a scallop shell, or a child's hand as a template for part of her composition. However, she had to rely on her skills of observation to create architectural designs and the resulting images are usually condensed versions of a house or homestead, seldom actual renditions of a particular place. Buildings were portrayed with varying degrees of sophistication. Some were primitive, boxy, blocklike forms embellished with only one or two windows, a door, a chimney, a pointed roof—the reduced essence of home sweet home. Others were intended to suggest a real place—their wings, windows, windowpanes, outbuildings, additions, and landscape settings fabricated in cloth strips with great attention to detail.

Hooked Rug Patterns

❋

The advent of prestamped patterns and cottage industries transformed rug hooking forever. During the second half of the nineteenth century, some astute male entrepreneurs sought to capitalize on the utility and appeal of rug hooking by widely distributing prestamped burlap patterns through catalogs and local retail outlets.

By the nation's Centennial, two important changes had ensued in how rugs were created. First, burlap, loosely woven Indian jute, had become increasingly available during the 1850s because it was the packaging material for all sorts of transported and imported dry goods. It came to be reused widely as the foundation for rug hooking, in place of arduously homespun material. The burlap sacks, when opened out and washed, became an appropriate size for rugs. Most rugs were rectangular, up to approximately 3 by 5 feet, worked on a small, easy-to-make frame; circular, demilune or half-pie, oval, and square shapes were less common. The most challenging to hook and the rarest to find from that era were the larger carpets made to cover the entire floor of a room.

Second, a method was invented to stamp burlap with stencils in attractive patterns for hooking. Though the Lowell, Massachusetts, firm of Chambers and Lealand first manufactured wooden printing blocks for stamping in 1853, it was Edward Sands Frost of Biddeford, Maine, with his metal stencils, who spurred the design vocabulary to its greatest heights during the Victorian era.

Taking note of the popularity of rug hooking among local women, Frost saw an opportunity to make the process easily available to women with limited design skills by producing stenciled patterns on burlap backings. His stamped rug patterns resulted in the home production of nearly identical rugs filled with flowers, scrolls, animals, or scenes, and even a generic house, no matter where the rug makers lived.

Frost, and later Ebenezer Ross of Toledo, Ohio, stamped out hundreds of designs, first in black ink and then in color to better guide the purchaser's hooking efforts. In the brief period 1864 through 1876, Frost designed 750 stencils and published 180 rug patterns, surprisingly only one of which includes architecture—the House and Mill, # 170.[4] Only one Ross pattern seems to have a geometric architectural background in a design with birds.[5]

Frost marketed his patterns through his peddler's cart, his catalog, and in retail outlets. Ross and other rug entrepreneurs, and mail-order firms like Sears & Roebuck and Montgomery Ward, inspired by Frost's success, issued their own prestamped patterns for decades to come, many of them copies of

Frost's designs. To facilitate the craft of rug hooking, improvements upon the old tools were invented, including Ross' 1886 punch or shuttle hook invention, and novelty gadgets like the Griffin Rug Machine manufactured in New Hampshire. The Canadian firm of Garrett's of New Glasgow, Nova Scotia, founded in 1892, introduced their Bluenose Hook in 1924, which accelerated the process by providing a tool that could be used with wool yarn instead of rag strips.

A distinguishing characteristic of Bluenose rugs is the evenness and uniformity of the looped surface. "This little machine pushes the loop through the burlap from the top, (the old fashioned hook pulls it up from the underneath side). The Bluenose Hooker is about six times as fast as the ordinary Hook, and is not nearly so tiresome to work. It is very simple to work, as we have several rugs made by a seven year old child."[6] "No rugs are more individual, none more artistic in design, more suggestive of quality, more upstanding in service, more moderate in cost."[7] The company manufactured and sold the tool in Boston as well as Nova Scotia for their large United States trade.

It may come as a surprise to learn that many rug patterns with houses originated with Garrett's. Girls working for the firm hand-painted the stenciled designs and eventually even hand-hooked rugs for sale. Patterns were sent throughout the United States and worldwide. Its stamped rug patterns were mail ordered from the 1890s until their last catalog was issued in 1974, distributed to a mailing list that at one time reached 20,000 names. Over 400 designs were issued, many incorporating favorite motifs of twigs, maple leaves, and scrolls. In one reported season alone, they sold 11,000 dozen patterns, for which they imported 150,000 yards of burlap.[8]

Ralph W. Burnham of Ipswich, Massachusetts, further transformed the world of

hooked rugs in the 1920s and '30s. Copying motifs from rugs gathered on shopping trips through Vermont, Maine, New Hampshire, Quebec, and Nova Scotia (some, no doubt, made from Frost and Garrett designs), Burnham developed his own stamped patterns on burlap, and sold them at his Burnham's Antique Trading Post for $2.00. Catalogs first published in 1922 were updated regularly. Burnham's patterns with architectural motifs included "New England Village"; "Cape Ann Primitive"; the seventeenth-century "Ipswich House"; and from his *American Boy* series, "Young Ben Franklin Arriving in Philadelphia" (page 146).

Eight yards of material would make up a 40- by 50-inch pattern, and customers could purchase the wool yarn or remnants, the hooking frame, and even a hook. Burnham also sold vintage and custom-made rugs to important collectors and prominent department stores like John Wanamaker, Marshall Field, and B. Altman. After his death in 1938 his widow Nellie Mae carried on the business until 1958, then sold it.

Even though critics have argued that stamped patterns stifled any creativity and individuality of design, close comparison of two rugs hooked from the same stamped pattern will often reveal the presence of elements that were added and color or material choices that ignored the guidelines, thus personalizing even a commercial design.

Cottage Industry Rugs
❋

Enterprising and public-spirited individuals both in the United States and the (now) Maritime Provinces created cottage industries that used rug hooking as a means to provide income for rural families, especially when work was seasonal or unavailable. Communities of women were organized and provided with materials and designs from which to hook rugs which would then be

merchandised by the association. As a result, rugs of seemingly identical image were marketed, some of which were identified by labels bearing the name of the group.

In fishing areas, rug money was often the only cash seen by the family, who otherwise bartered their catch for household goods. Such was the case with the beneficiaries of the Charitable Mission to Deep Sea Fisherman that Sir Wilfred Grenfell established in 1892 in Newfoundland and Labrador.

By 1912 Grenfell had developed a very profitable rug hooking and crafts business whose wares were marketed in the United States and Canada until World War II. The subtle shadings and precise hooking of Grenfell rugs were distinct from other hooked rugs for several reasons. The Mission gave workers fine silk and rayon rag strips cut from stockings with which to hook, instead of the traditional wool rags or yarn found in most other rugs. The lustrous, supple strips took readily to dye, in an extensive range of shades. Stockings were solicited mostly from American and British donors with the appeal: "Save your old silk stockings. When your stockings run, let them run to Labrador. . . . Please send your silk stockings and underwear no matter how old or worn. We need such silk and artificial silk for the making of hooked rugs of a beautiful type."[9] Brin, or unraveled burlap, was also used as a hooking material, giving some of the mats a distinctive texture and a honey color.

Lines of hooking were put in straight across, in contrast to the method of outlining and filling in motifs done in traditional rug hooking. Working through every hole in the burlap foundation, the skilled Grenfell workers might produce a supple and fine mat with as many as two hundred stitches to the square inch.

"Through the Mission 'Industrial,' organized by Grenfell's assistant Miss Jessie Luther of Massachusetts, island residents

produced superb quality goods of standard-ized design, unusual material, and precise construction," according to Paula Laverty, scholar and curator of a touring exhibition called *Silk Stockings: The Mats of the Grenfell Mission*.

The Mission worked with local women, among whom hooking had been a tradition for some fifty years. Luther, then Grenfell and his wife and a few designers, concocted the indigenous designs of northern life, and drew or stamped them on burlap. By 1923 over twenty copyright patterns were produced, quite a number with buildings, albeit small, simple, and unadorned homes and fishing "tilts," unidentifiable except for the six island churches which appear in several rug designs.

The fine, densely stitched Grenfell pictorial mats were sold in retail shops on Madison Avenue in New York City, on Locust Street in Philadelphia, and in Vermont and Connecticut. By the 1930s volunteers had spread out from the Mission to New York and New England resort areas to sell goods in hotels, clubs, schools, and homes. But a shortage of donated stockings and clothing led to production cutbacks and eventual closure by World War II. First sold in the United States for $5.00, they now command prices in the thousands.[10] Today, collectors know the Grenfell Mission best for its legacy of flawless and characteristic hooked mats of beautiful palette and northern coastal life imagery.

Many individuals founded groups to promote handicrafts for profit, increasing the knowledge about and interest in rug hooking that soon proliferated across the United States. Women suddenly found opportunity in the entrepreneurial world of hooked rugs and adopted the cottage indus-try approach on a smaller scale, aided by the use of prestamped patterns.

Helen Albee of Pequaket, New Hamp-shire, an adviser to Grenfell, trained local workers to hook her "Abnakee Rug" patterns. The Maine Seacoast Missionary Society; the South End House Industry in Boston; the New Hampshire League for Arts and Crafts; the Farm Bureau's Rosemont Industries in Marion, Virginia; the Spinning Wheel Cooperative in Asheville, North Carolina; and the Apison Community Rug Makers of Hamilton County, Tennessee, among others, promulgated rug hooking as a finan-cial opportunity for members.

Elizabeth Morse organized New England women to "hook every moment of their spare time authentic Early American rugs. They work at home and with the money thus earned are putting children through high school, paying taxes, buying new clothes for the families."[11] Morse controlled all steps of the process, obtaining materials from homes, factories, even casket companies that had broadcloth waste strips from coffin lin-ings. She distributed patterns, with the rag strips bundled by color she had dyed herself. She chose workers to complete the patterns based on their skills.

Finally, there was a whole group of gifted rug hooking teachers who became designers, entrepeneurs, lecturers, and authors, all in the cause of furthering the art of rug hook-ing for creative reasons rather than for char-itable purposes.

Beginning in the 1940s, Pearl McGown of West Boylston, Massachusetts did every-thing, including holding exhibitions and workshops, and graduating teachers certified in her methods to pass the skills along to others. She designed all the patterns she sold, and offered landscapes with architec-ture by copying Currier and Ives prints. Other talented teachers included Caroline Cleaves Saunders and Mildred Smith of Massachusetts, and particularly Louise Hunter Zeiser of Rhode Island, who published

several hundred intricate designs under the label "Heirloom Rug Patterns." These sold for from around $3.00 to $10.00 depend-ing on the complexity and size. Her "homes" included Pattern #523, "Home to Thanks-giving" (a Currier and Ives); #526, "Nova Scotia," a winter scene (pages 146–147); #686, "Colonial House," planted with hollyhocks and shrubs; #716H, "Primitive Scenic Pattern"; #716I, "Primitive House"; #716K, "Mountaineer's Cabin"; and #721, "Old Grist Mill" (pages 146–147).

Thanks evidently to such patterns, "many women who feel they have no artistic ability discover to their joy a natural gift for hooking rugs."[12] The emergence of patterns helped to continue a New England tradition in which mothers would hook rugs for their daughters to stand upon when they married. "For the woman with hands, eyes and imagination, a handmade rug is the simplest most satisfying way to self expression. . . . The growing work expresses every mood of the maker, and when it is finished it is the maker."[13]

Until the 1980s and 1990s, old rugs that found their way to auctions, estate sales, or antique shows would sell for comparatively little money relative to their folk art content. At the estate sale in the early 1980s of the noteworthy contents of Pokety, the home of pioneering folk art collectors Bernice and Edgar Chrysler Garbisch, early rugs went on the block, some of them the most significant examples known. A beautiful yarn-sewn floral table rug brought $34,000 at Skinner in 1989. In 1997, a room-size hooked rug dating from the late nineteenth century, depicting four Coton de Tulear dogs, sold for $74,000 at Sotheby's. Since those sweet-faced dogs exceeded by such a great margin any previous record for a hooked or yarn-sewn rug, who can predict to what upper limits the prices of the great ones may soar?

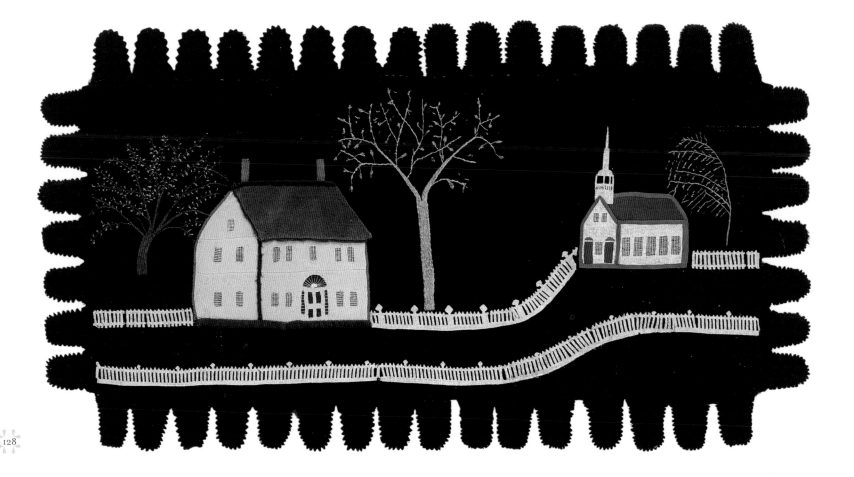

HOUSE AND CHURCH
PICTORIAL TABLE RUG,
c. 1840
Artist unidentified; Otisfield, Maine
Wool and gauze on wool, appliquéd
and embroidered, 28 ½ x 50 in.
Collection of the Museum of American
Folk Art, New York; Promised
anonymous gift

A place to live and a place to worship were the fundamental priorities of early American life. The two were linked together on this eloquent table rug by an intricate picket fence, every slat of which was individually cut out and appliquéd. A double length of fencing, each section linked with diamond-topped posts, delineates an otherwise unadorned road. Can we assume that the grand house represented the parsonage for the church's pastor, or was the rug maker illustrating the psychological proximity of the two most important shelters in her own life?

Thorough attention to the architectural components is evident in the fanlight and sidelights of the front door of the imposing residence and the mullioned windows and finely configured church spire. Delicate embroidery was used to create a weeping willow tree near the church—which suggests the presence of a cemetery—and the two trees flanking the house—perhaps an oak and fruit tree—symbolize strength and vitality. The pinked-edge heel-flap border lends a curious note of whimsy. Otherwise, the simplicity of the image and the clarity of its execution—light-toned geometrics against a stark black background—seem modern in comparison to that era's needlework traditions which favored naturalistic, realistically rendered forms and colors.

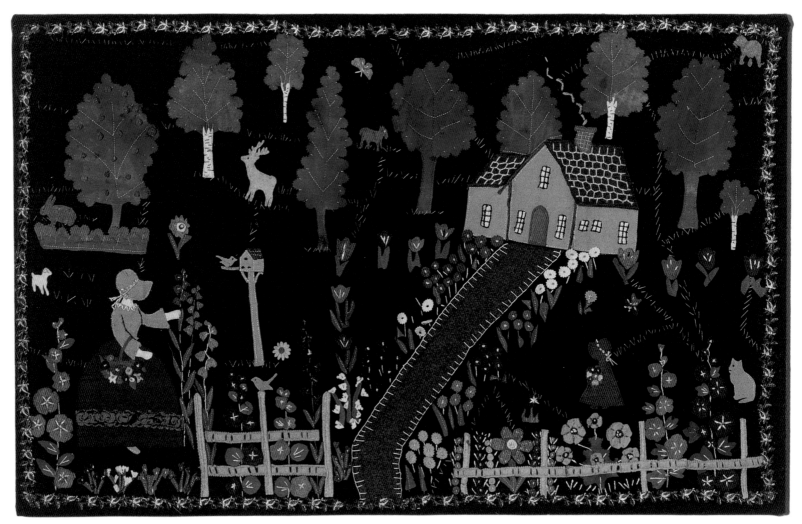

HOUSE WITH GARDEN
PATH, c. 1930
Artist unknown; found in New England
Wool felt and wool yarn, appliquéd
and embroidered, 24 x 38 in.
Collection of Laura Fisher
(Detail shown on page 122)

Approximately one hundred years after the making of the House and Church appliqué rug (page 128), another woman captured the relevant elements of her home life and era using the same materials and appliqué techniques. This artist combined ideas of her own with motifs derived from commercial patterns. For example, the female figures in profile tending to the garden (suggesting a mother and daughter) were familiar images to quilters. The smaller one resembles the endearing and enduring Sunbonnet Sue, a popular figure in the early twentieth century; the taller figure in a full, long skirt carrying a flower basket is no doubt derived from the Colonial Lady pattern. These figures and the floral elements were widely advertised in the 1930s.

The cozy cottage sits on its own plot of land—the American dream of a home of one's own. Even the birds have their own appliquéd dwelling. Hollyhocks, tulips, lilies of the valley, and stylized flowers sprout up around the fence and line the path to the garden. Blanket stitches outline the walkway and straight stitches define the windowpanes, roof shingles, brickwork chimney, and even the smoke. Wool embroidery serves as wisps of grass and accents the colorful stitched-on flowers. The gardeners share this idyllic domestic scene with animals: the ubiquitous folk art cat looks on, while wildlife gambols amid scalloped appliqué trees. The result is an engaging combination of the handling of pictorial elements, realistic or abstract, imitative or original.

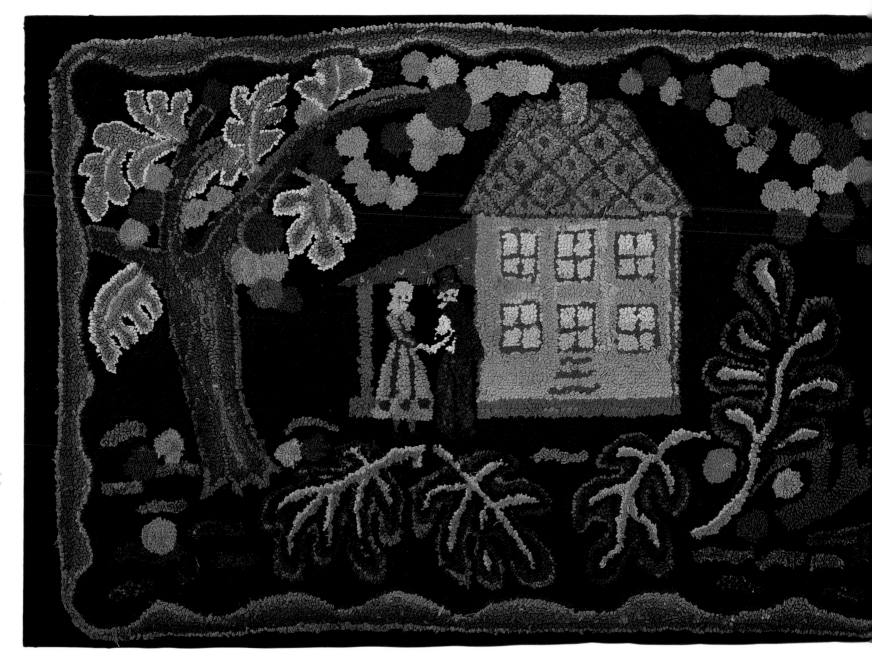

HONEYMOON COTTAGE,
c. 1930s

Artist unknown, probably Pennsylvania
Wool on burlap, hooked, 24 x 40 in.
Collection of Stella Rubin
and Robert Q. Barone
(Detail shown on page 2)

A June 1941 *Woman's Day* magazine article on rug hooking, one of many published from the Depression onward, discussed the revival of colonial crafts, particularly the popularity of rug making and collecting. It noted "the design of this pictorial rug, bold and brilliant, has an American folk art quality," and offered directions for hooking it to readers who sent in a self-addressed three-cent envelope. This rug varies slightly from the published version in color and its border, extending to an even edge beyond the scalloped original. The article attributed this rug to the Index of American Design (IAD), Pennsylvania

Art Program, WPA (Works Progress Administration). The Index, now housed in the National Gallery of Art in Washington, D.C., was established to record through watercolor illustrations more than 17,000 historic American designs from Colonial times through the 1890s on furniture, ceramics, glass, textiles, and pewter in the folk, decorative, and popular arts. In fact, the rug was not recorded in the IAD, only its design was. The happy couple at home appears on a Pennsylvania redware circular dish or pie plate (plate #2466), painted on the pottery foundation in liquid clay slip.

HOUSE WITH TWO TREES,
c. 1825–50
Artist unknown, initialed J.D.P.;
probably New England
Wool on burlap, shirred,
35¼ x 60 in.
Courtesy of the Society for the
Preservation of New England
Antiquities

Esteemed folk art scholar and collector Nina Fletcher Little recorded this folk icon as the first rug in the collections of early American furniture and artifacts that she and husband Bertram began cataloging in 1938, according to the Society for the Preservation of New England Antiquities (SPNEA). Unlike other people who followed the Colonial Revival trend in home decorating of that era by buying and/or making reproductions, the Littles pursued authentic pieces and researched them avidly. Their detective skills in referencing and attribution advanced the scholarship of American folk art in the post–World War I years, when great collections began to be assembled.

Mrs. Little discovered the initials J.D.P. stitched on the back of the burlap bag on which it was sewn. In her book examining early rugs, *Floor Coverings In New England Before 1850*, Mrs. Little describes the chenille effect created on this rug by tightly packed "caterpillar" rows, noting "soft rows of woolen cloth compose the design" and that "the trees with their oversized fruit and the floral corner sprigs suggest the influence of traditional needlework motifs." While the trees seem to be an appropriate size and scale for the building they flank, the fruits and half-dozen blooms that frame the homestead are outsized. Such a winsome composition epitomizes American folk art in its naive presentation and imaginative detail.

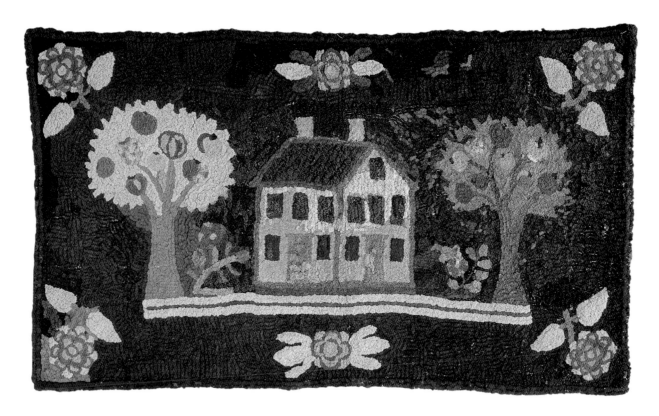

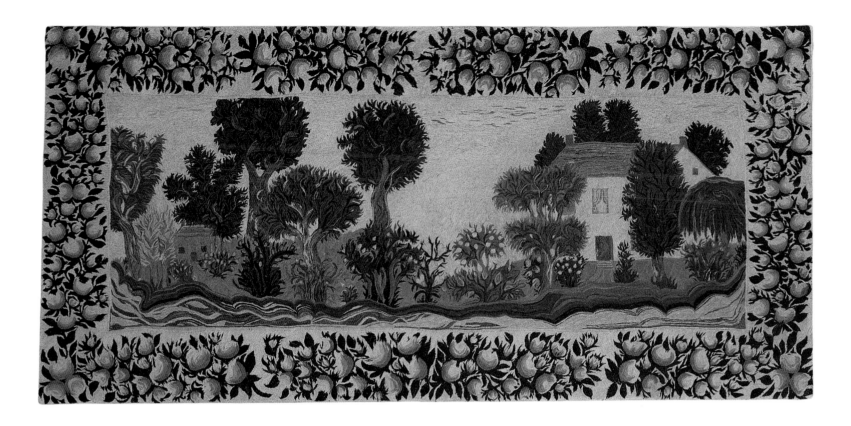

HOUSES IN A TREE-FILLED LANDSCAPE,

c. 1825-35

Artist unknown; found in northeastern
United States
Wool on linen, embroidered,
28 x 59 in.
Private collection; Photo courtesy
America Hurrah Archive,
New York

Many thousands of embroidery stitches, the needlework handled like paint, comprise a remarkable scene that is framed by an equally remarkable border. Its swirling energy and treatment of landscape elements foreshadow the style of Impressionist artist Vincent van Gogh at the end of the century. "In this labor-intensive work, there were no accidents," according to Joel and Kate Kopp, American folk art dealers; "every stitch was intentional, resulting in incredible undulations of line and color." The unknown artist animatedly captured all the organic details such as flowering and leafy trees, roses, buds, and sky. Both the massive two-story house with curtained window and its tiny counterpart on a hill across the valley are nearly obscured by bristling conifers, willows, and bushes. Was the great contrast in the size of these buildings meant to reflect an actual physical distance between neighboring homesteads, or perhaps a difference in economic status? Or was the smaller structure an outbuilding on a vast estate, or simply the whimsical result of the needleworker's attempt to convey

perspective? A rutted road or a river winds along the foreground of the rug. The buildings are minimally detailed in comparison to the myriad natural elements, yet the entire verdant composition portrays a locale as alive to us now as when it was sewn.

The breathtaking floral border is characteristic of crewelwork design that dated back to the eighteenth century—featuring trails of rose- and pink-shaded, rounded blossoms and ivy-green leaves on a cream background. At that time, greater emphasis was placed on workmanship rather than originality and it was customary for needleworkers to rely on similar pattern sources. Not surprisingly, New England pieces often reflect the influence of English embroidery. A design treatment such as this one might have decorated a petticoat border or a bed valence. However, in those instances there would be background fabric visible between the motifs. This rugmaker surpassed the efforts of her ancestors by covering every bit of the surface with intricate and elaborate stitching.

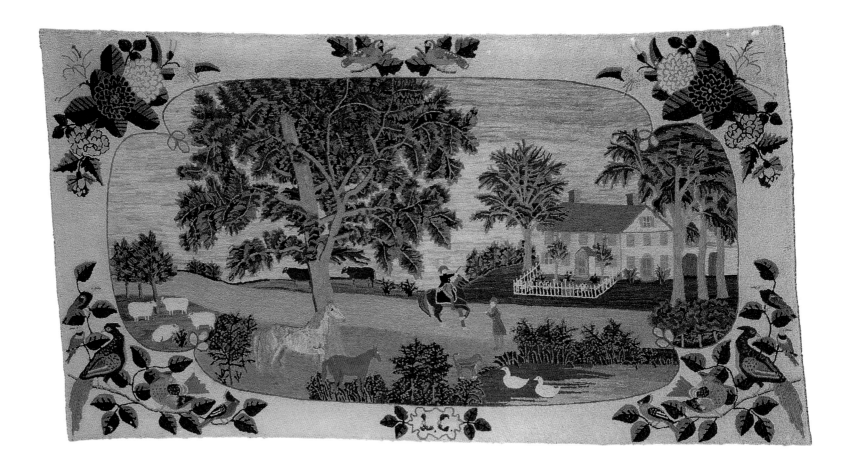

HOMESTEAD OF MAJOR
GENERAL HENRY KNOX
c. 1800

Initialed L.C.; probably Maine

Wool on homespun, embroidered,
28 3/4 x 53 1/2 in.

Collection of The Metropolitan
Museum of Art; Gift of Bernice
Chrysler Garbisch, 1965

Photo © 1999 The Metropolitan
Museum of Art

Tent-stitch embroidery delineates a lively pastoral vignette full of meaning about the moment and person it depicts. In the struggle for American Independence, Knox was a major general in the Continental Army, the first Secretary of War, the principal founder of the United States Military Academy, cofounder of the United States Navy, and "the Friend of Washington." He returned home from public life, retired after an illustrious career, to a tract of land thirty miles square in Thomaston, Maine. As Secretary of War, he had earned $2,450 a year. "When the gathering storm finally burst upon the country. . . . When from every sweet valley, and sheltered nook, and high hill of New England, the hardy yeomanry came thronging by thousands to avenge the blood shed at Concord and Lexington, he hastened to join them. . . . Pure in his patriotism, unswerving in integrity, and of noble self-devotion, he rises steady and strong, till he stands one of the chief pillars in the temple of American Liberty,"

declared a 1793 document about Henry Knox. In this brilliantly colored rug picture of the event, the robust officer halts his animated horse to greet a man in a brown coat. Around the estate, horses observe the homecoming scene while ducks, sheep, and cattle congregate in naturalistic formations.

Major General and Mrs. Knox each weighed more than three hundred pounds, and were referred to as the largest couple in New York City. Evidently they needed, and could afford, a manor house of substantial proportion. The fenced-in flower garden and the skilled execution of feathery leaves on the many tree branches and foliage suggest that the maker may have had academic needlework training. Although it seems likely that this rug was inspired by a print about Knox's return, imagination triumphed over imitation when the maker framed the scene with a jaunty, indented outline and filled the corners with enormous flowers and folky crested birds perched on leafy branches.

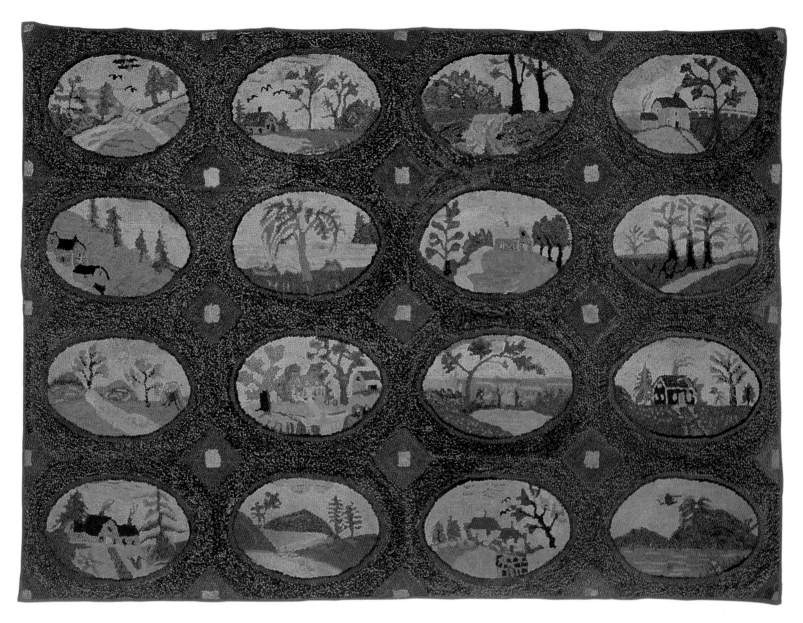

HOUSES AND
LANDSCAPES IN OVAL
MEDALLIONS, c. 1920
Artist unknown; found in New York
Wool yarn and rags, hooked,
52 x 72 in.
Collection of Penny Marshall;
Photo courtesy Laura Fisher

This most unusual hooked rug contains sixteen oval medallions that alternate a variety of housing styles and rustic country vistas. Each house oval contains landscape and other elements that differentiate it as a real place—on a sloping hillside, atop a hill, at the end of a winding path, in a homestead setting, in community with other buildings, and amid forested grounds. The varied scenery includes site-specific details such as rivers and lakes, clearings, and mountains. This charming composite looks as if the efforts of a Sunday easel painter had been translated into a rug, or the rug maker may have chosen to use hooking instead of painting as her artistic medium. If the region or town that the rug depicts were known, it might be possible to compare the accuracy of these hooked vignettes with county records or atlases of the period, or with an actual visit today. A combination of materials was used to bring about this unusual large rug: rag strips make up the oval medallions, while tweedy yarn fills in the surrounding background areas that are punctuated at regular intervals with square-in-diamond accents.

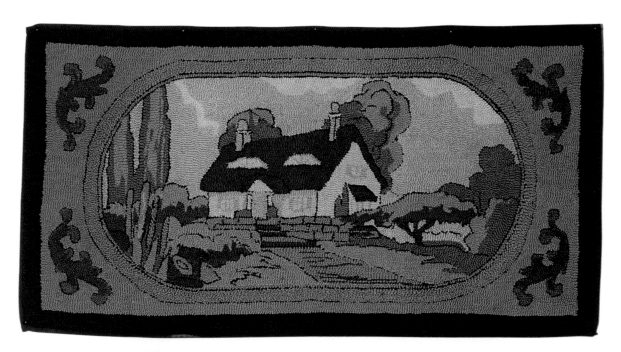

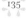

**OLD HOMESTEAD
PATTERN, c. 1930–40**
*Artists unknown; found in
New England*
*Wool yarn on burlap, hooked,
top rug: 32 x 60 in.;
bottom rug: 27 x 43 in.
Collection of Laura Fisher*

A prestamped design, probably Garrett's Bluenose Pattern #610, offered in different sizes, was used to hook two rugs that appear to be quite different and could fool a viewer into regarding them as distinct original designs. The house is the same structure in each rug, with a striped, sloped English-cottage-style roof, a curving portico over the front door, two roof windows, two chimneys, a side bay window, a stone foundation, and steps leading down to a path. The trees and foliage, including cattails, are similar in both examples but executed with such different color combinations that they bear little resemblance to each other. One maker hooked the pattern as printed, while the other seems to have flipped it over, shifting the placement of the house on its site from facing right to facing left. The top rug was hooked with yarn in a completely naturalistic palette; the bottom rug became an Art Deco or Fauve delight, hooked in an artistic palette of deep pastels that gave it a fantasy quality. Garrett's of Nova Scotia produced hundreds of rug patterns during the twentieth century, circulating them throughout Canada and the United States by mail order and direct sales in American outlets.

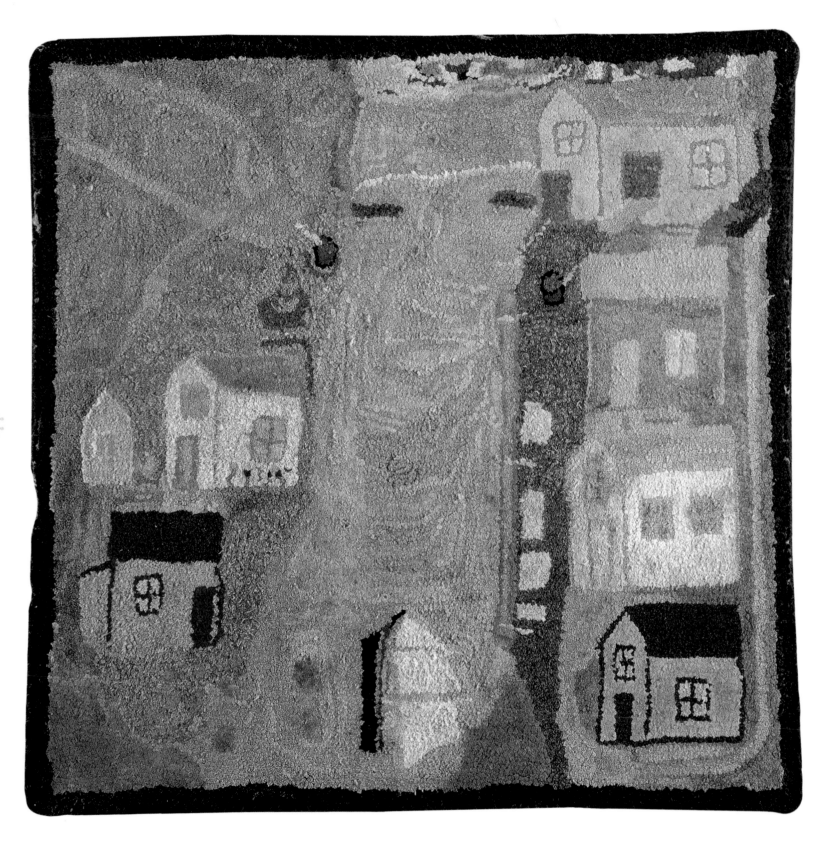

Opposite:
RIVERSIDE AERIAL VIEW,
Late nineteenth century
Artist unknown; found in New York State
Wool on burlap, hooked, 40 x 40 in.
Photo courtesy America Hurrah Archive, New York

Trying to capture a riverside vista on her rug, the unknown artist forsook perspective in order to include pertinent images. The result is a charming if precarious picture of a riverside community in progress. Though she tried to show both the front and side of most of the buildings to demonstrate their three-dimensional aspect, she was either unable or disinclined to portray the distance from foreground to background; instead the pictorial information appears as one flat plane. One shore apparently was more settled than the other; its structures are perhaps marine storehouses and the dock area is possibly a destination for the passing ship. On the other side, dirt paths meander toward the sparser shore. The largest building there is signed below the window "Zyser" or "Zysea," perhaps the name of the community or the maker.

FOURTEEN HOUSES, c. 1870–1925
Artist unknown; Maritime Provinces or New England origin
Cotton and wool on burlap, hooked, 89 3/4 x 24 3/4 in.
Courtesy Winterthur Museum

All the houses are hooked in a vertical format rather than horizontal, suggesting that it was designed for viewing in a specific place, possibly the entry hall of a house. The one-and-a-half-story dwellings are basically identical: there is a doorway and window on the front facade and a full-size window on the side. A smaller side window in the peaked roofs differs; it is round in some, diamond-shaped or square in others, an attempt perhaps to demonstrate that these were real and different homes, not merely an icon. The treatment of the house shape in repeat blocks, rather than in landscape, echoes quilts made from house patterns that were available to the public at about the same time period. In those, a pieced or appliquéd motif was repeated across the textile's surface to create an overall design; makers could vary the details to personalize either composition. Although in this rug the houses are aligned on a flat plane, there is no suggestion that the designer was trying to cope with the perspective, as appears to be the case in the Riverside Aerial View (opposite).

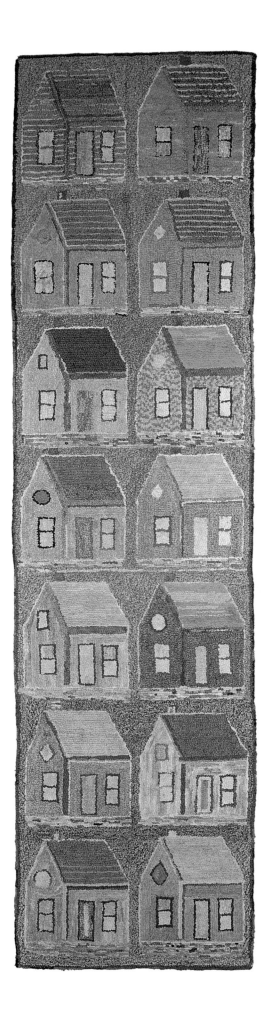

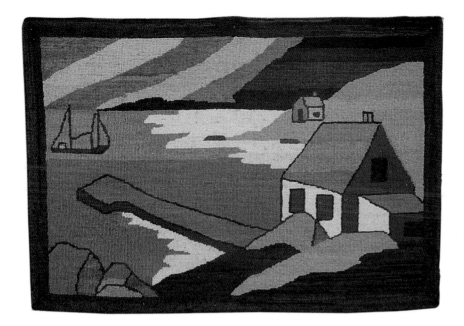

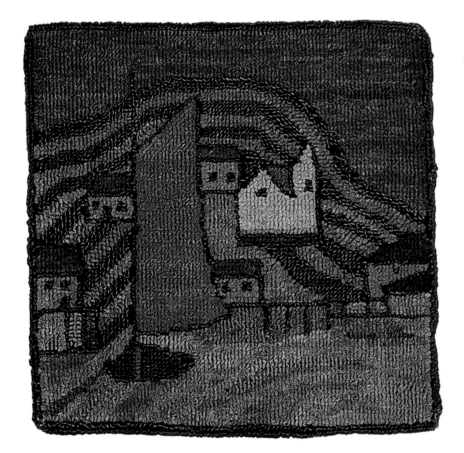

HOUSES, DOCK, AND SAILBOAT, c. 1935–40
Made for the Grenfell Mission; Newfoundland and Labrador
Silk and/or rayon on brin, 26 x 40 in.
Collection of Robert and Barbara Meltzer;
 Photo courtesy Paula Laverty

HOUSES, CHURCH, AND SAILBOAT, c. 1925
Made for the Grenfell Mission; Newfoundland and Labrador
Brin on brin, hooked, 9 x 9 in.
Collection of Paula and William Laverty

Modern abstractions of landscape emerged from the hands of many skilled Grenfell mat makers. In some artistic examples, blocks of solid undifferentiated color in outlined shapes were hooked. In others, what seems like a hundred different shades of blush, mauve, blue, and gold were hooked into just the one sky, capturing the palette of a northern sunset in a serendipitous fashion that has transformed into valuable art the unsurpassed craftsmanship of those workers. Shadows figure prominently in those compositions, expressing through the silken rag strips the powerful role of the sun in that region.

In the small mat (bottom), a striped hillside of buff-colored houses and a church evokes a visceral reaction from the viewer because it is foremost a powerful study of geometry, line, and color, not a real picture of the site. The curving stripes stand for the terrain, probably the geological strata of a rocky shoreline rather than plowed fields. Warm autumnal shades were used for the building forms and sailboat in the foreground. The wonderful sky was achieved by mingling shades of dark blue and bronze that add a mysterious sense of time to this small but powerful composition.

In the mat (top), in which a dock juts out into a bay, the cool tones and the absence of any bright color comprise an unusual and compelling variation. The many shades of gray, ranging from charcoal to palest dove, were accentuated subtly with mauve and celadon green tones that are barely visible. But it is the stark white that most commands attention: the water sparkling at the shoreline and dock, and the side of the house illuminated as if by the unseen sun's rays, as the boat returns home.

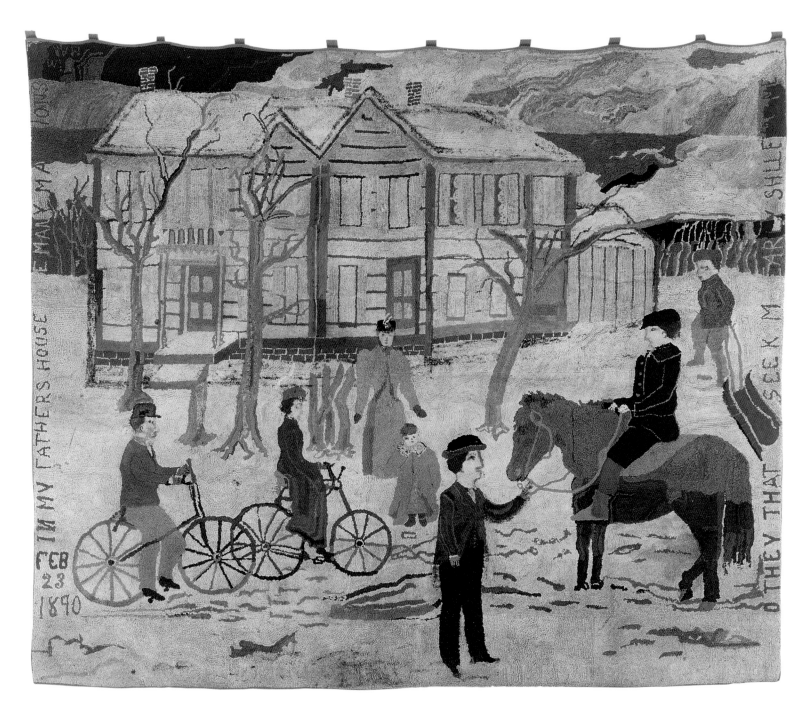

IN MY FATHER'S HOUSE
ARE MANY MANSIONS,
Dated Feb. 23, 1890
*Made by Eleanor Blackstone; designed
by Mrs. Blanche Blackstone
Grieves; Lacon, Illinois*

*Wool, cotton, silk, and human hair on
burlap, hooked, 93 x 112 in.*

*Collections of Henry Ford Museum &
Greenfield Village, Dearborn,
Michigan*

This is one of six exemplary narrative hooked rugs created by the Blackstones, mother and daughter, that portray the lifestyle and activities of a middle-class, midwestern family at the end of the nineteenth century. The Henry Ford Museum catalogs it as domestic/middle class/family record, and it is all of that. Seven Blackstones, adults and children, are shown outdoors after a February snowfall sledding, riding, and bicycling. The substantial home with its gabled roofline appears to be of clapboard siding on a brick foundation. The hair of the figures is actually the family's real hair, as is the fur trim on their clothing. Eyes and facial silhouettes have been inked or drawn in. The boy with his sled is J.P. Grieves, grandson of the rug's designer and son of its maker. Two Bible verses were hooked into the vertical sides of the rug: "In My Father's House Are Many Mansions" and "O They That Seek Me Early Shall Find Me." Other Blackstone rugs realistically portray the family having fun in a variety of seasonal activities.

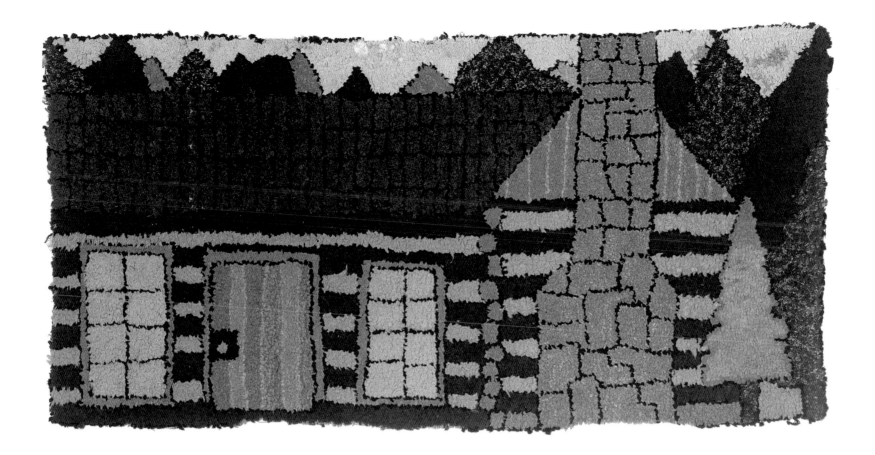

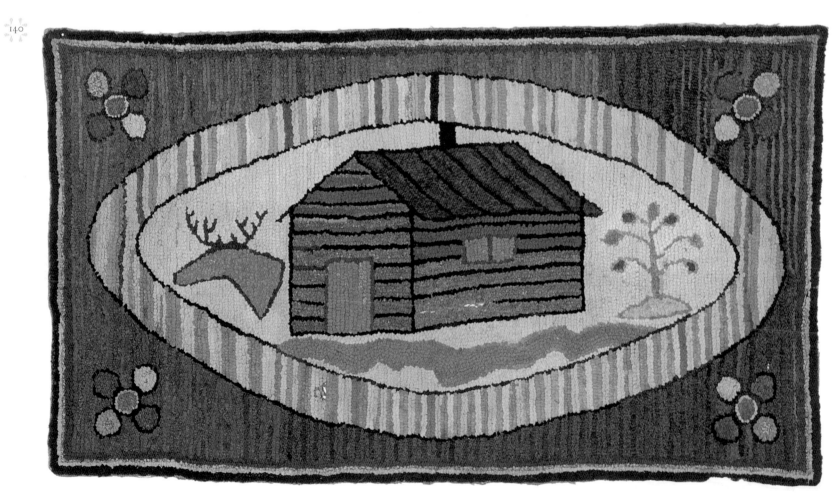

Opposite:

LOG CABIN, c. 1940

Artist unknown; found in New England
Wool rags on burlap, hooked, 23 x 48 in.
Collection of Penny Marshall

LOG CABIN WITH
DEER HEAD, c. 1920

Artist unknown; found in New England
Wool yarn on burlap, hooked,
26 x 48 in.
Collection of Laura Fisher

An enormous log cabin fills up an entire rug (top left), barely leaving space for a lone tree and a mountain range beyond. The house must have meant a great deal to the maker who immortalized it so boldly in rag strips. Details include the honey-colored sawed ends of the logs that interlock at the corner of the house, showing the cabin's construction; the planked door; and the stone chimney. Contrast this example with the cabin in an oval medallion (bottom left), in which the rug's overall design seems to have taken precedence over its central subject. The distinct parts considered together—a small house with stripes, a deer head, and the overall coloration—imply log cabin, although the building has none of the details of the larger one. Though it may not have been made from a stamped pattern, its oval framed center, corner motifs, and narrow hooked borders mimic many pattern rugs. Their format may have inspired this rug maker to compose her own version.

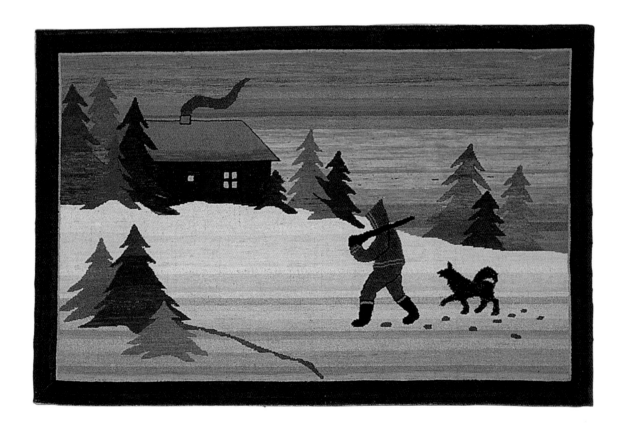

CABIN HUNTER, c. 1935–40

Made for the Grenfell Mission;
Newfoundland and Labrador
Silk stockings, rayon, and brin,
hooked, 24 x 36 in.
Collection of Robert and
Barbara Meltzer;
Photo courtesy Paula Laverty

In this story-telling mat, probably one of the most familiar of all Grenfell images, a hunter and his dog return home, their footprints hooked in the snow. Smoke rises from the chimney and lights are on in the cabin. Although the snow is white, it is hardly monochromatic; strands of color hooked in narrow lines suggest that the snow has drifted and the light has shifted. The twilight sky was realized through innumerable subtly shaded colors of stocking materials. Solicited from donors in the United States and Britain, the stockings were first dyed at the "Industrial," then cut into fine strips and given to the workers along with the stamped foundation. The alchemy of that operation became textile art that is studied, exhibited, and valued today. Although many examples of "Cabin Hunter" have been found, they differ due to the color choices and the hooking artistry of the individual workers.

**NEW ENGLAND TOWN
SCENE, DATED 1828**

*Maker unknown; initialed M P, A P,
 H K, E J; found in New England
Wool on linen, shirred, 32 x 72 in.
Private collection; Photo courtesy
 America Hurrah Archive,
 New York*

A densely coiled surface that looks and feels like caterpillars distinguishes this shirred narrative rug. Applied to the linen foundation in several directions, the shirred fabric strips convey landscape dimension. The rug has a still-brilliant palette and great texture from the thick strips forming the spirited images and background of the detailed panorama. A radiant sun, plus the moon and stars, shine on two buildings that flank a clapboard church. The three-story school is approached by a top-hatted schoolmaster chastising an errant student. A tiny lady ascends the church slope, where beyond, a man aims his gun at birds on the roof. Similarly worked trees, resembling a giant leaf, were a stylistic convention in schoolgirl needlework. A charming folky detail is the feet partially hidden by the rolling hills. Sets of upside-down initials, and various enigmatic motifs throughout, heighten the rug's mysterious appeal.

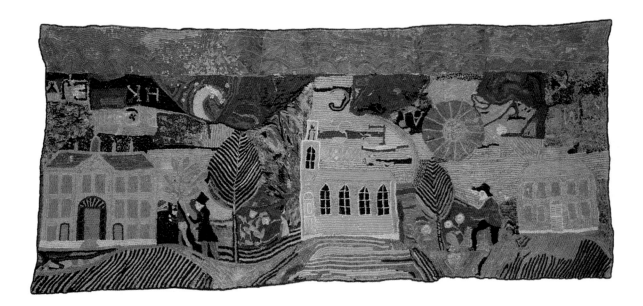

Opposite:

**PENNSYLVANIA AMISH
FARMSTEAD, c. 1930s**

*Mamie Smoker; Lancaster County,
 Pennsylvania
Wool on burlap, hooked, 40 x 103 in.
Collection of Dr. Leslie Williamson*

**LANCASTER COUNTY
FARM, c. 1910**

*Artist unknown; Lancaster County,
 Pennsylvania
Wool and cotton on burlap, hooked,
 26 x 40 in.
Collection of Connie and William Hayes*

In these rare property portraits of successful farmsteads are clues to the rugs' regional and even "ethnic" origin. The buildings and plantings typify Pennsylvania Amish and Mennonite farm layouts. Those Anabaptist religious sects placed their homes, barns, sheds, and gardens in a time-honored and characteristic relationship to one another. The architectural perspective was skillfully and accurately rendered in both, unlike earlier New England rugs in which images were hooked on the same plane, or in which distance was implied by the disproportionate sizes of things.

The wide scenic rug (top) documented a specific, orderly Amish farmstead including front gardens, a second house for grandparents, tobacco shed, summer kitchen, and chicken house. In keeping with religious prohibition, no people or animals were shown. The farm's first occupants were the Zugs, and later Christian Schmucker, whose descendent hooked this rug. The main house still stands, not amid farmland, but instead absorbed into downtown Lancaster, a familiar fate of large farms.

The unidentified Lancaster farm (bottom) has the house, barn, and gardens probably situated facing a southern exposure to catch the sun. The wide raised front porch conveys "farmhouse," despite the absence of livestock. The Greek key border, atypical for Amish and Mennonite folk art, suggests the rug was to display, not to walk on. In the absence of photographs, such heirloom rugs as well as paintings remain the only pictures chronicling the historic American farm landscape.

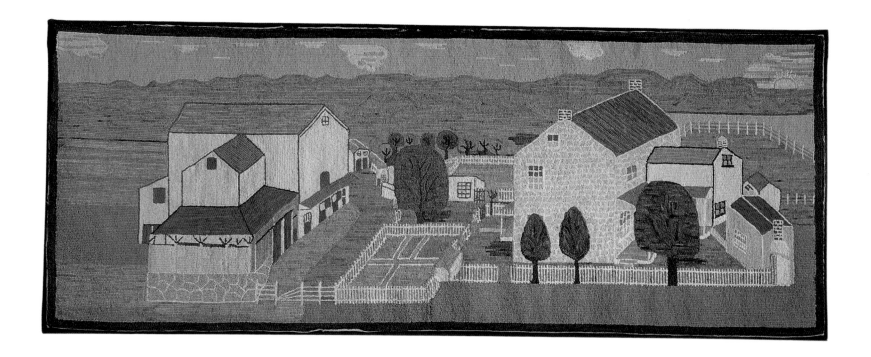

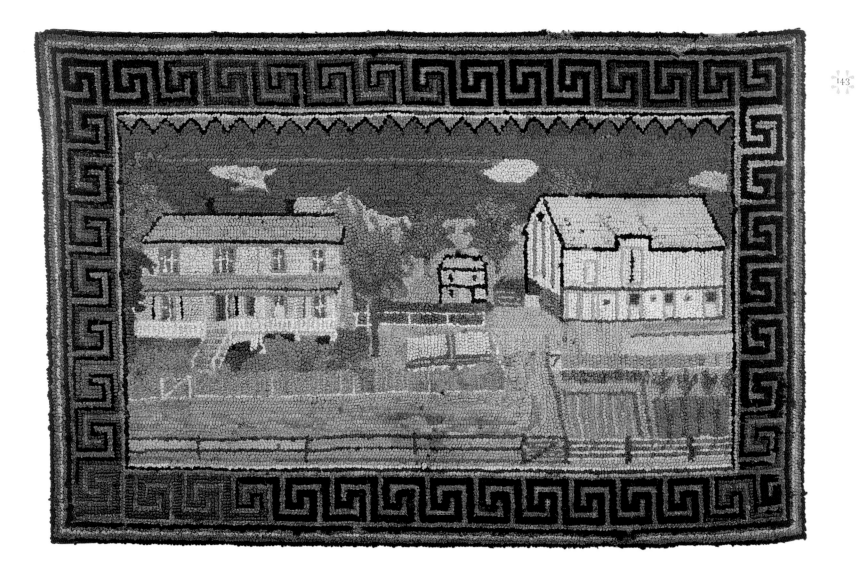

THE FISHERMAN'S HOUSE,
c. 1885

Mrs. Ebe; Baltimore, Maryland

Wool rags on burlap, hooked,

28¹/₂ x 41¹/₂ in.

Private collection Kristina Johnson

A simple country cottage shares the surface of this enigmatic rug with a big fish, a sailor's (or a love) knot, a slender tree (or a narwhale's tusk), and a bird. Bright windows and smoke rising from the chimneys imply a family at home. These motifs likely had meaning for the rug-maker wife of a fisherman that was not passed along as the rug transferred ownership, leaving the contemporary viewer to only conjecture about its message. The house and the surrounding area were hooked in the same dark tones; only a single row of lighter hooking separates one from the other. These tonal variegations occurred because the scrap rag strips were probably culled from many sources and have oxidized and changed color over time. Thanks to the rug maker's freedom of imagination, a cottage portrait advanced beyond its primitive construction of utilitarian woolen scraps, and went from somber to enchanting with the addition of the fish flying in the sky and other personal symbols.

OUR TOWN, c. 1930

Mrs. Turnley; LaGrange, Indiana

Cotton chenille yarn on burlap,

hooked, 26 x 46 in.

Private collection; Photo courtesy

Kristina Johnson

Every activity of town life was captured in this small area rug, quite an accomplishment considering the limitations of detail inherent in the process of hooking through holes in burlap rather than laying down brushstrokes on canvas. The artist, said to be a Mrs. Turnley, a Mennonite, evidently lived in a thriving community that encompassed a factory and a water tower, fertile farms and homesteads, and churches and public buildings. People and goods traveled its roads, as seen in the variety of cars and trucks. Even the town pond was immortalized,

stocked with fish. Progress, already visible through the diverse buildings and activities, was on this town's horizon, hinted at by an airplane overhead. In outsized and folky scale, one farmer is portrayed plowing his field while a nearby figure has an implement in hand to suggest gardening. Mrs. Turnley was fairly successful in conveying perspective through her meandering roads and hilly topography, but revealed a naive and whimsical artistry by depicting those two figures as large as or larger than the foreground buildings and vehicles.

YOUNG BEN FRANKLIN
ARRIVES IN
PHILADELPHIA, c. 1925–30
Artist unknown; found in Pennsylvania
Wool and cotton on burlap, hooked,
62 x 89 in.
Collection of Kristina Johnson

An urban streetscape with buildings of brick and stone was an infrequent theme for a hooked rug. The fact that this example features an identifiable national figure as its subject adds to its distinction. A buttoned-up Ben Franklin crosses the street in front of the skillfully delineated features of a brick-work building, cobblestone sidewalk, paned and shuttered window, and storm cellar door. The covered bridge in the background is believed to be the one built across the Schuykill River at Market Street in the late 1700s. In the 1980s, when auctioned in the folk art collection of Bernard Barenholz, this

rug was catalogued as dating from 1875. Curiously, a similar pattern was published in the 1922 Burnham catalog in its *American Boy* series. Ralph W. Burnham of Ipswich, Massachusetts, was an astute antiques dealer who helped fuel the passion for hooked rugs among the collectors and decorators who frequented his shop. He sold vintage rugs and also issued stamped patterns to hook, or to be hooked at his workshop. Some were his own designs and others were adapted from vintage rugs. Was this the rug that inspired Burnham's pattern or was this a rug hooked from his pattern?

Opposite:
SLEIGH APPROACHING
HOUSES, c. 1940–50
Artist unknown; found in
Massachusetts
Wool on burlap, hooked, 31 x 33 in.
Collection of Laura Fisher

MILL SCENE, c. 1940–50
Artist unknown; found in Connecticut
Wool on burlap, hooked, 27 x 52 in.
Collection of Laura Fisher

These colorful hooked rugs from the mid-twentieth century represent the variety of pictorial rug patterns that inspirational hooking teachers and designers like Louise Hunter Zeiser of Providence, Rhode Island, composed and offered to their students and customers. Zeiser, for example, issued hundreds of patterns of her own design and by others, priced from about $3.00 to $10.00 depending on complexity and size, printed on "fine India

burlap"; most were realistic, bountiful florals. Interestingly, she and other entrepreneurial women rug artists copied old Currier and Ives prints as enticing subjects for rug designs; Zeiser's pattern #523 was "Home to Thanksgiving," and pattern #526, "Nova Scotia," depicted a similar country village winter scene with a horse and sleigh. Pattern #721, the "Old Grist Mill," depicted the Millbourne Mill of Cobb's Creek, Philadelphia.

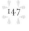
147

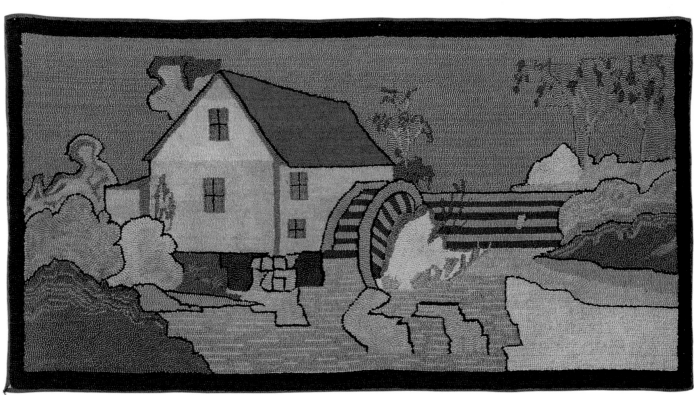

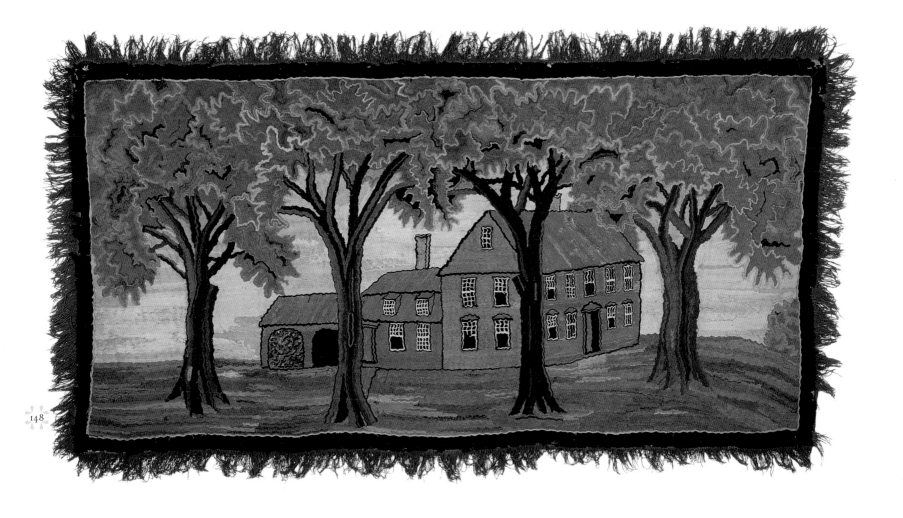

THE SHELDON HOUSE, DATED 1842

Mrs. Arabella S. Sheldon Wells;
Deerfield, Massachusetts
Wool on linen, shirred,
33 1/2 x 53 1/2 in.
Collection of Pocumtuck Valley
Memorial Association,
Memorial Hall Museum,
Deerfield, Massachusetts

The talented thirty-year-old rug maker Arabella Sheldon lived in this house until she married Henry Wells of Shelburne, Massachusetts, in 1843, a year after she finished this detailed portrait. Her parents were Seth and Caroline (Stebbins) Sheldon, and theirs was a prosperous life. The large main building has many nine-over-nine and twelve-over-twelve windows, a smaller wing, and an attached structure where firewood fills an arched opening. The tangible, wriggling surface pile of the piece occurs from shirring, the technique in which strips of cloth are gathered and

sewn down to a foundation. The deft handling of the shirred strips forms a near-canopy of the tree foliage, and establishes an effective visual perspective within this remarkable work. A strong sense of season is conveyed through the use of autumnal shades of bronze, gold, and brown for both the trees and the undulating foreground. In 1837 Sheldon had created a similar rug portrait of the Old Indian House in Deerfield, Massachusetts, exercising her nimble fingers and observation skills in anticipation of this work that she considered her personal masterpiece.

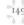

LEDOUX HOUSE, c. 1935
Made by Corinne Angelina Ledoux,
from a design by Lucille Ledoux;
Manchester, New Hampshire
Wool yarn on burlap, hooked,
28 x 51 in.
Collection of the National Museum
of American History,
Smithsonian Institution

A photograph of Amedee and Corinne Ledoux accompanying the rug shows the couple standing in front of the brick steps and columns of their brick house. The formidable building was hooked in accurate detail by their daughter, right up to its tiled or shingled roof. Here was the embodiment of the American dream for the middle class of the 1930s and beyond—a big house made of brick and not two-by-fours, front and side entrances, and a substantial corner plot on a tree-lined street.

By the turn of the century, Americans were able to buy design books containing house patterns; mail-order plans from Sears & Roebuck; and even mass-produced prefabricated houses. The family's French names suggested that they were immigrants from French Canada who had made their way to New Hampshire to follow just that kind of dream. How thoughtful of their daughter to acknowledge the family's accomplishment through this unusual rug.

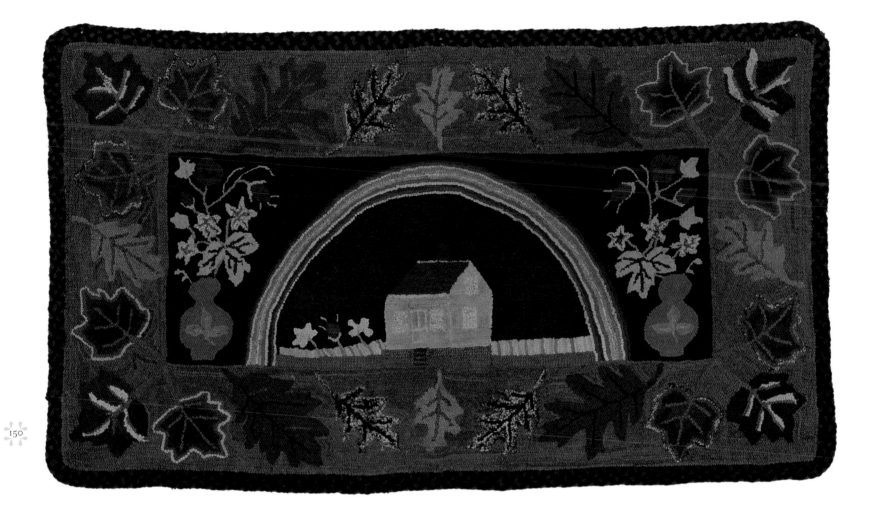

RAINBOW HOUSE,

c. 1920–40

Artist unknown; possibly Connecticut

Wool on burlap, hooked, 26 x 46 in.

Collection of Jessie A. Turbayne

This fanciful rug communicates an optimistic message through symbols, not words. A huge rainbow arches protectively like a dome over a diminutive cottage that is the embodiment of home, with its fence and flowers. Vases as big as the house fill up both sides of the rectangular field. A border that measures about half the width of the entire center is strewn with oak and maple leaves, enormous in comparison to the size of the house. The rug maker may have traced fallen autumn leaves to create

this border treatment, which would be a further clue to its origin in the northeastern United States. Rainbows, considered an omen of good fortune, were a fairly popular subject for early rug hookers; a quite similar example, made a century earlier, in which an exuberant rainbow shelters a house, was hooked by Lucy Barnard of Dixfield Commons, Maine. Now in New York's Metropolitan Museum, it may have been a source of inspiration for the rug shown here.

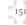

HOME SWEET HOME,
c. 1900
Artist unknown; northern New
England or Maritime Provinces
Wool and cotton on brin, hooked,
30½ x 60 in.
Collection of Virginia Cave;
Photo courtesy Northeast Auctions,
New Hampshire

The maker did not have to hook the title "Home Sweet Home"; it is evident from how she pictured the sturdy simple building. An abundance of birds, a perky bunny, and the family pet surround her home. The hooking was done in fine straight rows across; brin (or unraveled burlap) forms the honey-colored background. This hooking style and material are hallmarks of many rugs found in areas where the Grenfell Mission operated and along the northern coastal region. Sometimes workers for Grenfell hooked their own designs using the distinctive Grenfell hooking technique. These were not accepted for sale through the Mission, but eventually entered the commercial market. A tailored accent inserted by the rug's designer is visible in the mitered corners (emphasized with dark lines) at the scene's inner border. It frames the charming, light-hearted house portrait within.

BIBLIOGRAPHY

American Classics: Hooked Rugs from the Barbara Johnson Collection. Princeton, NJ: Squibb Gallery, 1998.

American Country: Folk Art. Alexandria, VA: Time-Life Books, 1990.

"This is Hooking." American Needlework Series, Woman's Day, January 1941, pp. 19-23,44,47

Bath, Virginia Churchill. Needlework in America: History, Designs, and Techniques. New York: Viking Press, 1979.

Bishop, Robert. Folk Painters of America. New York: E.P. Dutton, 1979.

Bishop, Robert, and Jacqueline Marx Atkins, Folk Art in America. New York: Viking Studio Books and Museum of American Folk Art, 1995.

Bolton, Ethel Stanwood, and Eva Johnston Coe. American Samplers. Princeton, NJ: Pyne Press, 1921; reprint, 1973.

Bowles, Ella Shannon. Hand Made Rugs. Garden City, NY: Garden City Publishing Company, 1937.

Brackman, Barbara. Clues in the Calico: A Guide to Identifying and Dating Antique Quilts. McLean, VA: EPM Publications, 1989.

———. Encyclopedia of Appliqué: An Illustrated, Numerical Index to Traditional and Modern Patterns. McLean, VA: EPM Publications, 1993.

Brackman, Barbara, comp. Encyclopedia of Pieced Quilt Patterns. Paducah, KY: American Quilter's Society, 1993.

Burroughs, Alan. Limners and Likenesses: Three Centuries of American Painting. Cambridge, MA: Harvard University Press, 1936.

Cahill, Holger. American Primitives: An Exhibit of the Paintings of Nineteenth-Century Folk Artists. Newark, NJ: The Newark Museum, 1930.

A Centennial Celebration: Collections from the New York State Historical Association. New York: Cooperstown, 1999.

Colwill, Stiles Tuthill. Francis Guy, 1760–1820. Baltimore: Maryland Historical Society, 1981.

Comstock, Helen, ed. The Concise Encyclopedia of American Antiques. New York: Hawthorn Books, 1958.

Connecticut Historical Society. Morgan B. Brainard's Tavern Signs. Hartford, CT: Connecticut Historical Society, 1958.

Country Furniture. New York: Time-Life Books, 1989.

D'Ambroisio, Paul S. "The Erie Canal and New York State Folk Art." Antiques, April 1999, pp. 597–603.

Davidson, Mildred, and Christa C. Mayer-Thurman. A Handbook on the Collection of Woven Coverlets in the Art Institute of Chicago. Chicago: Art Institute of Chicago, 1973.

Delderfield, Eric R. Introduction to Inn Signs. New York: Arco Publishing Company, 1969.

Duke, Dennis, and Deborah Harding. America's Glorious Quilts. New York: Hugh Lauter Levin Associates, 1987.

Earle, Alice Morse. Home Life in Colonial Days. Middle Village, NY: Jonathan David Publishers, 1975.

Earnest, Corinne, and Russell Earnest. "Fraktur: Folk Art and Family." Antiques and the Arts Weekly (Newtown, Connecticut), October 8, 1999, pp. 1, 68–70A.

Ebert, John, and Katherine Ebert. American Folk Painters. New York: Scribner, 1975.

Embroidered Samplers in the Collection of the Cooper-Hewitt Museum, the Smithsonian's National Museum of Design. Washington, D.C.: Smithsonian Institution, 1984.

Emlen, Robert P. Shaker Village Views. Hanover, NH: University Press of New England, 1987.

Fales, Dean A., Jr. American Painted Furniture, 1660–1880. New York: E.P. Dutton, 1979.

Fendelman, Helaine W. and Jonathan Taylor. Tramp Art. New York: Stewart, Tabori & Chang, 1999.

Finley, Ruth E. Old Patchwork Quilts and the Women Who Made Them. Newton Center, MA: Charles T. Branford Company, 1929; reprint 1983.

Fisher, Laura. Quilts of Illusion. New York: Sterling Publishing Company, 1990.

Fisher, Roger A. Tippencanoe and Trinkets Too: The Material Culture of American Presidential Campaigns, 1828–1984. University of Illinois Board of Trustees, 1988.

Folk Art: Imaginative Works from American Hands. New York: Time-Life Books, 1990.

Goldsborough, Jennifer F. "An Album of Baltimore Album Quilt Studies." *Uncoverings: Research Papers of the American Quilt Study Group,* vol. 15, 1994, edited by Virginia Gunn.

———. "Baltimore Album Quilts." *Antiques,* March 1994, pp. 413–21.

———. *Lavish Legacies: Baltimore Album and Related Quilts in the Collection of the Maryland Historical Society.* Baltimore: Maryland Historical Society, 1994.

Grudin, Eva Unger. *Stitching Memories: African-American Story Quilts.* Williamstown, MA: Williams College Museum of Art, 1990.

Hall, Carrie A., and Rose G. Kretsinger. *The Romance of the Patchwork Quilt in America.* Caldwell, ID: Bonanza Books, 1935.

Harding, Deborah. *Red & White: American Redwork Quilts and Patterns.* New York: Rizzoli, 2000.

Heisey, John W. *A Checklist of American Coverlet Weavers.* Williamsburg, VA: Colonial Williamsburg Foundation, 1978.

Hendershott, Robert L. *The 1904 St. Louis World's Fair, The Louisiana Purchase Exposition: Mementos and Memorabilia.* Iola, WI: Kurt R. Kruger Publishing, 1994.

Hills, Patricia. *The Painters' America: Rural and Urban Life, 1810–1910.* New York: Praeger Publishers, 1974.

Holstein, Jonathan. *The Pieced Quilt: An American Design Tradition.* Greenwich, CT: New York Graphic Society, 1973.

Hornung, Clarence P. *Treasury of American Design.* New York: Harry N. Abrams, 1950.

Horton, Laurel, ed. *Quiltmaking in America: Beyond the Myths—Selected Writings from the American Quilt Study Group.* Nashville, TN: Rutledge Hill Press, 1994.

Houck, Carter. *The Quilt Encyclopedia Illustrated.* New York: Harry N. Abrams, 1991.

Huish, Marcus B. *Samplers and Tapestry Embroideries.* London: Longmans, Green, and Co., 1900; New York: Dover, 1970, reprint of 1913 edition.

Kent, William Winthrop. *The Hooked Rug.* New York: Tudor Publishing Company, 1930.

———*Hooked Rug Design.* Springfield, MA: Pond-Ekberg Company, 1949.

———*Rare Hooked Rugs.* Springfield, MA: Pond-Ekberg Company, 1941.

Ketchum, William C., Jr. *Hooked Rugs: A Historical and Collectors Guide.* New York: Harcourt Brace Jovanovich, 1976.

Keyser, Alan G. "Domestic Architecture of the Schwenkfelders in Eighteenth-Century Pennsylvania." In *Schwenkfelders in America,* Peter C. Erb, ed. Pennsburg, PA: Schwenkfelder Library, 1987.

Khin, Yvonne M. *The Collector's Dictionary of Quilt Names and Patterns.* New York: Portland House, 1980.

Kiracofe, Roderick. *The American Quilt: A History of Cloth and Comfort, 1750–1950.* New York: Clarkson-Potter, 1993.

Kopp, Joel, and Kate Kopp. *American Hooked and Sewn Rugs: Folk Art Underfoot.* New York: E.P. Dutton, 1975.

Krueger, Glee. *A Gallery of American Samplers: The Theodore H. Kapnek Collection.* New York: Bonanza Books, 1984.

———. *New England Samplers to 1840.* Sturbridge, MA: Old Sturbridge, 1978.

Ladies Art Company. *Diagram of Quilt Sofa and Pin Cushion Patterns. Ninth Revised Edition.* St. Louis: Ladies Art Co., 1898.

———. *Miniature Diagrams of Quilt Patterns,* 2nd ed., 1897.

Lasansky, Jeanette. *Central Pennsylvania Redware Pottery 1780–1904.* Lewisburg, PA: Union County Oral Traditions Projects, 1979.

Laverty, Paula. "Save Your Old Silk Stockings: The Hooked Mats of the Grenfell Mission." *Folk Art,* Winter 1993–94.

Linsley, Leslie. *Hooked Rugs: An American Folk Art.* New York: Clarkson N. Potter, 1992.

Lipman, Jean. *American Folk Decoration.* New York: Oxford University Press, 1951.

———. *American Primitive Painting.* New York: Oxford University Press, 1942.

———. *Provocative Parallels*. New York: Dutton Paperbacks, 1975.

———. *Rufus Porter, Yankee Pioneer*. New York: Clarkson N. Potter, 1968.

———. *Rufus Porter, Yankee Wall Painter, Art in America*. Springfield, MA: Pond-Ekberg Company, 1950.

Lipman, Jean, and Alice Winchester. *The Flowering of American Folk Art*. New York: Viking Press and Whitney Museum of American Art, 1974.

Lipman, Jean and Tom Armstrong, eds. *American Folk Painters of Three Centuries*. New York: Hudson Hills Press and the Whitney Museum of Art, 1980.

Lipman, Jean, Elizabeth V. Warren, and Robert Bishop. *Young America: A Folk Art History*. New York: Hudson Hills Press and the Museum of American Folk Art, 1986.

Little, Nina Fletcher. *American Decorative Wall Painting 1700–1850*, New York: Studio Publications, 1952.

———. *Country Art in New England, 1790–1840*. Sturbridge, MA: Old Sturbridge Village, 1960.

———. *Floor Coverings in New England Before 1850*. Sturbridge, MA: Old Sturbridge Village, 1967.

———. *Little by Little, Six Decades of Collecting American Decorative Arts*. Hanover, NH: Society for the Preservation of New England Antiquities and University Press of New England, 1998.

———. *Paintings by New England Provincial Artists, 1775–1800*. Boston: Museum of Fine Arts, 1976.

Lord, Priscilla Sawyer, and Daniel J. Foley. *The Folk Art and Crafts of New England*. Radnor, PA: Chilton Book Company, 1975.

McGown, Pearl K. *Color in Hooked Rugs*. West Boyleston, MA: Pearl K. McGown, 1954.

———. *You Can Hook Rugs*. West Boyleston, MA: Pearl K. McGown, 1951.

McKim, Ruby Short. *One Hundred and One Patchwork Patterns*. Independence, MO: McKim Studios, 1931.

Montgomery, Florence M. *Textiles in America 1650–1870*. New York: W.W. Norton and Co., 1984.

Moshimer, Joan. *The Complete Rug Hooker*. Boston: New York Graphic Society, 1975.

Orlofsky, Patsy, and Myron Orlofsky. *Quilts in America*. New York: McGraw-Hill Book Company, 1974.

Peck, Amelia. *American Quilts and Coverlets in the Metropolitan Museum of Art*. New York: Metropolitan Museum of Art and Dutton Studio Books, 1990.

Peters, Harry T. *Currier & Ives, Printmakers to America*. Garden City, NY: Doubleday, Doran & Co., 1962.

Polley, Robert L., ed. *America's Folk Art: Treasures of American Folk Arts and Crafts in Distinguished Museums and Collections*. New York: Putnam, 1968.

Ramsey, Bets, and Merikay Waldvogel. *The Quilts of Tennessee, Images of Domestic Life Prior to 1930*. Nashville, TN: Rutledge Hill Press, 1986.

Rice, Kym S. *Early American Taverns: For the Entertainment of Friends and Strangers*. New York: Fraunces Tavern Museum, 1983.

Rifkind, Carole. *A Field Guide to American Architecture*. New York: New American Library, 1980.

Ring, Betty. *American Needlework Treasures: Samplers and Silk Embroideries from the Collection of Betty Ring*. New York: E.P. Dutton and Museum of American Folk Art, 1987.

———. *Girlhood Embroidery: American Samplers & Pictorial Needlework, 1650–1850*. vols. 1, 2. New York: Alfred A. Knopf, 1993.

———. "Let Virtue Be a Guide to Thee." In *Needlework in the Educations of Rhode Island Women*. Providence: Rhode Island Historical Society, 1983.

———. "Samplers and Silk Embroideries of Portland, Maine." *Antiques*, September 19, 1988, pp. 512-525.

Rumford, Beatrix T., and Carolyn J. Weekley. *Treasures of American Folk Art from the Abby Aldrich Rockefeller Folk Art Center*. Boston: Bullfinch Press, 1989.

Ryan, Nanette, and Doreen Wright. *Garretts and the Bluenose Rugs of Nova Scotia*. Halifax, N.S., 1990

Safford, Carleton E., and Robert Bishop. *America's Quilts and Coverlets*. New York: E.P. Dutton, 1980.

Samplers and Samplemakers: An American Schoolgirl Art, 1700–1850. New York: Rizzoli, 1991.

Schaffner, Cynthia V.A., and Susan Klein. *American Painted Furniture, 1790–1880*. New York: Clarkson Potter, 1997.

Schiffer, Herbert, comp. *Shaker Architecture*. Atglen, PA: Schiffer Publishing Limited, 1979.

Sebba, Anne. *Samplers: Five Centuries of a Gentle Craft*. New York: Thames and Hudson, 1979.

Sienkiewicz, Elly. *Baltimore Album Quilts, Historic Notes and Antique Patterns: A Pattern Companion to Baltimore Beauties and Beyond*. vol. 1. Lafayette, CA: C&T Publishing, 1990.

Smith, J.E.A. *The History of Pittsfield, (Berkshire County) Massachusetts from the Year 1800 to the Year 1876*. Springfield: C.W. Bryan & Co., 1876.

Smith, Patricia Lynch. "Grenfell Mats." *Northern Scenes: Hooked Art of the Grenfell Mission*. New York: Museum of American Folk Art, 1994.

Stradling, Diana, and J. Garrison Stradling, eds. *The Art of the Potter, Redware and Stoneware*. New York: Main Street, Universe Books, 1977.

Studies In Traditional American Crafts. Oneida, NY: Madison County Historical Society, 1982.

Swan, Susan Burrows. *Plain & Fancy: American Women and Their Needlework, 1700–1850*. New York: Holt, Rinehart, Winston, 1977.

"Talking About Samplers." *Early American Life*, February 1987, pp. 18-23.

Tennant, Emma. *Rag Rugs of England and America*. London: Walker Books, 1992.

Turbayne, Jessie A. *Hooked Rugs: History and the Continuing Tradition*. West Chester, PA: Schiffer Publishing, 1991.

———*The Hooker's Art*. Atglen, PA: Schiffer Publishing, 1993.

Underhill, Vera Bisbee, with Arthur J. Burks. *Creating Hooked Rugs*. New York: Bramhall House (division of Coward-McCann), 1951.

Von Rosenstiel, Helene. *American Rugs and Carpets from the 17th Century to Modern Times*. New York: William Morrow and Co., 1978.

Waldvogel, Merikay, and Barbara Brackman. *Patchwork Souvenirs of the 1933 World's Fair*. Nashville, TN: Rutledge Hill Press, 1993.

Walker, Lydia LeBaron. *Home Craft Rugs: Their Historic Background, Romance of Stitchery and Method of Making*. New York: Frederick A. Stokes Co., 1929.

Waring, Janet. *Early American Stencils on Walls and Furniture*. New York: William R. Scott, 1937; reprint, Dover Publications, 1968.

Warren, Elizabeth V., and Sharon L. Eisenstat. *Glorious American Quilts: The Quilt Collection of the Museum of American Folk Art*. New York: Penguin Books, 1996.

Warren, Elizabeth V. and Stacy C. Hollander. *Expressions of a New Spirit*. New York: Museum of American Folk Art, 1989

Webster, Donald Blake. *Decorated Stoneware Pottery of North America*. Rutland, VT: Charles E. Tuttle, 1971.

Webster, Marie D. *Quilts: Their Story and How to Make Them*, rev. ed., with notes and a biography of the author, by Rosalind Webster Perry. Santa Barbara, CA: Practical Patchwork, 1990.

Weekley, Carolyn J., with Laura Pass Barry. *The Kingdoms of Edward Hicks*. New York: Harry Abrams, 1999.

Weekley, Carolyn J., and Scott W. Nolley. "Edward Hicks." *Folk Art: Magazine of the Museum of American Folk Art*, Fall 1999 pp. 46–52.

Weissman, Judith Reiter, and Wendy Lavitt. *Labors of Love: America's Textiles and Needlework, 1650–1930*. New York: Alfred A. Knopf, 1987.

Wheeler, Candace. *The Development of Embroidery in America*. New York and London: Harper & Brothers Publishers, 1921.

Wiltshire, William E., III. *Folk Pottery of the Shenandoah Valley*. New York: Dutton, 1975.

Wood, Ralph, ed. *The Pennsylvania Germans*. Princeton, NJ: Princeton University Press, 1942.

Woodard, Thos. K., and Blanche Greenstein. *Twentieth Century Quilts, 1900–1950*. New York: E.P. Dutton, 1988.

NOTES

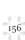

CHAPTER 1:
SAMPLERS & SILK EMBROIDERY

[1] Marcus B. Huish, *Samplers and Tapestry Embroideries* (London: Longmans, Green, and Co., 1900; 1913 edition reprint: New York: Dover, 1970), p. 13.

[2] Ibid, pp. 98–104.

[3] Anne Sebba, *Samplers: Five Centuries of a Gentle Craft* (New York: Thames and Hudson, 1979). p. 134.

[4] Betty Ring, *Girlhood Embroidery: American Samplers & Pictorial Needlework, 1650–1850*, vols. 1, 2 (New York: Alfred A. Knopf, 1993).

[5] Candace Wheeler, *The Development of Embroidery in America* (New York and London: Harper & Brothers Publishers, 1921), p. 55.

[6] Betty Ring, *Girlhood Embroidery: American Samplers & Pictorial Needlework*, Vol. 1 (New York: Alfred A. Knopf, 1993), p. 154, Fig. 173.

CHAPTER 2:
QUILTS & COVERLETS

[1] Carter Houck, *The Quilt Encyclopedia Illustrated* (New York: Harry Abrams, 1991), p. 73.

[2] *Diagrams of Quilt Sofa and Pin Cushion Patterns, Ninth Revised Edition*, Ladies Art Co., 1898, pp. 1–3, 7–8, 14, 16–17.

[3] Ruby Short McKim, *One Hundred and One Patchwork Patterns* (Independence, Mo.: McKim Studios, 1931), p. 117.

[4] Ruth E. Finley, *Old Patchwork Quilts and the Women Who Made Them* (Charles T. Brandford Company, 1929, reprint 1983), pp. 194–96.

[5] Roger A. Fisher, *Tippecanoe and Trinkets Too: The Material Culture of American Presidential Campaigns, 1828–1984*, (University of Illinois: Board of Trustees, 1988), p. 30.

[6] Jennifer F. Goldsborough, *Lavish Legacies: Baltimore Album and Related Quilts in the Collection of the Maryland Historical Society*, (Baltimore, Md.: Maryland Historical Society, 1994), p. 4.

[7] Information obtained from the Buffalo and Erie County Historical Society:

records of Julia Boyer Reinstein and *The Official Catalogue and Guide to the Pan-American Exposition*, 1901.

[8] Helen Comstock, ed., *The Concise Encyclopedia of American Antiques* (New York: Hawthorn Books, 1958) pp. 343–46.

[9] John W. Heisey, *A Checklist of American Coverlet Weavers* (Williamsburg, Va.: Colonial Williamsburg Foundation, 1991).

[10] Ibid, p. 24.

[11] Eva Unger Grudin, *Stitching Memories: African-American Story Quilts* (Williamstown, Mass.: Williams College Museum of Art, 1990). p. 28.

[12] Ruby Short McKim, *One Hundred and One Patchwork Patterns* (Independence, Mo.: McKim Studios, 1931). p. 117.

[13] Merikay Waldvogel and Barbara Brackman, *Patchwork Souvenirs of the 1933 World's Fair* (Nashville, Tenn.: Rutledge Hill Press, 1993), pp. 91–92.

CHAPTER 3:
PAINTINGS & DRAWINGS

[1] Robert Bishop, *Folk Painters of America* (New York: E.P. Dutton, 1979). p. 11.

[2] John and Katherine Ebert, *American Folk Painters* (New York: Charles Scribner's, 1975), p. 127.

[3] *The Crayon*, vol. 3 (1856), p. 5, excerpted from Stiles Tuttle Colwill, *Francis Guy, 1760–1820*, (Baltimore, Md.: Museum and Library of Maryland History, Maryland Historical Society, 1981), p. 20.

[4] J.E.A. Smith, *The History of Pittsfield, Massachussetts from the Year 1800 to the Year 1875*, (Springfield, Mass.: C.W. Bryan & Co., 1876). pp. 672–79.

[5] All period quotes in this caption are from Stiles Tuttle Colwill, *Francis Guy, 1760–1820*, (Baltimore, Md.: Museum and Library of Maryland History, Maryland Historical Society, 1981).

CHAPTER 4:
FURNISHINGS & ACCESSORIES

[1] Jean Lipman, *Rufus Porter Yankee Pioneer* (New York: Clarkson N. Potter, 1968) p. 97.

[2] Dean A. Fales, Jr., *American Painted Furniture 1660-1880* (New York: E.P. Dutton, 1972), p. 50.

[3] Monroe H. Fabian, *The Pennsylvania-German Decorated Chest* (New York: Universe Books, 1978).

[4] Stiles Tuthill Colwill, *Francis Guy, 1760–1820* (Baltimore, Md.: Maryland Historical Society, 1981), p. 24.

[5] Robert Bishop and Jacqueline M. Atkins, *Folk Art in American Life* (New York: Viking Studio Books, 1995), p. 64.

[6] Helaine Fendelman and Jonathan Taylor, *Tramp Art* (New York: Stewart, Tabori & Chang, 1999), p. TK.

[7] Curatorial files, Musuem of American Folk Art, New York.

CHAPTER 5:
YARN-SEWN, SHIRRED, & HOOKED RUGS

[1] Ella Shannon Bowles, *Hand Made Rugs* (New York: Garden City Publishing Company, 1937), p. TK?.

[2] Ibid. p. TK?.

[3] Nina Fletcher Little, *Floor Coverings in New England Before 1850* (Sturbridge, Mass.: Old Sturbridge Village, 1967), p. 246.

[4] Catalogue of Edward Sands Frost, reproduction (Dearborn, Mich: Henry Ford Museum and Greenfield Village, 1971), p. TK?.

[5] Catalogue of Ebenezer Ross, 1893. p. TK.

[6] Nanette Ryan and Doreen Wright, *Garretts and the Bluenose Rugs of Nova Scotia*, (Halifax, Nova Scotia, 1990), p. 6.

[7] Ibid, p. TK.

[8] Ibid, p. 3.

[9] Paula Laverty, "Save Your Old Silk Stockings: The Hooked Mats of the Grenfell Mission," *Folk Art*, Winter 1993–94.

[10] Ibid.

[11] "This is Hooking," American Needlework Series, *Woman's Day*, June 1941.

[12] Vera Bisbee Underhill and Arthur J. Burks, *Creating Hooked Rugs* (New York: Bramhall House, 1951), p. 8.

[13] Ibid, p. 8.

Index

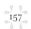

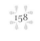

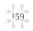